BARN, POINT REYES, CALIFORNIA

To Jon,
Good luck
with the 📷.

JOHN FIELDER
Nov 97

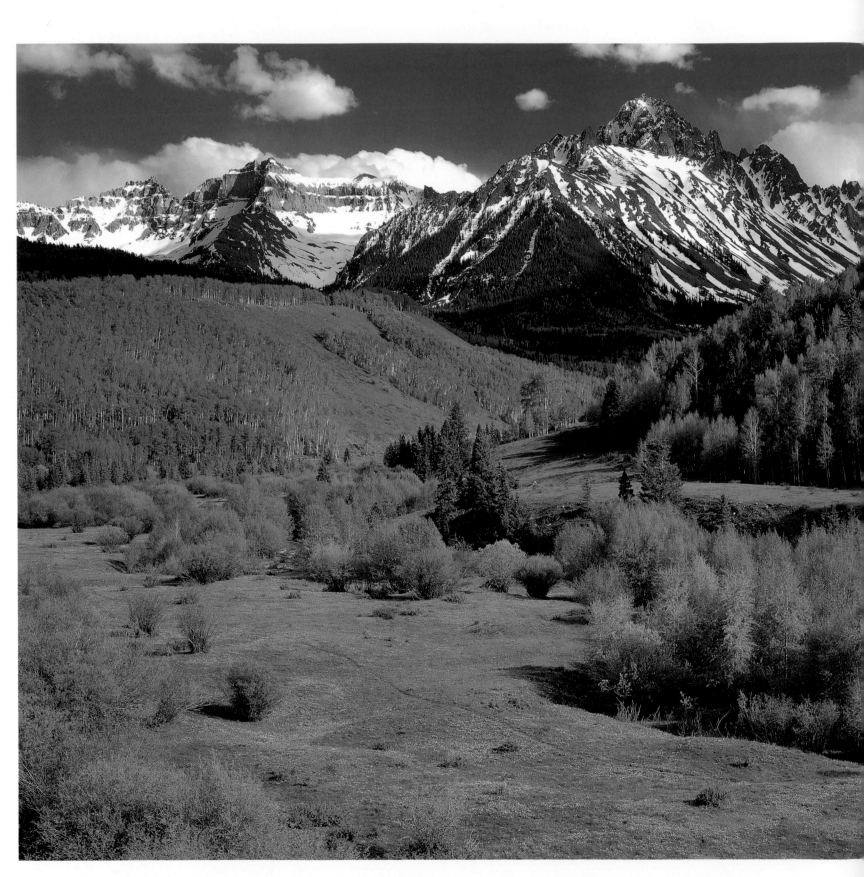

MT. SNEFFELS, COLORADO

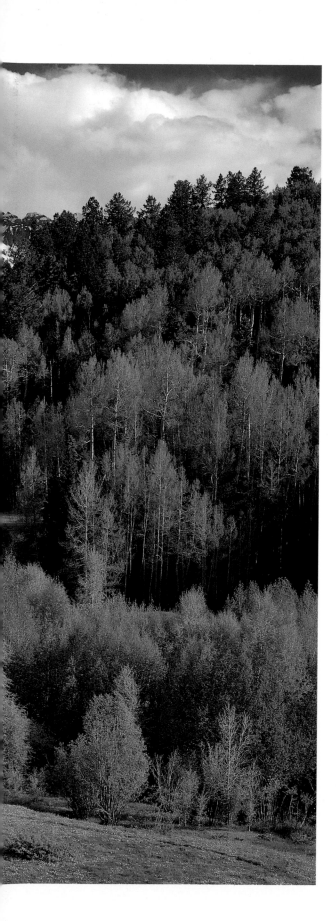

PHOTOGRAPHING THE LANDSCAPE

The Art of Seeing

by

John Fielder

WESTCLIFFE PUBLISHERS

Photographs and text copyright, 1996 John Fielder

Designer: Mark Mulvany
Production: Tim George
Editor: Patrick Shea
Assistant Editor: Kiki Sayre

Published by Westcliffe Publishers, Inc.
2650 South Zuni Street
Englewood, Colorado 80110

Printed in Hong Kong
by C & C Offset Printing Co., Ltd.

Publisher's Cataloging in Publication Data
prepared by Quality Books Inc.
Fielder, John.
 Photographing the Landscape: the art of seeing / by John
Fielder.
 p. cm.
 Includes index.
 isbn: 1-56579-150-9
 1. Nature photography. 2. Landscape photography.
3. Photography, Artistic. 4. Outdoor photography. I. Title.
TR721.F54 1996 778.9'43
 QB196-20455

Thanks to Mountainsmith and LowePro for supplying packs to
me over the years. Their ingenious harness systems have protected
my back from the rigors of hauling gear for so many years. – J.F.

**To receive a color catalog of Westcliffe books and calendars,
call 303-935-0900 or fax 303-935-0903. See page 192 for a
complete list of John Fielder books and calenders.**

Rifle Falls State Park, Colorado

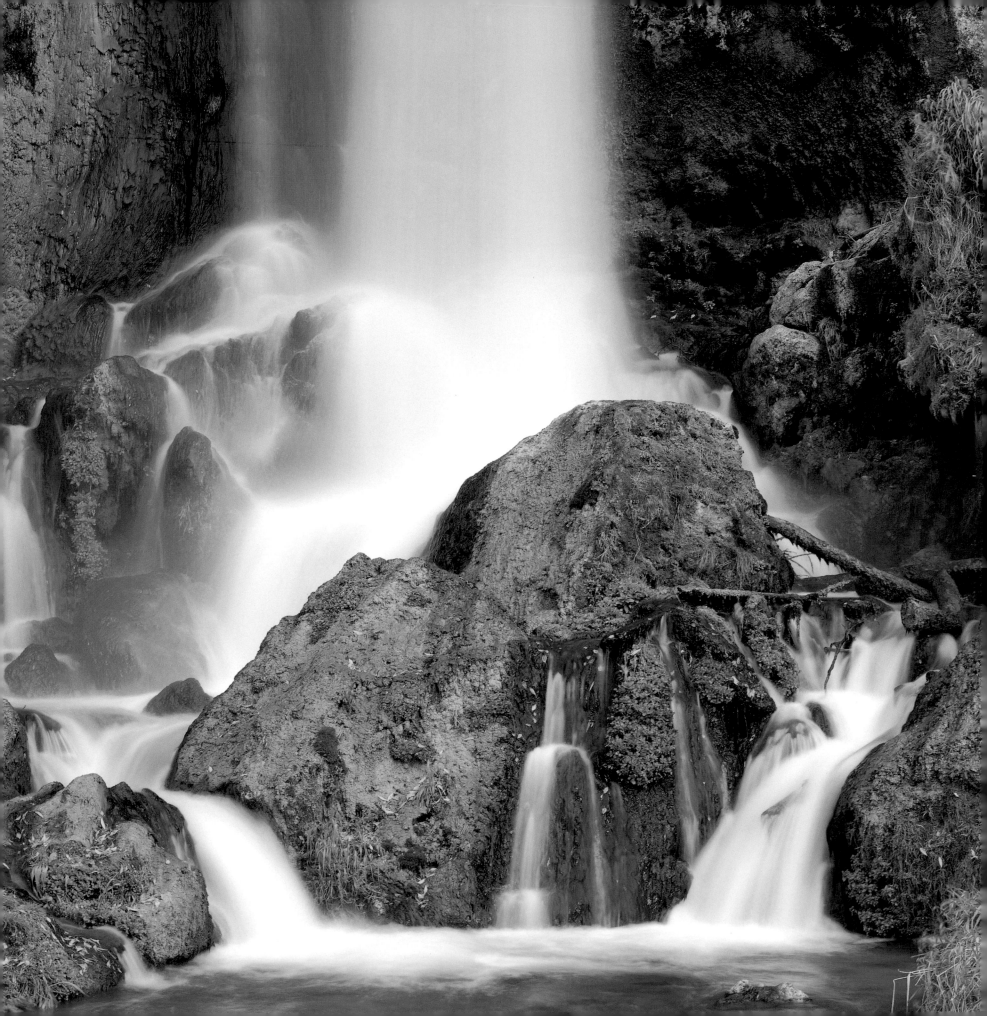

TABLE OF CONTENTS

THE EVOLUTION OF A PHOTOGRAPHER

From birth to death, ideas and events arouse our minds and bodies and piece together our personae, steering us in directions often difficult to foresee. Like wandering up a new trail, uncertain of what lies around the next bend, it can be fun to accept and appreciate life's unpredictability.

Growing up in a suburban North Carolina community created typically urban expectations for me. I had the opportunity to play sports every day after school, and my social life was dominated by things mostly unnatural — movies, television, cars, and hanging out with friends. I didn't discover nature until I went to summer camp in the Appalachian Mountains. For four summers, five weeks at a time, I did all the things one does at a mountain camp. Even though I enjoyed overnight excursions into the wilds of southeastern deciduous forests, I think archery and riflery were my favorite activities. It was fun sleeping out under the stars, but playing tetherball matches were more fun. In short, I had discovered nature, but I didn't fully embrace her.

Of course, academics became more challenging and intense as the grades passed by, as did activities sporting and social. Summer camp in the mountains and nature took a back seat to summer tennis and football practice. Yet new influences emerged from the quagmire of teenage chaos, ones that began to provide lucidity during a time most of us know to be perpetual fog.

The science teacher that inspired me most during all of my school years managed to convince a few of us that Atlantic Coast Conference college basketball was not necessarily the most exciting thing in life. Although we learned from her science textbooks and teaching style, her guided summer excursions across North America inspired us more.

Inside a station wagon towing a pop-up trailer, six teenage boys, a college geology student/counselor, and our teacher, Mrs. Dolly Hickman, coursed the U.S., Canada, and Mexico searching for places depicted in our textbooks — geode fields, national parks, limestone caves, and more.

Whether we were climbing volcanoes in Mexico or snowcatting across glaciers in British Columbia, we peanut butter-and-jellied our way around North America for two summers.

Even for a teenage boy, one would have to be chemically challenged not to have been aroused by the sights, sounds, and smells of nature during those two summers. To this day, these impressions have significantly influenced my life. Yet the metamorphosis did not end here.

During my last two years in high school, maturation and thoughts more worldly and serious led me not to nature but to art. Another inspirational teacher provided us access to the world inside ourselves. Challenged with paints and brush, paper and glue, clay and water, we discovered what our brains and hearts could do with color, form, and rhythm. The degree to which our hands could express feelings varied from person to person, but — talent aside — each of us embraced art and the man who taught it for allowing us to reveal ourselves as we had not done before. Though I was not blessed with great artistic abilities, for many years after high school I continued to paint.

During my college years, I spent a summer working on a cattle ranch in Colorado, and for two summers I prospected for gold and silver around the West. Still, nature did not secure a place inside me. My spirit, now beginning to take shape as the chemical processes of human growth began to slow, was dominated more by curiosity than by anything exalted. What's over the next ridge on top of that mountain? How quickly can I get there? Although I was not fully conscious of it then, the stimuli of sight, sound, smell, and touch was finally creating a comfortable attraction to nature for me.

I now know that my first glimpse in 1963 of snow-capped peaks appearing out of nowhere above the Great Plains (a view no different for the millions who preceded me) was more influential than I had realized. That auspicious view

through the windshield of Mrs. Hickman's station wagon was probably the primary reason why I moved from North Carolina to Colorado. The mere sound of the poetic word, *Colorado*, had not left my subconscious mind for 10 years.

A business degree and ultimately a career in the department store business were pathways leading to a place no one could possibly predict. At the same time, my curiosity for nature grew, particularly for the Colorado Rocky Mountains. I would rise at 2:45 a.m. and drive to southern Colorado's Wet Mountain Valley before sunrise so I could hike far into the Sangre de Cristo mountains and back with enough time to return home that evening for work the next day in Denver. I loved to run because it allowed me to see more country in less time. After taping my ankles to prevent injury, pulling on the only cross-country shoes sold in the early '70s — Adidas "Countries" with the green stripe — and hoisting my day pack, I would run from 9,000 feet to 12,000 feet and back, loving the stares of hikers wondering just what in the world this crazy person was doing. I bushwhacked through willows, across the tundra, and over downed timber as I tried to discover how well I could "orienteer" with the aid of a topographic map and strong legs. All the while, I subconsciously absorbed the sensuality of nature. I never took up technical climbing, but I did become a first-class "scrambler."

Along the way I gave up painting, and I felt empty for it. I realized right away that I needed to evoke and express, yet this was difficult for me to do intimately with other people. Painting had been my catharsis. Then the color landscape photography of Eliot Porter inspired a new outlet for me. I will never forget when I first saw Porter's book, *In Wildness is the Preservation of the World*. I was spellbound by his ability to depict so genuinely on film the natural world that I was beginning to know. How could anyone's photographs look as good as his? Why was the contrast in his photographs so even and the colors simultaneously so rich? I assumed there must have been subterfuge in the printing process. Here was a *nature*, who I thought I was beginning to know so well, depicted in ways I did not understand. If it wasn't trickery, what was it? I was determined to find out.

I didn't own a camera, but I knew of a store in Denver that rented single lens reflex (SLR) cameras. One Friday afternoon I picked up a Pentax body and two lenses (a 24mm wide-angle and a standard 50mm), a tripod and cable release,

and two rolls of Kodachrome 25 slide film. Up at 2:45 a.m. in Denver, I was on foot in the Sangre de Cristos by sunrise and home after dark with two exposed rolls of film and a grin on my face appropriate for someone who thought he'd just duplicated the work of Eliot Porter.

A few days later I reviewed my slides from the Kodak lab. What had gone wrong? The lab must have suffered processing failure. The film might have been defective. The camera was a lemon. My photography was no closer to that of Porter than my painting had been to Picasso. The shadow areas were black, the highlights washed out, everything had a blue cast to it — his book must have been trickery. I was mad and discouraged for the time and money wasted and for the lost expectations. Mad enough, though, to try to discover why my photographs were so poor. I didn't realize I was hooked.

That was 1973. Some 23 years later I am still at it. Even though I have published 23 books of my own, I am still trying to find out why I can't make photographs that are as good as Porter's. To my credit, I have made progress. I've hiked thousands of miles across Colorado and the West, and I've driven hundreds of thousands. I have come to better know nature and her sensuality.

Along the way I began to share my experience with nature and my knowledge of photography by teaching workshops. Workshops are a two-way street; they allow both participant and teacher to understand the craft better. The process of organizing one's thoughts in preparation for sharing them requires introspection and analysis that can only edify and reinforce knowledge. Conducting dozens of workshops has allowed me to refine the sharing process to the extent that I think you will find this book understandable yet challenging.

Nothing is learned so well as a craft mastered through trial and error. No book, no classroom can ever be as valuable as experience. Join me now as I share with you my experiences during the past 23 years. Though I think I can accelerate the process of learning nature photography, you will have to get to know nature herself on your own.

John Fielder
Englewood, Colorado

THE PHILOSOPHY OF A NATURE PHOTOGRAPHER

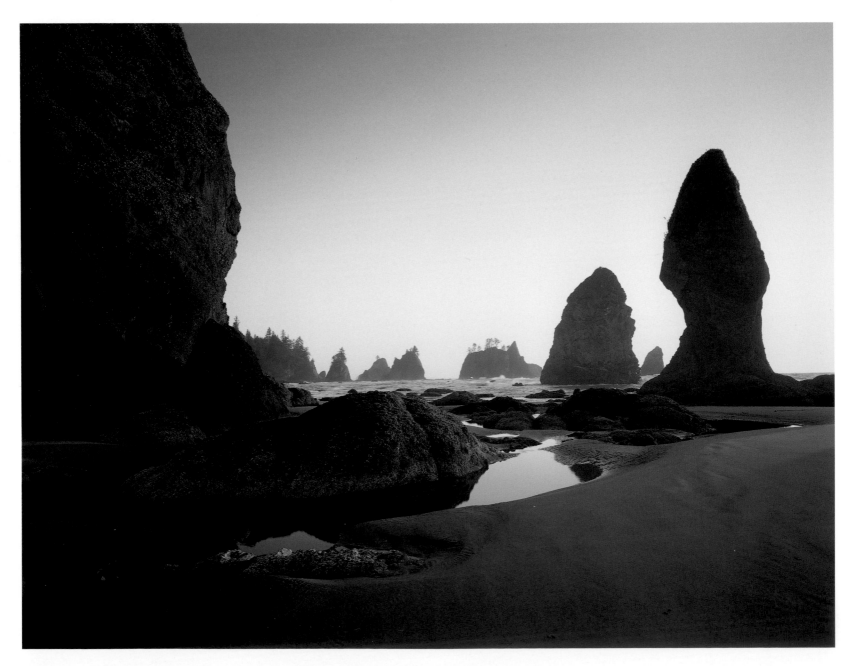

POINT OF THE ARCHES, WASHINGTON

NATURE AND PHOTOGRAPHY

*Photography is the simultaneous recognition, in a fraction
of a second, of the significance of an event as well as of a
precise organization of forms which give that event its proper
expression. I believe that, through the act of living, the
discovery of one's self is made concurrently with the discovery
of the world around us which can mold us, but which can
also be affected by us. A balance must be established
between these two worlds — the one inside us and the one
outside us. As the result of a constant reciprocal process,
both these worlds come to form a single one. And it is this
world that we must communicate.*

— HENRY CARTIER-BRESSON, 20TH CENTURY PHOTOGRAPHER

Excellent photography reveals an emotional attachment
between photographer and subject matter. Passion is a powerful
force. In my case, I appreciate the medium of photography,
but I appreciate nature much more. Nevertheless, I cannot
accomplish my goals unless I know both. For me, nature herself
— not photography — is the means to an end. I hope that
people who view my images are impressed more by the integrity
of nature than by the photography itself, and I hope my
photography helps generate a greater appreciation for all things
natural. Better yet, I hope that people who see my work will
want to visit natural places themselves and come to understand
nature in their own way.

Every good photographer I know has a special relationship
with his or her subject matter. Excellent portrait photographers
are fascinated by people more than most. Excellent photo-
journalists possess an exceptional ability to be at the right place
at the right time. Excellent commercial photographers strive to
render their client's products as faithfully as possible. And
excellent nature photographers love nature and know her
sensuality better than most.

Most photographers are drawn to the medium for one of
two reasons — or often a combination of both: a fascination
with the camera and its workings or an attraction to a particular
subject matter. Every photographer I've met who is more
enchanted with the technical side of photography than with the
subject — be it cameras and formats or merely the physics of
light and optics — falls short of excellence. The photographs
are often precisely composed, even beautiful, but they usually
lack emotion. As Cartier-Bresson said, in this case there is no
balance between discovering one's self and discovering the
world. A great photograph always portrays a unique moment
containing qualities that are aesthetically pleasing and usually
transitory; but a great photograph also conveys an indescribable
and abstract sentiment.

However, this doesn't mean you don't need to know your
equipment well. As I discuss in Chapter Two, "The Essentials
of Nature Photography," the people who record transitory
moments in time on film are usually the ones who best know
their gear and can react most quickly to changing light.

SEEING AND PHOTOGRAPHING

Photography is 90 percent seeing and 10 percent
photographing; if you can't see it, you can't photograph it. This
book is predominantly about seeing and reacting. Chapter One,
"The Art of Seeing," is entirely devoted to helping you discover
elements in nature that you might normally overlook. Among
other things, it teaches you to behold and compose the most
challenging of all scenes — the grand scenic. I will take you
into nature to observe lichens on rock and other microcosms
most people only step over. I will also show you how to isolate
and fashion grand views without a horizon, a type of composition
that Eliot Porter called the "intimate landscape." And you
don't even need to be a photographer in order to learn from
Chapter One — just a lover of nature who wants to observe
more on a day hike.

Seeing is more than just a spontaneous act. Have you ever
wondered how good photographers can make so many wonderful
images in a relatively short time in one geographic location?
Chapter Three, "Being at the Right Place at the Right Time,"
teaches you how to see and compose more easily by actually
predicting what will happen when conditions of light are optimal
for photography. *Previsualization* is the word we use for this, but
don't let it scare you. It's actually quite easy to perform.

The Eye versus the Camera

The eye, though similar in design and function to the camera, produces different visual results. This disparity is the single greatest challenge to the photographer who wants to make nature appear on film the way it does to the eye. For those who prefer impressionistic photography, this disparity provides opportunity.

View — Our eyes don't see nature and the rest of the world the same way a camera's lens and film do. For one thing, we see almost 180 degrees in our normal field of view, whereas the camera "sees" only that angle of view possible with the particular lens attached. Only a "fish-eye" lens sees as much as our eyes do.

Though the viewfinder of the camera is usually a rectangle or square, the barrel of any lens is round, which causes the image projected by a lens to be circular. The viewfinder of the camera "vignettes" the circular image with its rectangular shape. You may take it for granted, but the view through your eyes is also round, but with no viewfinder to vignette what you see.

Depending on the lens focal length, a camera viewfinder is used to isolate a portion of the view you see through your eyes. What *you* see may be chaotic and lacking order — a scene with too many shapes, forms, and colors. With the camera as your editor, you can isolate parts of the scene with the viewfinder merely by moving the camera around until the composition of elements pleases you. In effect, you are isolating order out of the chaos of uncomplementary elements, and this may be the greatest single talent of the excellent photographer. Chapter One contains a thorough discussion of composition.

Dimension — People have two eyes, but most cameras see through only one lens (although you can buy stereoscopic cameras with two lenses). People perceive depth because they are seeing points in a scene with two individual eyes, each one regarding the scene from a slightly different angle. Without this luxury, cameras neither perceive nor record depth on film. Have you ever wondered why your photograph taken on the edge of the Grand Canyon doesn't convey the awe you experienced when you were there? It's because the camera can't see the incredible distance from the canyon edge to the Colorado River the same way you do. Nevertheless, you can emulate depth perception with the camera, and I present ways to do this in Chapter One and Chapter Two.

Contrast and Light — Sunlight shining on the landscape often makes shadows, and any given scene will contain both bright and dark areas. As the sun rises higher in the sky, the difference in illumination between shadow and highlighted areas increases. This difference in illumination is called contrast. The human eye can perceive a greater range of contrast than film can. In fact, we can see the equivalent of 14 stops worth of contrast, whereas color slide film can see only five (for a complete discussion of stops, f-stops, and exposure control, refer to "Understanding and Controlling Exposure" in Chapter Two).

In a scene containing both highlights and shadows, *you* will see all the detail in the highlighted areas as well as the shadow areas, but the film may not, depending on the time of day. When looking at a photograph of such a scene, the highlighted area will seem "washed out." That is, some portion of the detail may be partially or completely white, which we call *overexposed.* Conversely, some portion of the shadow area may be partially or completely underexposed (black). This can be an advantage or a disadvantage, and I talk about both exploiting and avoiding contrast in Chapter One and Chapter Two.

Color to the Eye and Film — Not only is contrast perceived differently by the eye and film, so too is color, but to a lesser degree. And different kinds of color film see color differently. The photographer must decide which film is best for his or her needs. I discuss films thoroughly in Chapter Two.

ETHICS

Despite the differences between how our eye sees and how the camera sees, my personal goal, with a couple of exceptions, is to make nature look on film the way it does to the eye. I feel that nature need not look any better (and should never look any worse) on film than it really is. It already is beautiful. Therefore, I work hard to resolve the limitations of both the camera and film with the goal of matching what I see with what is captured on film.

Excellent nature photographs usually project a given moment so unique that relatively few people have the opportunity to witness it. Sometimes the less experienced nature traveler will conclude that the photograph was either manipulated with filters at the time the picture was taken or retouched when it was printed. People always ask me if filters make my photographs look so wonderful. The truth is I do not use many, and only for certain purposes, which I discuss in Chapter Two and Chapter Three.

In today's digital world, it is quite easy to alter a photograph. This capability is the subject of intense philosophical debate. The ultimate use of a photograph should determine whether or not manipulation is ethical. Photography that misleads can only compromise the integrity of the medium, as well as the subject matter itself.

COLOR VERSUS BLACK AND WHITE PHOTOGRAPHY

This book teaches color nature photography. I personally love excellent black and white landscape photography. The greatest landscape photographer of the 20th century, Ansel Adams, set a standard of excellence for all photographers regardless of camera format, film type, or subject matter. His photography is still the gauge by which all black and white landscape work is judged. And Adams' efforts to preserve our nation's wildlands is a wonderful example for all nature photographers to emulate.

Nevertheless, black and white photography and color photography are as different from one another as painting is from sculpture. Both should be appreciated for the sake of their unique characteristics and demands — and according to the preferences of the photographer. In some ways, the element of color is a positive addition to an image, but it can also be negative. For those whose senses are titillated by light's spectrum of color, imagery without color is difficult to appreciate. On the other hand, for those who appreciate the form in nature, the element of color can be a distraction.

In black and white photography, what we see is not what we enjoy on the final print. In color, it is. Though the black and white medium does not require the eye-to-hand coordination of a painter, it does require the proficiency of a "linguist" who can translate the "language" of color into tones of gray, black, and white.

Good black and white photography results from proficiency with not only taking the picture but making the print as well. The manner in which the original negative is filtered with the camera and processed in the darkroom, as well as how the print is exposed and developed, produces a photograph less real than one in color. More often than not, the color photographer's goal is to duplicate what he or she saw. When reality is altered, it happens when the image is made — not in the darkroom. Therefore, if you want to be a black and white photographer, prepare to spend at least as much time indoors as you would spend outside making photographs.

LANDSCAPE VERSUS WILDLIFE PHOTOGRAPHY

People ask me why my photographs rarely include animals. My answer invariably is: By the time I set up the view camera, compose the scene, and calculate the exposure, the darn animal is long gone. I prefer the large-format view camera for landscape photography, which means the relatively short focal lengths of lenses and the long preparation for image-making are not conducive to wildlife photography.

The gear I usually carry weighs 70 pounds, so it's hard to hike deep into the wilderness where the wildlife are. When they are willing, my helpers, who I call "sherpas," carry the 35mm system in addition to food and camping equipment. On these excursions I do make photographs of wildlife. However, excellent wildlife photography requires long telephoto lenses that weigh as much as 10 pounds and are next to impossible to fit in a pack along with my view camera. In addition, excellent wildlife photography demands a knowledge of animal habits and the patience to wait long hours — if not days — for the animals to appear.

Landscape photography also requires patience but not to the degree of wildlife photography. People often tell me I must be very patient, always having to wait for the right light. In truth, I am not very patient, and I prefer to move on down the trail in search of better light and better locations. I only wait for light to improve when the lay of the land is exceptional enough to justify the time that might be spent elsewhere.

Just as I love excellent black and white photography, I also love excellent wildlife photography. More importantly, I love wildlife, and it is common for me to break out the binoculars high on a ridge following a morning or evening of photography to scan the landscape for elk, deer, bighorn sheep, or mountain goats. More often than not I am successful.

VERSATILITY

If nothing else, this book will teach you how to be versatile with your eye and camera. When lay of the land or conditions of light are not conducive to making a grand scenic, you can find other opportunities that might yield an excellent image of nature. When one type of composition will not work for a scene, another may work very well. Making verticals of horizontals, and vice versa, is an easy way to increase versatility. Chapters one and three show you how to bring back successful images from every photography excursion.

UNPREDICTABILITY AND PHOTOGRAPHY

At any given moment, you either love photography or you hate it; you either think you have it all figured out or you are completely confused. It is important to constantly remind yourself that photography is an art form, not a science, and you can't always predict success. The photographer must be patient and always ready to react to the unknown.

Unpredictability may be photography's greatest joy. Unless you shoot Polaroid film, you have to endure the time difference between when the image is made and when the film is processed. For me this gap always breeds anxiety because I never really know what I'll see on the processed film. Quite often the images you think should have been the best turn out to be mediocre, and the pictures you thought flopped were actually winners.

Here is a statistic that may surprise and console you, so keep it for future reference. I make *500* photographs on average for each week I am in the field. If these images will yield 30 unique, excellent photographs, then I consider my week productive. And out of the entire shoot, I will usually toss about 10 in the trash. What about the other 460? They are verticals of horizontal compositions and vice versa, different exposures of the same scene, different angles of view of the same general composition, as well as duplicates of the ones I thought would be the most popular at the time I made the images. I discuss versatility and unpredictability more thoroughly in Chapter Three.

PERSONAL PERSPECTIVE AND PHOTOGRAPHY

All of us, photographer or not, evolve as unique human beings, are affected by different stimuli in our development, and are still being stimulated according to an indecipherable physiological and psychological code. In other words, we all see things differently — even nature. For example, I may not be as impressed by a mountain in my backyard as would photographers from Omaha who see it for the first time. In photography, where emotion is so important, this first impression may be a handicap for me and an advantage for them. We all perceive our environment differently, and each of us tends to photograph the same scene in completely different ways.

The rules and lessons in this book are not irrefutable. Situations occur that challenge the integrity of any precept. When you doubt the worth of a rule in a certain instance, or when there is no rule to cover a new kind of moment, don't be afraid to revert to instinct. I do this all the time.

Finally, do not fear that using this book will make your photographs look like everyone else's. Nature is too diverse and unpredictable to allow this to happen. And never assume there is not a better way to make a photograph.

TALENT, SELF-CRITICISM, AND EGO

Relatively few people are born with the mind-to-hand coordination necessary to be an excellent painter. With practice, most of us can learn to paint what we see, but lacking innate talent, it is difficult to achieve excellence. Photography is a wonderful medium of art because it does not penalize those of us lacking a painter's talent. All we have to do is compose the scene with the camera, and the film will chemically paint it for us.

This book represents more than two decades of learning photography "by the seat of my pants." Though I never had the chance to take a photography class or attend a workshop, I did read several "how to" books. Some were useful; others were not. Most importantly, I photographed until the money for film and processing ran out, or I hiked until my energy was exhausted. On vacations and days off from my job, which were unpredictable in the department store business, you could always find me outside practicing my avocation.

And, I was not afraid to admit my mistakes. In the field, I recorded data about the conditions in which I made photographs (e.g., time of day, condition of light, f-stop, shutter speed) in order to learn from those mistakes. I was always disappointed with mediocre images, and I was never afraid to analyze the mistakes I had made. A quick scan of the "winners" always gave me the courage to analyze the "losers," and I did this with as much fervor as I devoted to my hikes in the wilderness.

In addition to the self-critiquing process, I scoured stores for landscape photography books. Porter, Adams, Weston, Haas and others did not escape my scrutiny. Time of day, angle of view of the lens, depth of focus, the kind of light, and the place itself were ingredients I examined in every image. I wanted to know why a photograph did or did not work aesthetically in relation to each of those elements.

This detective work taught me how to use the camera, and it allowed me to make better photographs. Nevertheless, my images were only duplications of the qualities I saw in the work of others. I was anxious to advance to a level where I could see and photograph features in nature that I had not seen in other photographs. Over time I learned that I must first know my subject matter more intimately before I could expect to achieve excellence. Minor White described that next level well:

> *The state of mind of a photographer while creating is a blank.... A mind specially blank — how can we describe it to one who has not experienced it? "Sensitive" is one word. "Sensitized" is better, because there is not only a sensitive mind at work but there is effort on the part of the photographer to reach such a condition. "Sympathetic" is fair, if we mean by it an openness of mind which in turn leads to comprehending, understanding everything seen. The photographer projects himself into everything he sees, identifying himself with everything in order to know it and feel it better.*

I have spent more than two decades acquainting myself with nature — living in it some 100 days a year, sensitizing myself to its rhythms, to the aesthetics of the concept of *place* on Earth.

I have just one warning: *Do not let your ego get in the way of your photography.* So many photographers strive to be different, to make unique imagery. Unto itself this goal is not a bad one, as long as during its pursuit the photographer does not forget about the integrity and importance of the subject matter. Considering yourself more than your subject often produces photographs more ordinary than intended. If you believe like I do that nature is sublime, then you want nature to speak for herself without bias or influence from anyone's ego. Trust me on this one: *If you unwaveringly let nature and your love for it be your guide, a photographic style will emerge all by itself.*

THE ART OF SEEING

ONE

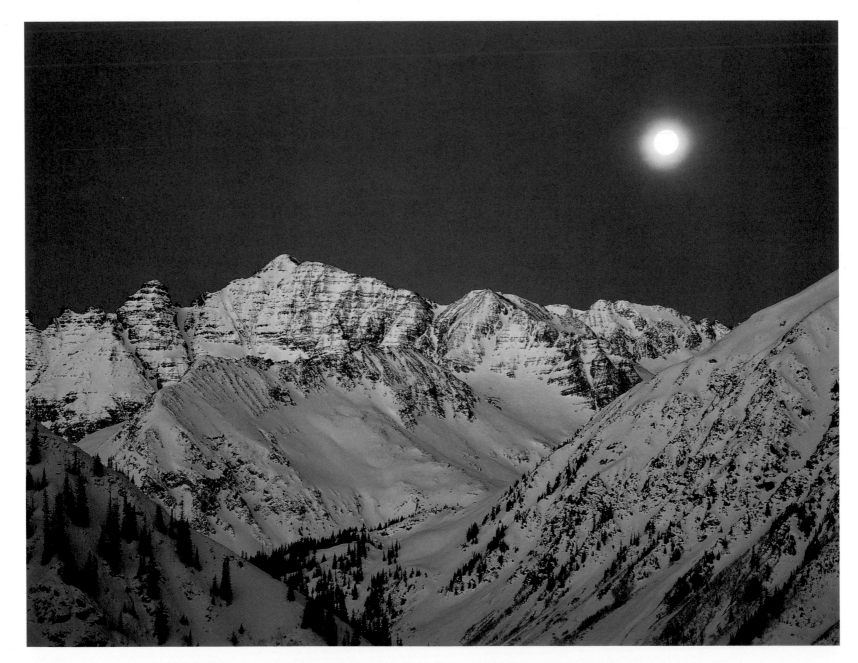

Moonset over Castle Peak, Colorado

I will say it again, over and over, *if you can't see it, you can't photograph it*. Ever since people have inhabited the Earth, they have enjoyed rendering images of their environment with charcoal, pigments of innumerable concoctions, clay, cameras and film, and hundreds of other media. We call this art. In order to make art, people must study their surroundings. Throughout art history, perception of reality has been altered by influences such as spiritual illumination and profound imagination, resulting in visual art styles such as romanticism and impressionism. In every case, however, the environment first stimulates the eye.

Seeing is perceiving. Perceiving is knowing. Knowing is experiencing. Experiencing nature will yield excellent photography. After more than two decades of photographing, I still do not assume I have made the ultimate photograph, that I ever will, or that I am as perceptive as I think I will be next year, or even 20 years from now.

Experience has taught me that the more I do something — if I care about doing it well — the more I improve. I am a better communicator today, and I am a better skier who is in better shape than I was 10 years ago. Each of these facts is important to my career. I care about quality, and with a conscious effort I have improved performance.

The more I have explored the wilds of the West, the more I have seen. If I return to a place I visited 10 years ago, I see more now than I saw then. Before, I may not have noticed the patterns of lines in that barkless dead tree trunk, or I may have missed the contrast between the mountain and its reflection. My eye was untrained — not perceptive enough to discover anything other than nature's most obvious designs. I was harried, too busy with my relative ineptness with the camera to notice the sensuality of nature — her smells, sounds, textures, and sights.

I will not forget my first week in California when I started a two-year project photographing the entire state for a book. Having not previously known the Pacific coast, and curious to discover it, I headed there first — Big Sur, Mendocino County, Arcata. From dawn to dusk, in fog, rain, and blue skies, I documented on film that bastion of color, form, and motion as had Edward Weston before me. At home in Colorado with 400

sheets of film on my light table, I saw results that were similar to the batch of 1973 slides representing my first serious attempt at photography — what a disaster!

This was 12 years and thousands of photographs later at a time when I thought I knew what I was doing. The problem was nothing so obvious as underexposure or overexposure. Technically, the images were fine. The problem was much more subjective. Of 400 photographs, not one was excellent; not one exuded that intangible quality that makes the viewer want to be with you in that place. Though I had experienced fine moments, I had not been able to render them sensitively on film.

I had not truly *seen* the coast of California. Though I was physically present in California, mentally I remained in Colorado's mountains and valleys. Two years later, after many weeks on the coast and elsewhere, I had photographs of which I was proud, ones that projected the essence of the places I ultimately took the time to know.

Always get to know a place first before you photograph it. Don't be anxious to make images of it immediately. Leave the camera in the car, hike around for a day or a week observing, absorbing. Only then set out to put it on film. And don't assume you've seen it all. From year to year, season to season, day to day, and morning to evening, a place is never the same. If you grow to love a place, your perceptivity will grow, too.

Finally, never assume that a photographer cannot create just like a painter. A painter can either paint from reality or from his or her imagination, in which case the artist gathers and composes subject matter in the mind. Photographers can paint within the mind too, even though they are forced to work with reality. Creative photographers often make images by allowing certain features in the landscape to appear more conspicuous in the photograph than they might be to the eye. A skillful photographer controls the outcome of the image — the art.

When I teach workshops, I show participants how they can successfully control the outcome of an image by using a combination of seven distinct elements. For example, you can use some of these elements to "take the viewer on a journey" through the scene from one prescribed place to another in a particular order. Or you may simply want to emphasize one important feature within a large scene. In effect, you steer the viewer to that which happens to be important to you.

Bear with me as I attempt to simplify photography by showing you the seven important elements. Let's prepare a pizza. We will use five basic toppings on the pizza (including cheese), an oven, and a kitchen — a total of seven elements. And let's take for granted that the pizza already comes with a crust and tomato sauce. Finally, assume that the pizza will taste just fine with any one of the toppings but that its taste becomes better and more complex as we add more toppings. The toppings on our photography pizza are: *color, form, moment, perspective,* and the cheese is *view.* Alone, any one of these five photographic toppings can make an excellent photograph, but as we employ more of them together, the photograph becomes increasingly dramatic.

Despite tasty toppings, the pizza will not be palatable until it is baked in the oven. Similarly, a photograph will not be excellent unless the elements are composed in a way that pleases the eye. The oven — the baking of the pizza — is analogous to *composition.* Finally, the kitchen in which we make the pizza is analogous to *light.* Whether you utilize one or all five toppings, whether the composition is good or bad, the image can never be excellent unless you understand and utilize light. You can find many kinds and colors of light on our planet, and each affects the way we perceive and photograph the landscape. Let's first explore the five basic "toppings."

COLOR

The Theory of Color

The most conspicuous of all the elements is color. By itself, color can make an excellent photograph. An image may exhibit the simplest of compositions, but it can still attract and titillate the eye with a display of color. It can even do this with only one color.

I love excellent black and white photography. Without the distraction of color, my eye naturally gravitates to shapes, their edges, and their textures. Nevertheless, our senses are stimulated by color, and that feels good. Though color can distract the eye and make it more difficult to perceive form, I enjoy finding ways that color and form can complement one another. I talk about these techniques later.

Before we proceed, a brief discussion of the physics of light and color is necessary. *All color is light, and all light possesses color, whether we perceive it or not.* The light from the sun is white light, and white light contains the colors of the spectrum. A prism will visibly separate those colors, as will moisture from a rainstorm at day's end in the form of a rainbow. In art we call the yellows, oranges, and reds of the spectrum "warm" colors, and the blues and greens we call "cool" colors.

Separation of colors also occurs in ways that give everything we see an associated color. When light strikes the surface of a red apple, its unique molecular composition absorbs cooler colors in the spectrum and reflects red colors back to our eyes. Similarly, sunlight passing through the Earth's atmosphere at noon on a clear day makes vivid blue sky because the molecules of air absorb all warm colors in the spectrum. At sunrise and sunset, the low-angled sun skimming across the surface of the planet must penetrate many more air molecules than at noon. In this case, the cool colors of the spectrum are absorbed, causing the light to appear yellow, orange, and red. Moisture from an afternoon shower, dust from winds stirring the surface of the Earth, smoke, and air pollution will intensify these warm colors.

Complementary Colors

In its simplest breakdown, white light consists of three primary colors: red, green, and blue. When these three colors of light are projected together, they become a beam of white light. Mixing various combinations of red, green, and blue light produces all the colors we see in life. Every primary color has a complement, or opposite. The opposites of red, green, and blue are respectively, cyan, magenta, and yellow. When these three colors of light are projected together, the result is black. They, too, when mixed in various combinations, will produce all of the colors that we see.

Filters made of any given color will absorb, or block, its complementary color. For example, a magenta filter will block green, a yellow filter will block blue, and so on.

In design and composition, it is important to understand complementary colors. If you wish to make a feature stand out from its background, to make it more conspicuous than it might be otherwise, this can be done with color alone. Yellow autumn leaves photographed against a deep blue sky will render the leaves more noticeable than if their backdrop is a red barn. Why? Because yellow is the complement to blue. Using complementary colors, I can create dramatic images by photographing pure magenta Parry primrose wildflowers against a background of their complementary green foliage.

Other Color Relationships

Harmonious colors are similar, not opposite, colors. For example, yellow is similar to red, and blue is similar to green. A combination of harmonious colors allows other elements in a photograph besides color, such as form and moment, to dominate a composition. I particularly enjoy composing blues and greens together.

Nature makes pastel colors, too. Pastel colors are diluted, more subtle versions of their more intense cousins. Single pastel colors are common in nature; combinations of pastels are less so. Light pinks and baby blues catch my attention in evening and morning skies when the sun gently colors high, thin clouds.

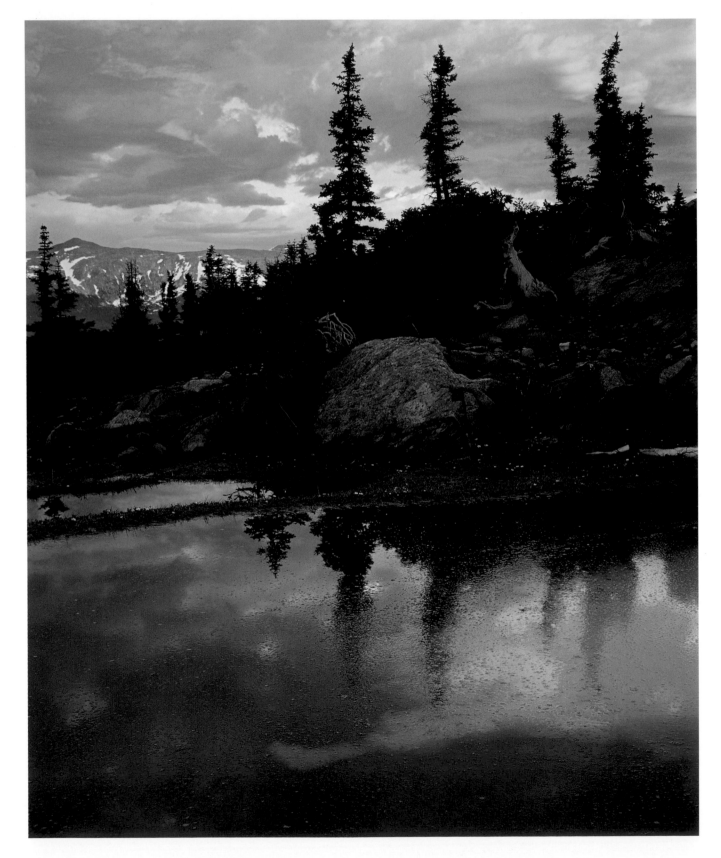

THE ELEMENT OF COLOR

My first foray into this wilderness was a hastily planned trip in the days before I used llamas to help pack gear. Late in the afternoon, I arrived at the French Creek trailhead with Bob Newman, who had agreed to help me photograph for a few days. Fortunately, it was early July and daylight lasted until after 9:00. We quickly donned big packs — his with food and camping gear for both of us, and mine with view camera and personal items.

We had five miles to go to get to our first night's destination — Seven Sisters Lakes, a beautiful cluster of paternoster lakes above timberline. We would need to average two miles an hour in order to photograph sunset at the lakes, which is no easy task with heavy packs and 2,000 feet of vertical gain. As this was my first backpacking trip of the summer, my body was not in shape and two miles an hour proved to be impossible. I envisioned an evening bereft of photographs.

Well before we reached the lakes, and just as the sun began to set, we rounded a bend in the trail to behold a series of small ponds along French Creek. As I saw hints of red form on distant clouds, I knew we should abandon our plan to reach the Seven Sisters. We dropped our packs, and Bob came over to help set up the 4 x 5. Standing on the trail, I saw the wind-shaped fir trees begin to silhouette against an ever-reddening sky. I then noticed that the entire scene was reflecting in the still, icy waters of one pond.

We scurried to the pond's edge, slapped on the 150mm lens, and began to consider exposure. We were in deep shade, while the sky was becoming ever brighter. I knew that contrast might be a problem. My first exposure was one stop darker than my ambient light reading with the gray card, and this proved to be the best of the exposure brackets. Thank goodness the contrast range in the scene had only been three stops, for the photograph preserved detail in the brilliant clouds and had enough in the landscape to make it interesting.

Only when I was home working on the light table several days later did I notice the beautiful pastel blue color of ice in the water. I considered this my bonus for hustling up that trail.

COMPLEMENTARY COLORS

This illustration shows the three primary colors and their complements, or opposites.

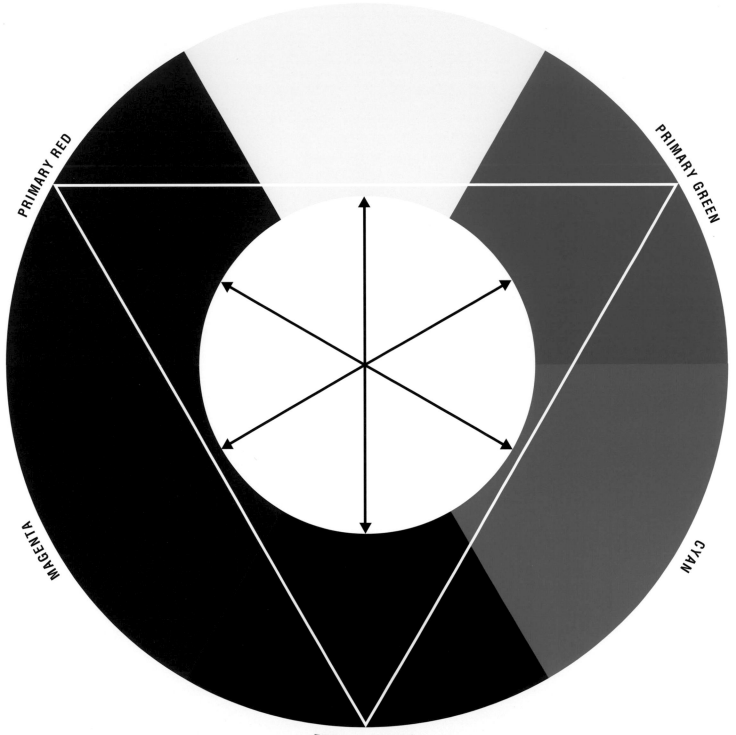

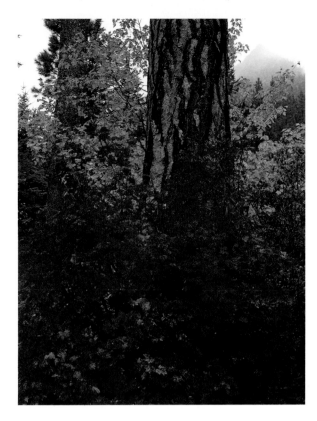

CASCADE RANGE, WASHINGTON

In black and white, the image is underwhelming because it does not include enough contrast. (Contrast is a prerequisite for powerful black and white photography.) The reflectivity of the different colors in the scene are too similar to allow the various features to stand apart from one another in black and white.

COLOR VERSUS BLACK AND WHITE

I made this color image in 1985 with the first box of Fujichrome film I ever used. Fuji had just entered the U.S. film market with its brilliantly colored films. If your senses are titillated by the element of color, here's testament to its visual power.

Warm, soft light allows colors in the landscape to shine. The composition of this image is quite simple, and my intention at the time was only to manifest the glory of color in nature. This photograph is proof that complex design is not a requirement for excellence, and it proves that the solitary element of color can make an alluring image.

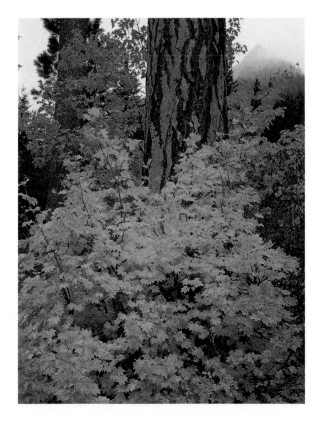

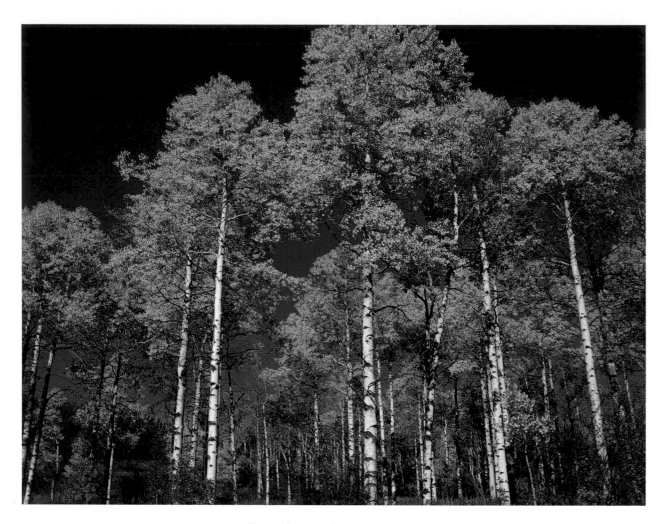

ROUTT NATIONAL FOREST, COLORADO

COMPLEMENTARY COLORS

In black and white photography, black against white creates stark contrast. In color photography, complementary colors create dramatic contrast. Colorado's aspen trees offer some of the most brilliant yellows on the planet, and their marriage with clear mountain skies within two hours of sunset certifies that blue and yellow are absolute complements. This contrast of color directs the viewer's eye immediately to the trees.

This composition is very direct and rudimentary, relying only on color, trees, and sky to attract the eye. The power of color as an element by itself creates an attractive photograph. Note the slight parallax distortion of the aspen trunks. I created this effect by pointing a wide-angle lens up to contain the full length of the trees.

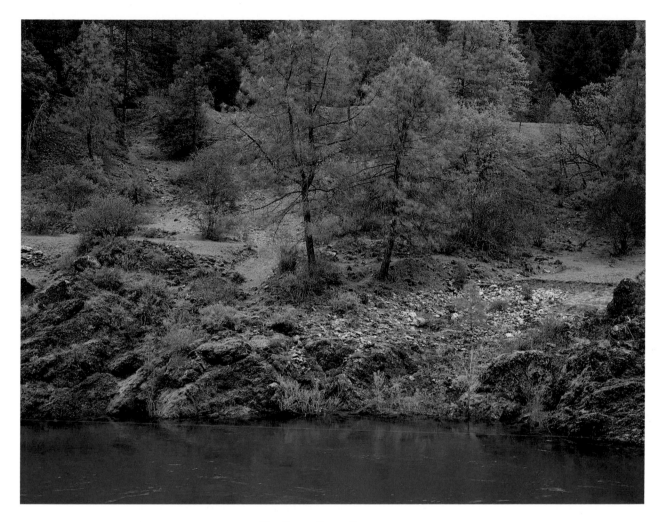

VAN DUZEN RIVER, CALIFORNIA

Note the myriad shades of green in grass, pines, and water in the northern coastal mountains of California. In May the redbud bush blooms in pink pastel and complements the spring greens. The viewer's eye immediately moves to the redbud, and then to places beyond. Though this, too, is a very simple composition with almost no depth, the eye is delighted to explore the fields and forest. This idyllic place creates the urge to swim across the impassable river!

The light could not have been more perfect for photographing this scene. Neither too dark nor too thin, a white veil of clouds had completely covered the sky. Direct afternoon light would have washed out the subtle pastel colors, and high contrast would have distracted the eye away from features in the landscape. Soft light such as this is ubiquitous in coastal regions.

HARMONIOUS COLORS

Because they are so similar in tone, I love finding nature's blues and greens together in a scene. They produce understated images in which the eye is allowed to explore elements other than color, such as shape, texture, and form. In this photograph, the eye tends to follow the edges of ponds and mountains while the mind imagines what might be on the other side of ridges and peaks.

Nothing but back lighting can make grasses glow so green. The direction of light also produces an interesting mix of shadows and highlights that creates depth in the scene. Your eye moves from one place to another, and from foreground to background, as if you were there on foot exploring the nooks and crannies of this place.

SUNRISE, WEMINUCHE WILDERNESS, COLORADO

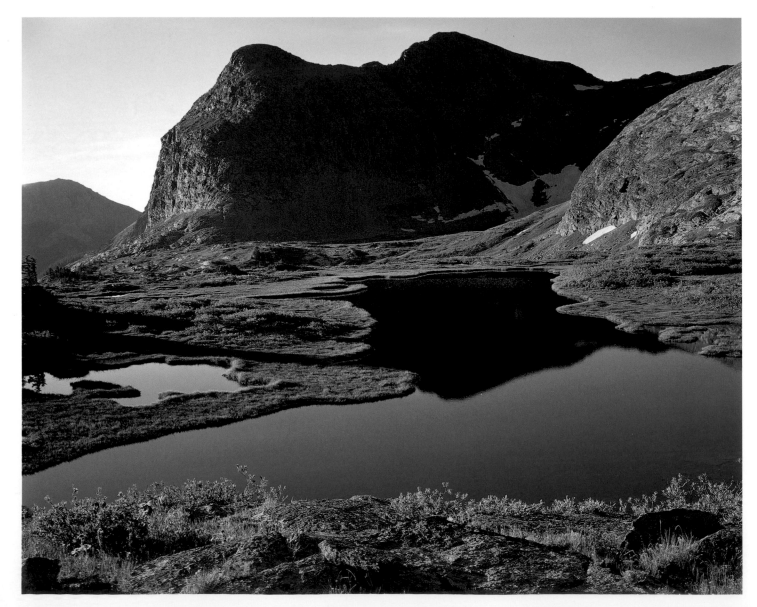

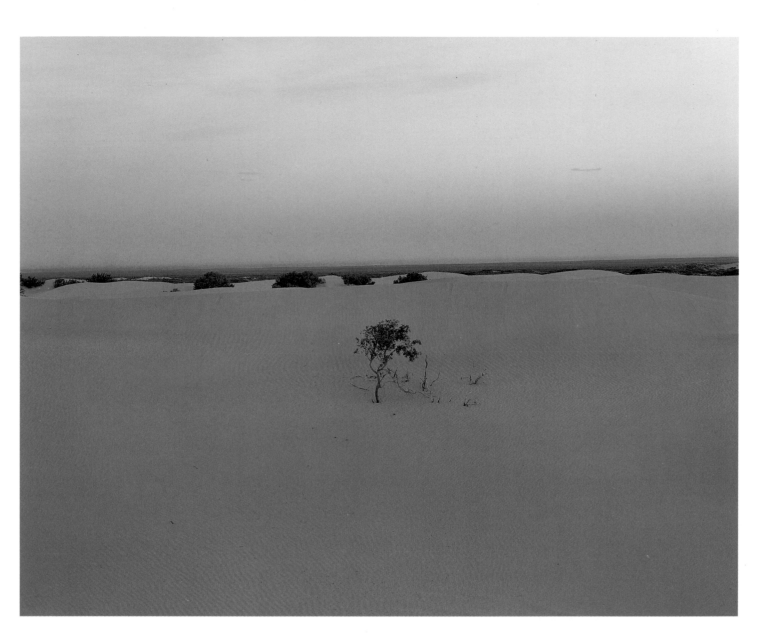

MESCALLERO SAND DUNES, NEW MEXICO

Good landscape photographers never wait until sunrise to photograph, nor do they put away the camera after sunset. On clear days, warm colors form at the horizon and progress through a multitude of shades before melding with blue. Sky color tends to be most vivid well before sunrise or after sunset, and color softens as the still unseen sun rises higher behind the horizon. Pastel pinks reflect their color on the landscape minutes before the sun obliterates it all with shadows and direct yellow light.

Note the subtle warmth of color on the dunes created by the brightening sky and vestiges of twilight pink. The lone cottonwood tree struggles for survival by sinking roots several feet below to tap nourishment from aquifers. Its presence provides counterpoint to a landscape and view that seem endless.

From sea stacks on the coast of Washington to sandstone spires in Utah's redrock country, nature's form, our second "topping," is a source of wonder. As with the element of color, form by itself can make an excellent photograph. The medium of black and white photography is testament to this fact. In part, a black and white photograph draws your eye directly to the *lines, shapes, patterns, textures,* and *volume* in an image because there is no distracting color.

You will see so much more in nature if you understand the essence of form. Let's learn it by analyzing this collection of statements: *Lines define shape. Shapes are two-dimensional. Combinations of shapes are patterns. The interior of shapes and patterns can contain texture. Shapes that suggest three dimensions show volume.*

Line

Lines are the edges of shapes. The conspicuousness of a line is determined by the contrast between a shape and its background. Degree of contrast can be a function of light versus dark, or one color against another. Lines not only define shape; depending upon their direction and position, lines can steer the viewer from one place to another in the image. I talk more about this in my discussion of composition.

Shape

Shapes are two-dimensional and have no depth. Their boundaries are either lines (edges) or the boundaries of the viewfinder of the camera. Just like lines, shapes appear more or less prominent according to the contrast they make with their background. Shapes in nature are ubiquitous, and they can be defined by straight lines, curved lines, angles, or combinations of all three. They can also be irregular.

Pattern

Patterns repeat a certain shape or combination of shapes over and over again. Just like shapes, they are two-dimensional and have no depth. Color, light, and the degree of contrast determines the prominence of the pattern.

Texture

Texture lies within a shape. Even though a photograph by nature is two-dimensional, texture can imply depth. Texture tends to distract the eye away from shapes and their edges.

Volume

Volume is the three-dimensional aspect of shape. Though an object is by nature three-dimensional, in the context of a photograph it can only have two dimensions. Photographers employ a number of tools within the camera to include volume in an image. I talk about controlling depth of focus and exposure in Chapter Two.

Contrast and Form

Simply stated, contrast is the difference in the intensity of illumination from one object to another. The intensity of the light source (which in nature is the sun), the direction of the light, weather, and the colors of the landscape all affect contrast. The sun becomes brighter as it rises in the sky. The difference in brightness between a directly lighted area and an area in shade within a scene is at its greatest around noon each day. When the sun is not directly overhead, light is less intense, and the degree of contrast between highlight and shadow decreases. Clouds in the sky affect contrast by reducing the overall intensity of the light, thereby reducing contrast.

In my introduction to this book, I mentioned that film records contrast differently than the eye, and that the eye sees contrast four times better than film. In a brightly lighted scene, you and I may be able to see small details in both the highlight and shadow areas, but the film cannot. On film, the highlights may appear washed out, overexposed, and the shadows might be almost solid black. In Chapter Two I talk about mitigating this problem.

More than any other factor, contrast affects our perception of form in nature.

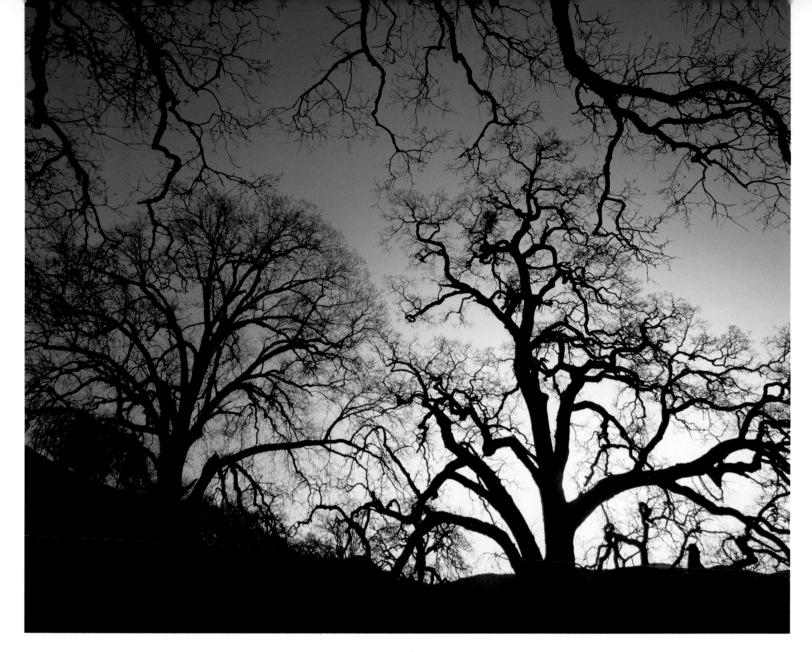

OAK TREES, CALIFORNIA

THE ELEMENT OF FORM

In both color and black and white photography, there is no better way to make shapes conspicuous than by allowing black to silhouette against lighter values. One of the deficiencies of film is its inability to accommodate the same range of contrast as the eye. Nevertheless, this flaw is useful if the photographer wishes to emphasize shape. When I made this image, I knew the pre-sunrise morning sky was five stops brighter than the trees and landscape, and I knew that my light meter would demand underexposure. Before I made the image, I realized there would be no detail at all in the trunks and branches.

Notice how your eye gravitates toward the edges of the dendritic shapes. If there were any texture at all — if the bark could be seen — this image would not have the impact that it does. I made the photograph with a wide-angle lens and positioned the camera very close to the ground. I pointed it up 40 degrees to provide a compositional base of land, as well as to include the branches of tall trees overhanging behind me. The effect creates visual tension, and it arouses curiosity about the origin of the branches descending into the scene.

LINE

Rainfall keeps California hillsides green in winter; in summer they dry up and turn brown. Within sight of the ocean, mornings often begin in fog, and by noon blue skies appear. As the fog recedes, there are stages of mist and mood that prevent direct light from reaching the landscape. Amid this warm glow, shadows are subtle and, in certain places, form becomes dominant. This image promotes both texture and form, but I especially like the sense of order created by the diagonal lines that feed into the center of the image.

CONTRA COSTA COUNTY, CALIFORNIA

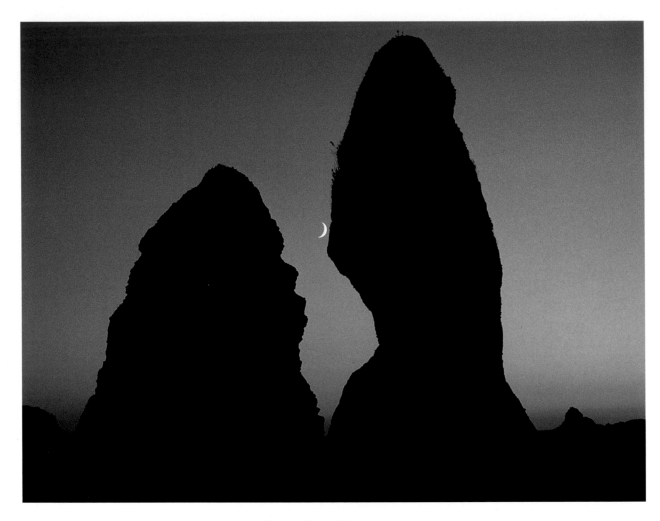

SHI-SHI BEACH, WASHINGTON

SHAPE

Ambient illumination is minimal in this scene, and the post-sunset sky is much brighter than the landscape. Once again, high contrast transparency film is wonderful for making silhouettes out of nature's shapes. The eye is immediately attracted to the shapes of the 60-foot high sea stacks just off the coast before it retreats to the vivid colors in the sky.

I had lugged a 100-pound pack filled with the view camera, camping gear, and food for a three-day solitary stay on Shi-shi Beach. Mother Nature challenged my photographic mettle with moment after resplendent moment, from gaudy sunrises to misty afternoons and sensuous sunsets. I didn't see another person during my stay, and the solitude engendered a focus upon nature and her moods that might not have been possible with others around.

MAROON BELLS-SNOWMASS WILDERNESS, COLORADO

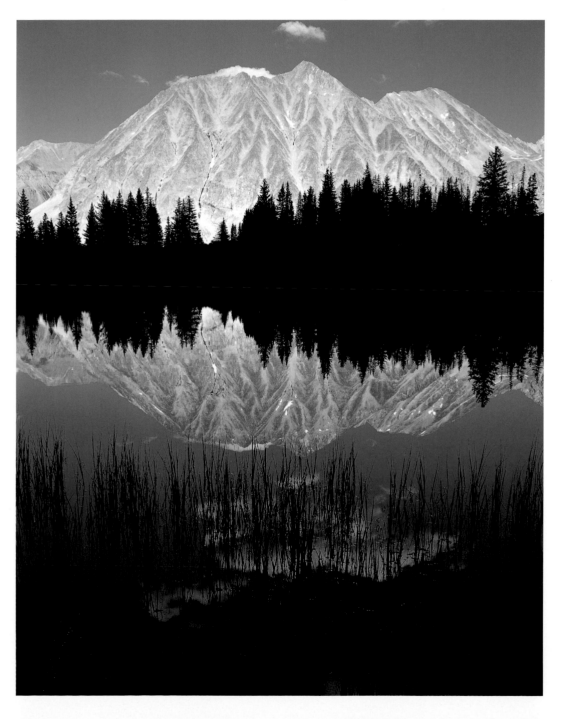

It is possible for an instructor to make good images in the field without being accused of ignoring workshop participants. This photograph is testament to that fact. Back in the days when I taught photography in Crested Butte, Colorado, I led a particular llama excursion into the Maroon Bells-Snowmass Wilderness. Six llamas, six participants, two guides, and I spent three days in the heart of wilderness practicing our craft.

One evening we were gathered together at the edge of an alpine tarn, waiting for the sun to descend far enough to take the edge off a scene full of contrast. During the magic hour before sunset, White Rock Mountain received light from the setting sun head-on while we were in shade. With a certain amount of exposure bracketing — and without using graduated neutral density filters — each of us had the good fortune of taking this image home on film.

PATTERN

I once spent two years photographing for a book about California. I made several trips to Mono Lake, a place as visually interesting as any I've ever explored. From tufa formations around the lake itself to giant Jeffrey pines on its edges, shape and form are the essence of Mono Lake.

When I came across these fallen cones — not one of which measured less than eight inches long — I was struck by the order of their fall and the symmetry of their placement. Not much later, I recognized the subtle color palette made possible by the alliance of cones from year's past with those that had recently fallen.

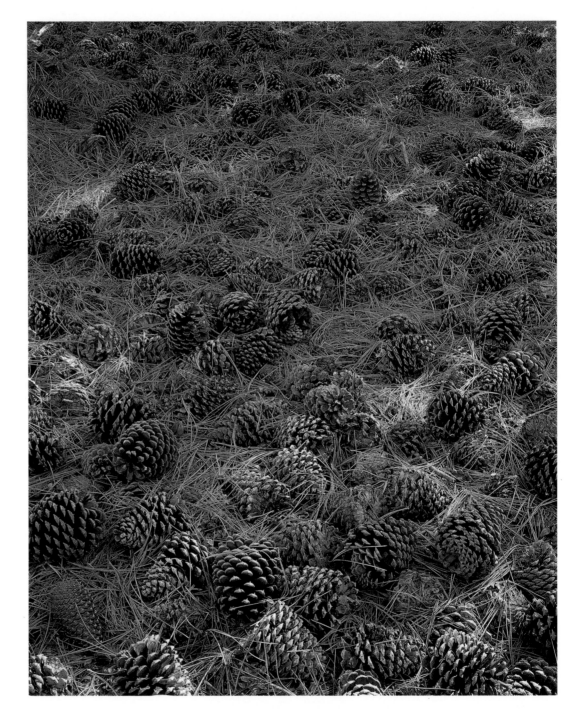

MONO COUNTY, CALIFORNIA

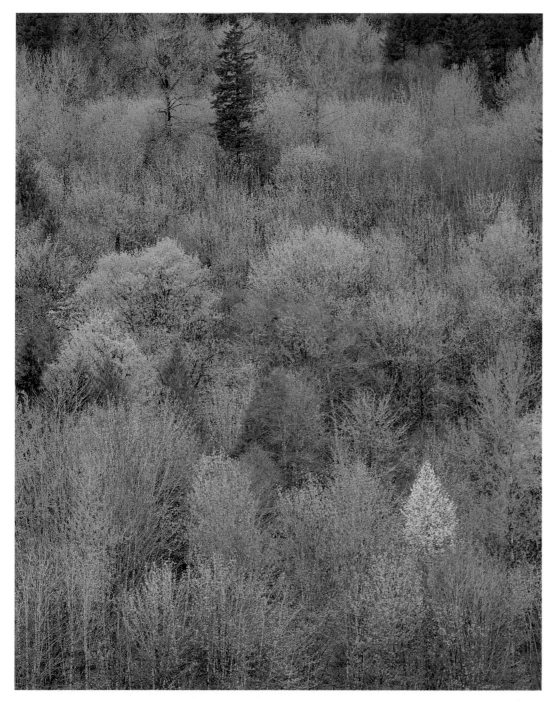

TEXTURE

I am a dangerous person to ride with in a car if I'm driving. I'm constantly looking out the side windows for photogenic opportunities. I haven't crashed yet, or driven off a cliff, but chances are good I will one day.

I was driving along the highway in Washington one spring day when I saw something out of the corner of my eye. I have learned to react to such stimuli by quickly stopping to investigate. As I suspected, a photogenic scene was waiting to be noticed. In this case, a sea of green leaves just out of their buds was interrupted by a lone flowering tree.

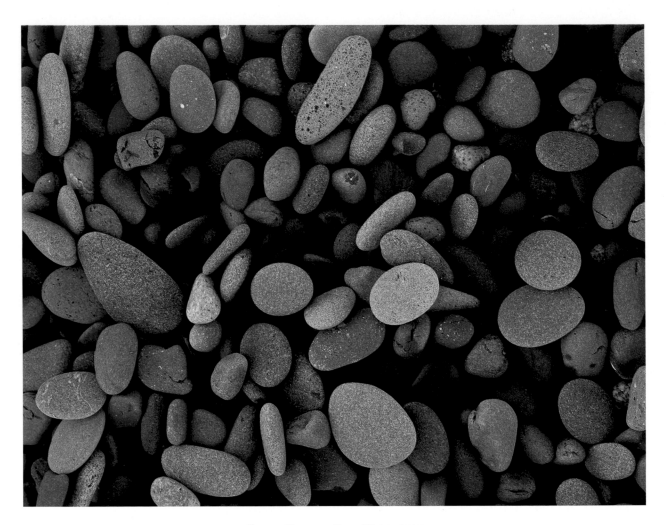

OLYMPIC NATIONAL PARK, WASHINGTON

VOLUME

The most wonderful hike along wilderness coast in the continental U.S. is in Olympic National Park. Two untrammeled stretches of coast, each about 25 miles long, are separated only by the Indian town of La Push. Trails are infrequent, so you hike on beaches and across tidal pools at low tide. I emphasize the words low tide because many hikers have drowned after being caught in small bays at high tide. Tide tables are mandatory.

Elk and eagles, sea stacks and sea urchins are ubiquitous. Shapes made interesting by the action of the Pacific Ocean make this a visual place. Beaches are mostly of sand, while others are composed of poor man's sand — rounded stones and pebbles. When the sun hid behind a cloud, the blue sky reflected on this group of gray stones. Shape, texture, and pattern all conspired to make this perfect example of volume.

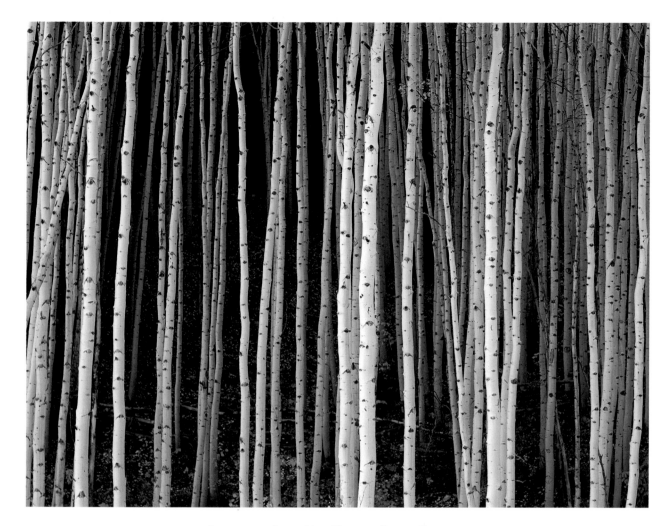

ASPEN BOLES, GRAND MESA NATIONAL FOREST, COLORADO

Even without leaves, the aspen tree is a remarkable plant. Though people appreciate most its delicate green leaves of spring and golden leaves of fall, I never tire of the integrity of the trunks, or boles. As straight and parallel as any trunk on the planet, their whiteness makes them conspicuous against almost any background. Only in cloudy light could such detail as this be portrayed on film. I discovered this scene from the window of my moving truck.

Moment is the most elusive of the five toppings, for it can only be employed when nature allows and when the photographer is at the right place at the right time. Even then, the photographer must be good enough, quick enough, and cool-headed enough to put a transitory moment on film. In our pizza analogy, if color is pepperoni and form is diced onion, then moment must be truffles from France at $50 an ounce! More often than any other element, moment can create an excellent photograph. Moment also affects the first two elements, for it can change colors and alter the film's perception of form.

Of the five toppings, moment is by far the most difficult to quantify. Nevertheless, nature regularly shares with us certain specific kinds of moments. Some are witnessed only in particular places; others are seen around the globe. Some are predictable; others are not. Here are a few.

Seasons

In a visual sense, seasons can render a given landscape at least four different ways. In my home state of Colorado, I will return to the same place each season and be able to make four completely different photographs.

Season after season, year after year, I like to return to a certain aspen tree forest near Crested Butte, Colorado. From a high vantage I can look down upon a sea of trees in front of a background of 13,000-foot mountains. In the spring the leaves take on the color of a lime as their delicate leaflets burst from buds for a week or two in early June. Behind the forest are white peaks only then losing their snow. In the summer, mature green leaves darken and become less translucent, and the peaks behind exhibit snowless tones of brown and gray. During autumn the leaves are canary yellow, and the peaks are decorated with a dusting of snow, creating pastel earth tones. In winter the leaves are on the ground, grayish-white aspen trunks connect to dendritic patterns of branches, and peaks are winter-white again. Except for blue sky and an occasional green conifer, color in the forest is minimal.

You can also find special moments in between seasons. Early in the fall, the leaves run the range from green and yellow to orange and red. Aspens propagate both by root and seed, creating genetically related aspen "families." Operating on different biological clocks, tree families leaf and deleaf at slightly different times, thereby creating variegated palettes of color before their autumn colors peak. In early spring, after the snows have melted in the forest, after the ferns and grasses have greened and the golden banner bloomed, the buds have still not leafed. The result is a wonderful contrast of parallel and tall aspen boles against a background of vibrant spring color.

Even from year to year, it is never the same. In 1995, we experienced no autumn color in Colorado because too much early precipitation turned leaves from green to brown.

The Cycle of the Day

On clear days from before dawn to after dark, the light's color and contrast change the appearance of the landscape from one hour to the next. Long shadows and rich, warm light mark the "magic" hours at the ends of the day. Add weather, and the ways in which a given scene can be viewed are infinite. Though some photographers might consider classic sunset photography cliché, I rarely pass up the chance to compose sunsets and sunrises in unique ways. In my discussion of light, I discuss and explain the complete daily cycle of light.

Soft Light

Artist's light. People who live near the coast know soft light well. Foggy, misty weather allows sunlight to penetrate and glow. Light bounces from one drop of water vapor to another, scattering warm light in all directions. Devoid of the harshness of direct sunlight, soft light scatters itself everywhere, reducing contrast and making all colors more vibrant than usual.

Such light is always transitory, and the photographer must react quickly to it. On the coast of California, summer fog sets in early in the morning and recedes around noon. One minute you are in a cloud; the next minute you have clear blue sky. It is during this transition, when the fog is neither too dense nor too thin, that artist's light is best.

Rainbows

Like sunsets and sunrises, rainbows are often taken for granted and deemed trite. However, every good photographer I know would give away the pot of gold at its end to be able to make a unique rainbow image. The best rainbow images contain not only the rainbow, but a sense of the place in which it occurred.

Rainbows form in the direction opposite the sun, when the sun is lower than 42 degrees above the horizon and when moisture particles from isolated thundershowers are a certain size. Sunlight is diffracted by the particles into colors of the spectrum in the shape of an arc. Walking toward a rainbow or away from it does not change its size. A caveat regarding rainbows: a polarizing filter can make them disappear.

Brocken Specter

Brocken Specter is the rarely seen "circular rainbow." Witnessed mostly from airplanes, this meteorological phenomenon is probably the origin of the religious symbol "halo." I have seen only two in my life, both from high mountain ridges. One lasted for over two hours.

The specter occurs under the same conditions as a rainbow and is positioned opposite the sun. There must be moisture particles in the atmosphere behind you in order to create the circular rainbow, and you need an opaque mist in front of you to serve as a "slide projector screen." The position of your body between sun and mist causes the formation of the specter. It is projected onto the cloud of mist with your own shadow appearing in the middle of the circle.

The Earth's Shadow

The Earth's shadow is most visible from high vantage points on clear days, opposite the sun, and about 15 minutes before you can see any direct morning light (or 15 minutes after sunset). Most dramatic at higher altitudes, this phenomenon contains a horizontal blue band of color just above the horizon superseded by a pink band. The colors are very intense and will appear on film even when overexposed.

Sunstars

The intensity of the sun makes viewing sunstars easier with the camera than with the eye. Composing the sun so that it is partially blocked by an object, such as a tree trunk or cloud, is the best way to make a sunstar. Beware of hexagonal lens flares, however. If you do not block enough of the sun, those red shapes will appear both in your viewfinder and on the film.

You can also create a sunstar in open sky. Stop lenses down to f/16 or f/22 and shoot directly into the sun. Compose the sun in the very middle of the viewfinder to insure that no lens flares are visible. When you line up the sun with the progressive flares so they are hidden by the sun, the lens flares are eliminated. You can also buy special filters that create sunstars from any source of light.

I often think that some moments are intended to be photographed, others not. Considering that composition, metering, and focusing must always occur before pressing the shutter, the length of a moment is often too short for the photographer to put it on film. In any event, they make fine memories. Photographers can increase the odds of "capturing" transitory moments by operating the camera quickly. I talk about this skill in Chapter Three.

THE ELEMENT OF MOMENT

Never assume that the wonderful moment you have just experienced in nature is the only one that will occur in that setting. On a few rare occasions over the past 20 years, I have been convinced I had just made that once-in-a-year image, only to look behind me to see an even more glorious moment happening.

Many great photographs are made on the edge of changing weather — usually at the end of severe storms but before skies have cleared and rain or snow has completely abated. On the occasion of this photograph, Jon, my sherpa, and I had crawled from our sleeping bags well before dawn to prepare an image preconceived the night before. I knew exactly what I wanted to do:

photograph silhouettes of tundra pool islands under clear morning skies. Instead, we awoke to cloudy skies and very little hope for a sunrise. As you see, the sun managed to find its way through, resulting in the most brilliant sunrise of the year.

After making eight exposures of this moment, rain began to fall. As we packed up gear for the run back to the shelter of our tents, we suddenly noticed a huge double rainbow arcing over a nearby lake, and the mountains bathed in yellow, stormy light. With wind and rain in our faces and lightning striking frighteningly close by, we ultimately made a photograph even more spectacular than the one below. But to see it, you'll have to buy my next book!

WEMINUCHE WILDERNESS, COLORADO

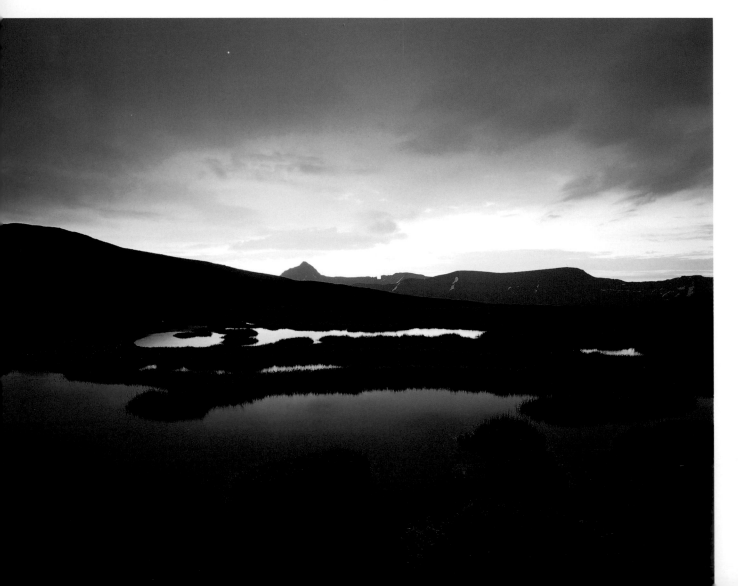

MOUNT RAINIER NATIONAL PARK, WASHINGTON

SOFT LIGHT

Alone, any one of the photographic "toppings" can make an excellent photograph, but the combination of several can take your photography to a new level. This image contains the brilliant and complementary colors of red mountain ash and forest greens, the conspicuous shapes of large dead conifers, and a very real sense of perspective and moment caused by the unusual lighting.

Fog is the mist inside a cloud. Clouds, fog, and Mount Rainier go together well, especially when the sun penetrates the mist. I prefer when sunlight illuminates the cloud, not the landscape directly. Here the mist becomes more dense with distance, creating the illusion of depth through the trees. Even though your face and fingers feel nature's damp chill, all color in the landscape is warm. Good photographers are always busiest in soft light.

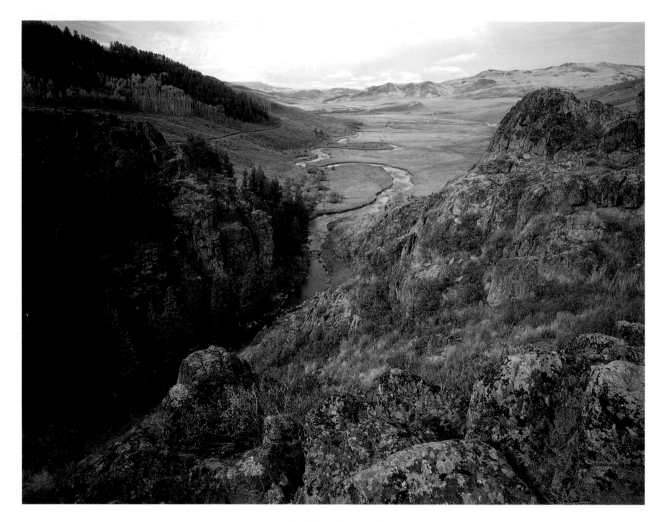

AUTUMN, THE YAMPA RIVER, COLORADO

SEASONS

After more than 20 years of exploring new places, I am finally finding time to revisit favorite scenes during different seasons. I am glad I photographed this vantage during spring and fall many years ago. Pleasant Valley, as

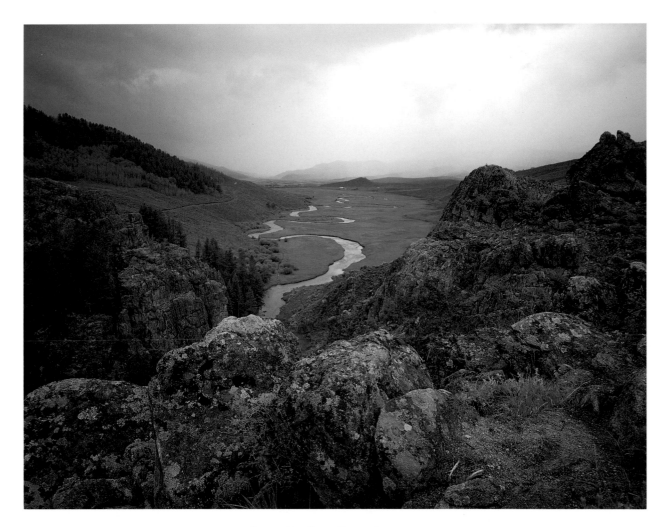

SPRING, THE YAMPA RIVER, COLORADO

it was called then, is now beneath Stagecoach Reservoir. The lovely meandering of the Yampa is gone forever, having succumbed to someone's notion that more electric power was needed in northern Colorado. I lament how we choose to dam some of the most beautiful rivers in our country. The life of this particular place can now only be considered a moment in time.

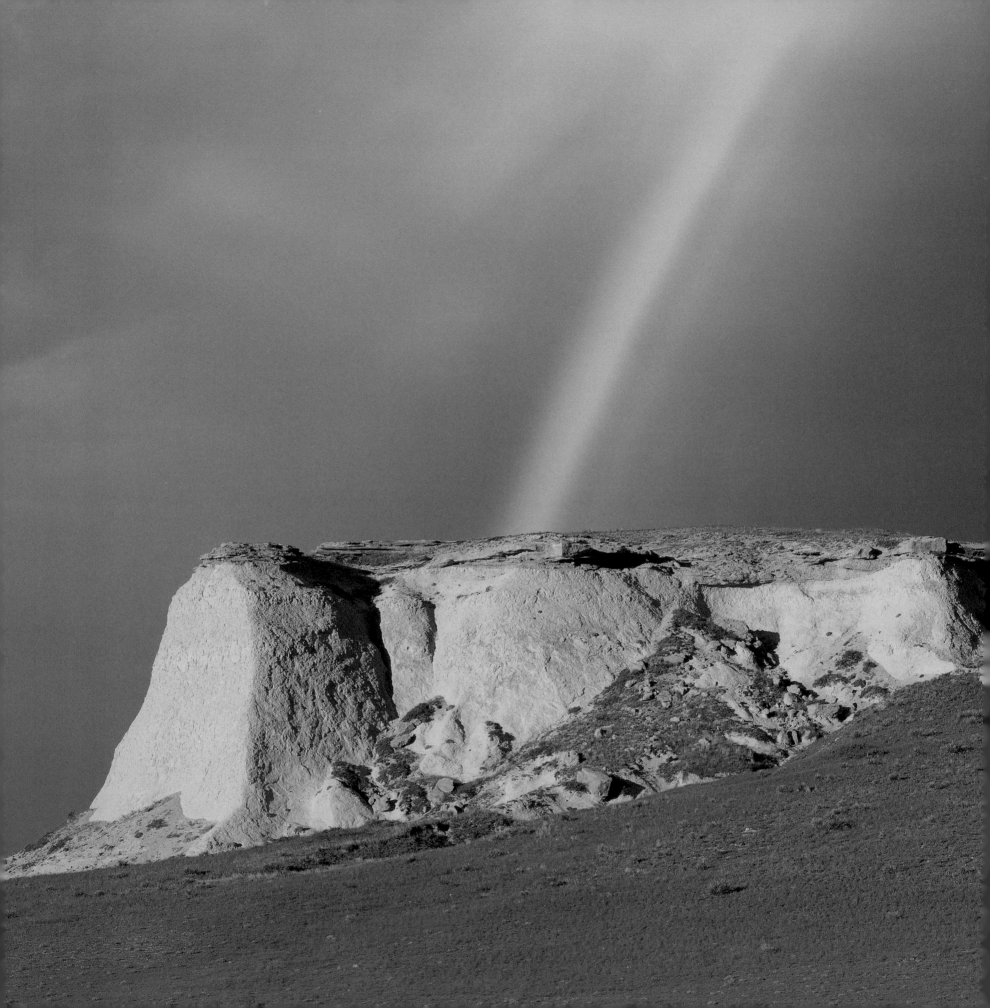

RAINBOW

Most rainbows occur at the tail end of afternoon thunderstorms. However, occasionally storms brew just as the day begins, especially during tornado season on the Great Plains in May and June. In this case, I had retired under the stars without a cloud in sight, and I awoke to wind and raindrops pelting my sleeping bag. The western sky was black and ominous, but clear skies to the east allowed the sun to rise over the horizon. Warm, direct light illuminated a nearby bluff against a background of dark gray clouds. The ambient moisture was enough to manufacture a rainbow, which appeared more brilliant than most against the stormy sky.

BROCKEN SPECTER

My injured sherpa had packed out the day before, leaving just me and my two llamas — Tommie and Pogo — to witness the specter. Thunderstorms had attacked us at 13,000 feet the night before on a ridge high above Lake City, Colorado. The vestiges of clouds and moisture floated all about as I left the tent at 6:00 in the morning. Ten minutes later the sun was peeking over the horizon, trying to find its way through the clouds. Just to the west of me was a swirling mass of clouds originating from the valley floor 3,000 feet below. A circular rainbow had formed on the clouds and inside it was my own shadow. My initial panic to put all of this on film was unnecessary; unbelievably, this phenomenon lasted for more than two hours.

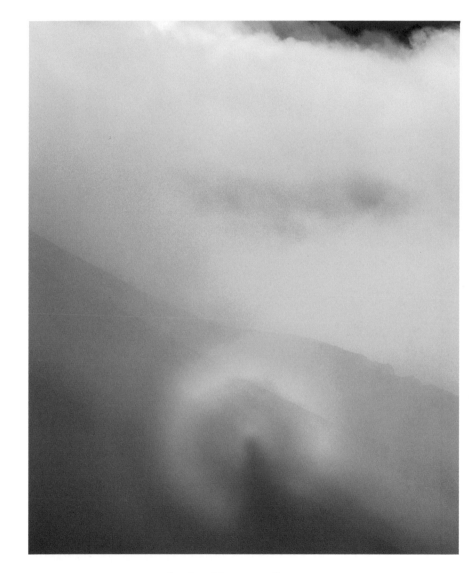

San Juan Mountains, Colorado

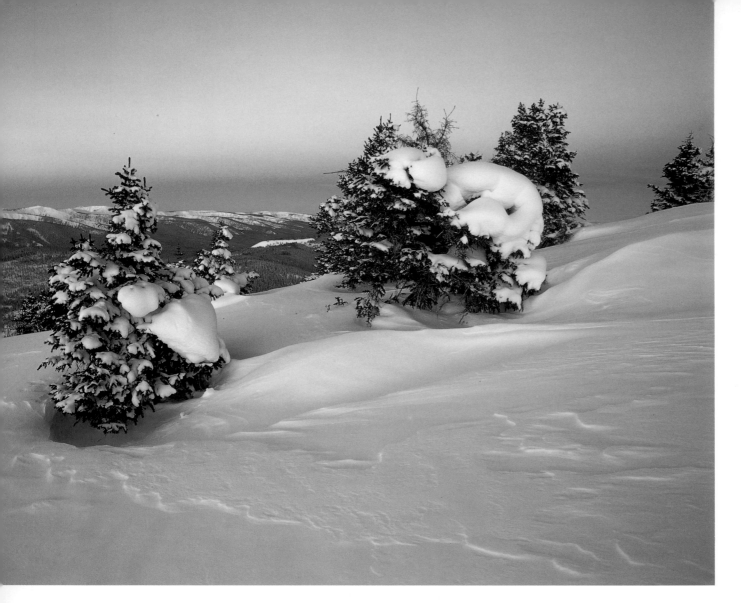

SAWATCH RANGE, COLORADO

THE EARTH'S SHADOW

Colorado possesses the most extensive system of backcountry ski huts in the nation. As of the writing of this book, 56 cabins are available to rent on a nightly basis. You can ski to just one, or you can link several together on a multi-day excursion. Nature is more peaceful in winter than any other season, and huts allow the wilderness traveler to enjoy this tranquility without living in a snow cave. Simple snow skills and a little backcountry ski experience allow comfort during what is assumed to be an inhospitable time of year.

Even in winter, the productive nature photographer rises well before sunrise to photograph twilight. With our head lamps strapped on, my companion, Brian Litz, and I left the Peter Estin Hut in the dark so we could ski to the top of Charles Ridge by daybreak. One hour later, with magnificent views of the Rocky Mountains in all directions, we set up cameras on tripods in the snow. Using lightweight gloves and lots of hot breath so our fingers could manipulate controls on the camera, we were able to work in sub-zero temperatures. Still, neither of us looked forward to the agony of fingers and toes thawing later in the hut. Note the saturated color of the earth's shadow on the horizon, despite the wealth of detail in the snow. This proves you need not underexpose a scene in order to maintain color saturation in the sky.

SUNSTARS

There is no better tree to photograph than the aspen. Its leaves are especially translucent, producing brilliant and sundry colors from one season to the next. With trunks straight and parallel, the aspen's shape and the patterns it creates in a dense stand allow the photographer a myriad of compositions. Combining the elements of color and form with the rising sun makes for very special photographs.

What is not captured in the photograph is the smell of decaying leaves in the grove and the touch of Rocky Mountain chill on the cheeks.

In autumn, I have time to enjoy nature's sensual side. Ironically, the nature photographer is often too busy composing and exposing to enjoy the moment. In the fall, however, the sun seems to set more slowly than in summer, and I can be more relaxed with my schedule. Indian summer weather means I don't need to react so quickly to changing moods; instead, I only need to respond to the predictability of the rising sun.

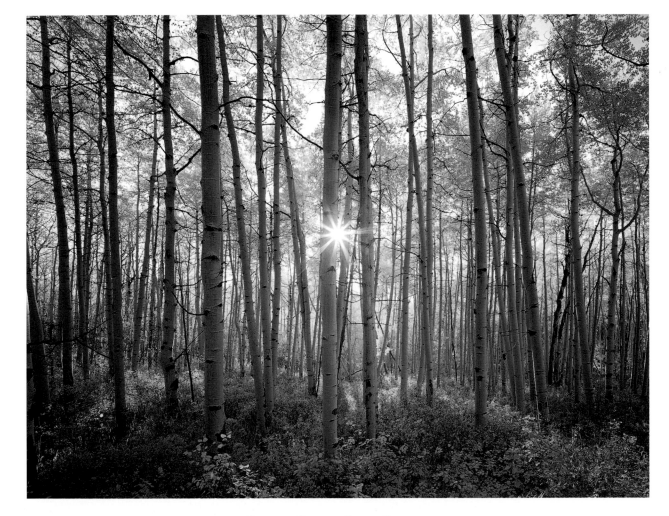

GUNNISON NATIONAL FOREST, COLORADO

PERSPECTIVE

The fourth "topping" on our pizza is perspective. A photograph need not contain perspective, though most do. Perspective is simply the relationship of size between objects within a scene or view. Stated another way, objects in the foreground will always appear larger than they really are in relation to objects in the background. There are two elementary ways in which perspective reveals itself: 1) objects appear to shrink in size as distance increases, and 2) parallel lines seem to converge toward a point in the distance. These are the clues upon which the brain relies in order to gauge distance and depth.

Depth perception (what you see with two eyes) is an entirely different way to judge distance. Having two eyes heightens our perception of depth and distance, an advantage over the one-eyed camera. Therefore, a person with only one eye can still gauge depth, but only by observing perspective. In photography, as well as painting, perspective control is the technique of representing three-dimensional objects and depth relationships on a two-dimensional surface. By manipulating perspective, the photographer can create the illusion of depth.

A photographer can use the two major depth clues to affect the perception of depth in a photograph. Converging lines within a given scene will generate the feeling of depth. And the larger a foreground object appears in relation to the actual size of background objects, the greater the illusion of depth. To increase perceived depth, all you have to do is move closer to objects in the foreground of a composition. To decrease depth, move away.

Moving closer to foreground objects presents a problem to both eye and camera. There is a limit to the amount of a scene both the eye or lens can see in focus. As you get closer, it becomes more difficult to keep both foreground and background objects in focus at the same time. Here's proof: Close one eye and focus on an object 25 feet away. Hold your index finger one inch from your open eye. Slowly move your finger away from your eye while still focusing on the object. Notice that your finger goes in and out of focus as it moves away. However, the camera can often solve this problem.

Depth of focus — the actual distance in a scene that is in focus from foreground to background — can be increased and decreased without you or the camera moving forward or backward. This is done by making the aperture of the camera — the opening through which light passes when you press the shutter — smaller or larger. The smaller the aperture, the greater the distance in focus in your scene from foreground to background. I talk extensively about how this occurs in Chapter Two. For now let's talk about perspective in relation to being creative with the camera.

Perspective in Nature Photography

When we think of nature, among other things we think of grandiose, open spaces. To our eye, nature seems wide open because we have depth perception. Most of us wonder why our photographs from the rim of the Grand Canyon don't have the majesty and power that we saw. The answer is depth perception. What a shame it would be if we let the handicap of the one-eyed camera affect the grandeur of our photographs. My personal goal is to "recruit" people to nature so that the world has more advocates for protecting it. I cannot accomplish that goal if I don't render nature accurately, and revealing depth is an important part of that integrity.

The spatial relationships between objects in a scene are a big reason why landscapes attract the human eye. Perspective conveys a sense of space. In my discussion of composition later in this chapter, I address this issue more thoroughly.

In the same way that perspective reveals spatial relationships, it can also show scale in the absence of depth. The diminutive figure of an elk standing below a large mountain, where depth is not necessarily a factor, creates a sense of scale. The great difference in the size of the two objects is already known to our brains, and composing one next to the other intensifies the effect.

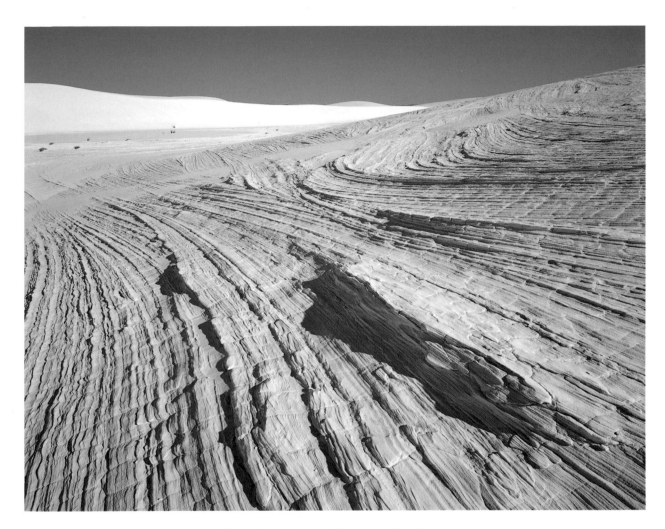

WHITE SANDS NATIONAL MONUMENT, NEW MEXICO

THE ELEMENT OF PERSPECTIVE

While exploring White Sands, I happened across this bedrock of sand — wind-blown and rain-hardened into linear patterns I could not believe were real. It is likely that dunes once covered this foundation of sand before moving on at the behest of westerly winds. With the wide-angle lens, I exaggerated the parallax distortion, which leads the viewer's eye through three-quarters of the scene. The low-lying morning sun created shadows, which dramatically increased the visibility of the outgoing lines. Notice how the convergence of parallel lines implies depth and creates perspective.

EXTREME DEPTH OF FOCUS

Making objects in the foreground appear larger than they are in relation to features in the background implies depth and creates perspective. The columbine wildflowers in the bottom left corner are as large as the mountains behind. To accomplish this, I placed my camera within inches of the flowers. If the camera had been held at eye level, the flowers would have been less than one-tenth the size they appear here. I talk in detail about depth of focus in Chapter Two.

I often see anomalies of color and form far in the distance while hiking the backcountry. Sometimes what I thought was a patch of wildflowers turns out to be uninteresting rocks. In all cases I make an effort to investigate because you never really know what treasure you might find. This time it paid off. Columbines, Indian paintbrush, orange sneezeweed, and larkspur wildflowers intersected here to create an alpine garden like few I've seen — and I've seen a few. Note the quality of the cloudy light. The clouds are not so dark that colors in the landscape are dulled, nor so dispersed that direct sunlight creates excessive contrast and washes out colors.

ALONG THE COLORADO TRAIL, SAN JUAN MOUNTAINS, COLORADO

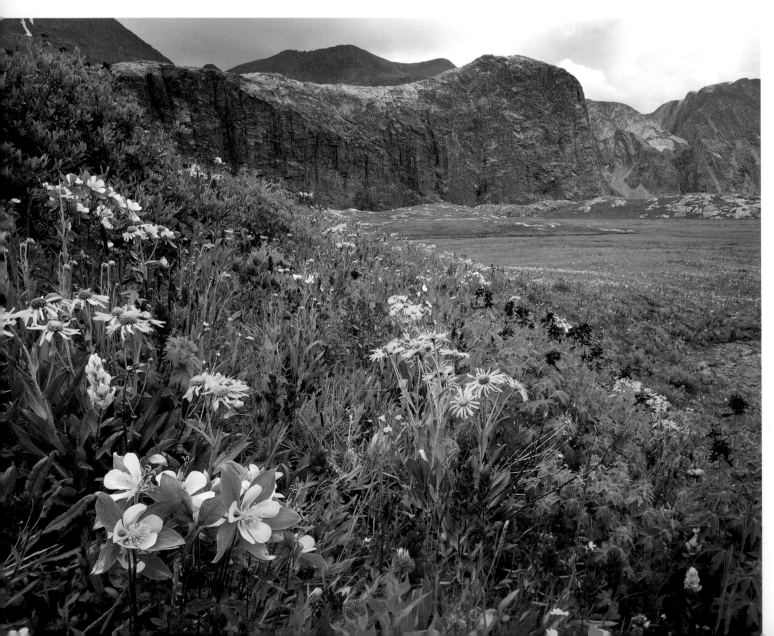

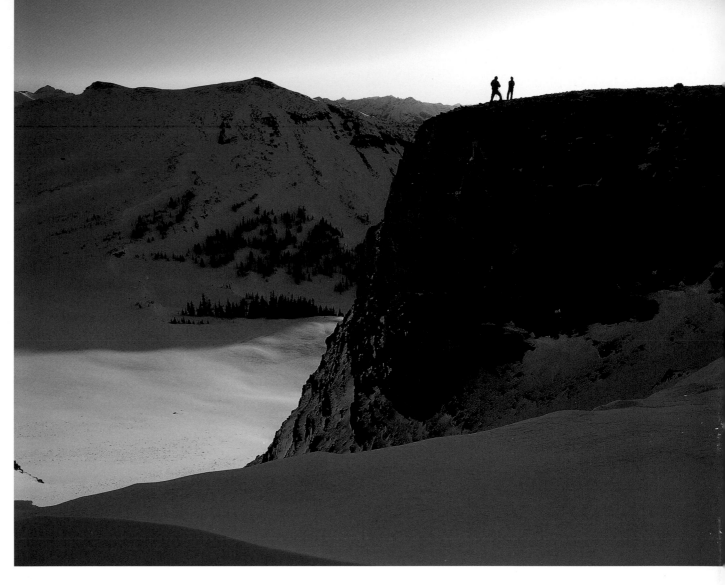

SCALE

I once skied 80 miles on a high traverse through the backcountry in the Ruby and Elk mountains of central Colorado. For eight days we averaged 7,000 feet of ascent and descent — in part, to get from one place to another for the night, but also to ski untracked powder on the 45-degree faces of tall mountains. Of course, I was there to take pictures, too, and I did all this with a 50-pound backpack. Our route through the Raggeds and Maroon Bells-Snowmass wilderness areas provided us amazing views of the winter environment.

The morning of our departure, I made this image of two of our party members standing on a nearby ridge. The sense of scale is remarkable. Overwhelmed by the grandness of the scene, your eye has a difficult time comprehending the insignificance of the two figures. This photograph was made with a medium-format camera just as the sun was about to appear over the ridge. Note the warm color of the snow in the valley below, as well as the remarkable overall contrast that best defines the success of this image.

The fifth topping — the cheese on our pizza — is view. Every photograph must have a particular view; therefore, our pizza always contains this ingredient (but in varying degrees.) View is the angle of sight of the eye, or any particular focal length of the lens. While the field of view of our eyes is always approximately 180 degrees, lenses run the range from 180 all the way down to a few degrees.

The angle of view of a lens determines how much of the total scene we see. But a lens not only narrows view, it magnifies it, too. Wide-angle lenses make objects in a scene look farther away than they really are. Standard lenses allow us to see spatially much like our own eyes. Telephoto lenses make objects look closer to the viewer than they really are because they magnify and compress distance. Expressed another way, wide-angle lenses add space between objects in a scene; telephoto lenses subtract space.

By nature, different focal lengths do not change perspective. The portion of a given vista (and the perceived size of objects in it) changes as focal length changes, but the size of objects in relation to one another does not. Therefore, standing in one place making photographs of the same scene with different lenses changes the view, but not perspective. As I said before, moving closer to or farther from a group of objects does change perspective.

Depth of focus changes with focal length. As focal length shortens, depth of focus increases, and vice versa. This is why photographs that make objects in the foreground appear significantly bigger than they really are in relation to objects in the background are usually made with wide-angle lenses. As we learned earlier, depth of focus also changes as we move closer to or farther away from an object. I discuss this more thoroughly in Chapter Two.

I also like to define view by borrowing from theories of composition. I define all landscape designs as one of three general viewtypes: *grand scenic, microcosm,* or *intimate landscape.* This simple categorization helps me to be more versatile in the field. When one type is not available to photograph — perhaps because the lay of the land is not conducive or because of light — I begin looking for another. Let's talk about each.

LENS ANGLES OF VIEW FOR DIFFERENT FILM FORMATS

This chart shows the angle of view for standard 35mm lens focal lengths, as well as focal lengths for other film formats. Non-35mm focal lengths match the specific angles of view, and they do not necessarily represent a focal length that is commercially available. Angles of view are defined by the horizontal dimension of each film format.

Horizontal angle of view	35mm	6x4.5 6x6	6x7	4x5	8x10
84°	20mm	30mm	38mm	67mm	134mm
73°	24mm	36mm	46mm	80mm	160mm
65°	28mm	43mm	54mm	93mm	186mm
54°	35mm	54mm	68mm	117mm	234mm
40°	50mm	76mm	96mm	167mm	334mm
30°	70mm	105mm	131mm	229mm	458mm
26°	80mm	122mm	150mm	261mm	522mm
21°	100mm	150mm	190mm	330mm	660mm
15°	135mm	206mm	259mm	450mm	900mm
10°	200mm	306mm	383mm	667mm	—
7°	300mm	458mm	575mm	1000mm	—

Grand Scenic

This is the classic landscape photograph — blue sky, clouds, and mountains reflecting in a lake, wildflowers in the foreground, all of this framed by stately trees. Whether you consider it classic or cliché, everyone loves a grand scenic of nature. Warm, direct light and broad shadows at the ends of the day complement the grand scenic. Characteristic to this composition are many objects and lines, colors galore, and enough ingredients to challenge the finest of designers.

It may surprise you to know that of the three types, I consider an excellent grand scenic the most difficult to make — but not for lack of ingredients. Most photographers get off to a bad start by picking a scene with too many features to compose. It is completely normal to want to include each and every beautiful thing we see. Nevertheless, resist the temptation to show all of nature's glory in just one image. Don't be afraid to isolate only certain features in a scene in a single photograph.

A SCENE PHOTOGRAPHED WITH A 35MM

CAMERA FROM THE SAME LOCATION WITH

FIVE DIFFERENT LENS FOCAL LENGTHS

80MM

20MM

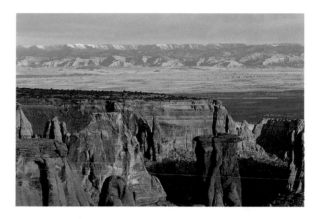

135MM

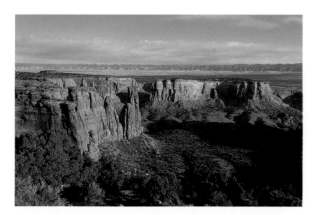

35MM

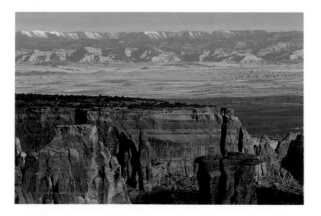

200MM

Make photographs that boast the integrity of just the trees, just the flowers and the lake, or just the mountains and the clouds.

This does not mean it's impossible make excellent grand scenics; good ones are simply few and far between. Successful grand scenics are usually a product of a great moment, often made in a pre-scouted location but always with the compositional skills of an experienced, well-trained photographer who was lucky enough to be in the right place at the right time.

Grand scenics often contain each of the five photographic toppings, and they employ their use in ways that heighten their impact. Colors are usually complementary, forms are unique and pleasing, the moment clearly transitory, the perspective implies great depth, and the view takes in only what is necessary to make an orderly composition. Most are made with medium- to wide-angle lenses, though angle of view is always a function of viewpoint (the place from which an image is made). A telephoto lens could very well take in the same amount of information from one location as might a wide-angle lens from another.

Microcosm

I used to be like most people — I would walk right over the top of a dozen good photographs each day without taking a picture. On the other end of the compositional spectrum from the grand scenic is nature's microcosm. The most commonly photographed microcosms are closeups of wildflowers. Though wildflowers make wonderful subjects, you can discover so much more right at your feet.

My favorite microcosms of nature tend to be two-dimensional patterns. Pine needles on the forest floor, pebbles along the beach, and the bark of a sycamore tree create wonderfully repetitious shapes and colors. In this world of foot-square areas, moment tends to be defined more by the biological processes of nature herself than by weather and light. Things like the growth of multiple lichen species on one rock and the collection of driftwood in a river eddy bring visual order to this smaller world.

When the light is not dramatic enough to make a good scenic, or when the contrast is too great, I find myself looking for microcosms. Typically I photograph them in evenly lighted situations where no one part of the scene is affected by light any differently than any other.

The Intimate Landscape

Intimate landscape is the descriptive phrase coined by Eliot Porter for scenes that lie between the compositional world of the grand scenic and the microcosm. It contains elements of each, but it is *a scenic with no natural horizon,* no break made by sky and land. Though the intimate landscape does not contain a horizon, it can still have a horizontal break point that, for example, might separate the ground from a rock wall. It is the part of the landscape starting 10 feet in front of you and ending 100 feet out and up.

Intimate landscapes are portraits of the planet — its geology and life forms — without the distraction of what is happening above. For many nature lovers and nature photographers, this is the part of the visual world that is most satisfying to discover. It is intimate — a place where you may be the only visitor to see this subtle mixture of natural elements.

Moments such as those experienced when morning fog recedes from a pond or when rays of sunlight penetrate the forest after a rain can play a part in the intimate landscape. This world is large enough to capture weather, but it's small enough to include the patterns of the microcosmic world, too. An intimate landscape needs perspective, for the illusion of depth distinguishes it from the microcosm. Of the three types of view, I see intimate landscape opportunities the most on any given day. Of the three, I enjoy finding and composing this view the most.

How you combine the five "toppings" is the basis of a photograph. The degree to which you mix and match the toppings is the creative latitude inherent in color photography.

By and large, a photograph becomes more dramatic as the number of elements employed increases. However, understanding these elements and their application is only half of the process of learning to see. The other half includes understanding composition (also called design) and recognizing the different kinds of natural light and how they affect the landscape. Next we'll open the oven and cook the pizza to bring out the very best of its flavors when we discuss composition.

GRAND SCENIC

It is possible to hike all the way around Mount Rainier. One of the most visually dominant mountains anywhere, Rainier is difficult to lose sight of no matter where you are on the trail. Perennial glaciers insure water is always flowing down through meadows and into lakes. Forests and flowers abound wherever you go. We awoke this morning to clouds remaining from an overnight storm. From one moment to the next, Rainier disappeared then reappeared. I must have made a dozen images of these fleeting moments, of which this was the best.

The elements of color, form, and moment make this a wonderful grand scenic photograph that, I hope, makes the viewer feel as if he or she is experiencing it firsthand. Though scenics are easy to make, great ones that exude a sense of place and moment are rare indeed. If I can make a handful of images of this quality each year, I am happy.

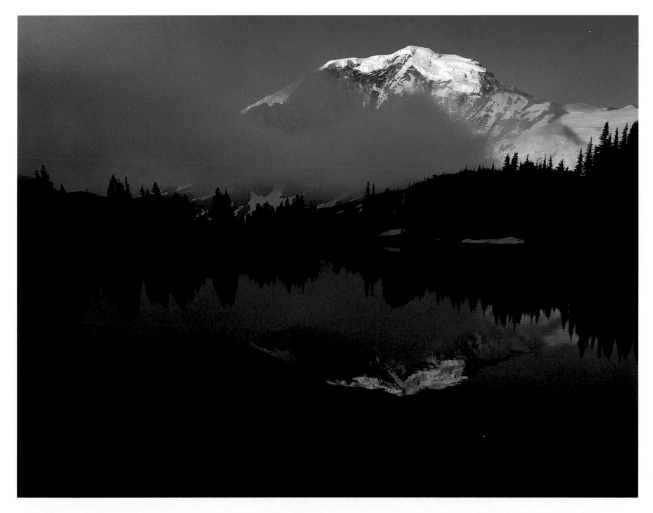

MOUNT RAINIER, WASHINGTON

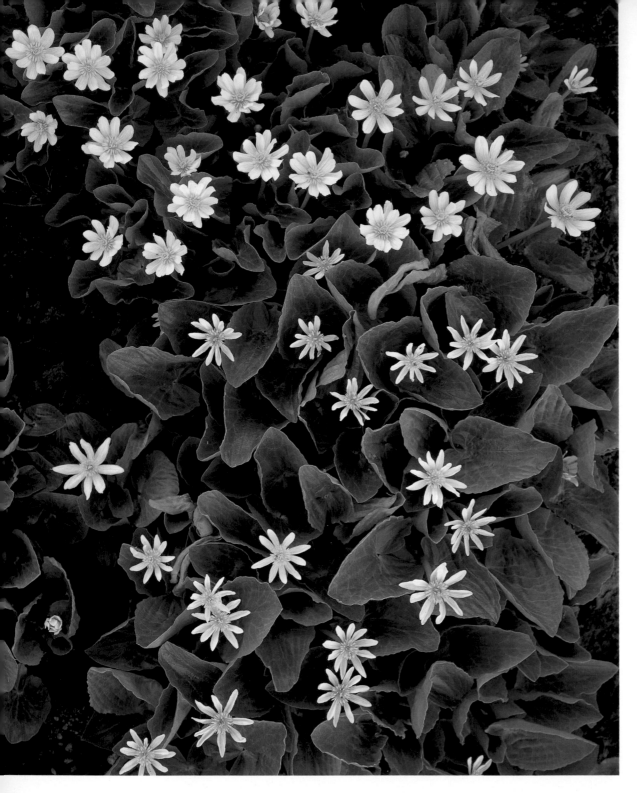

MARSH MARIGOLD, HOLY CROSS WILDERNESS, COLORADO

MICROCOSM

The world beneath our feet is a special one. It's a landscape that can manifest as much glory as larger scenes. With each step I take, I scan below for patterns and colors that radiate a sense of order. It is one thing to photograph a flower close-up, and it's entirely another to perceive the rhythm of this diminutive world. As with grand scenics, the great ones are scarce, and discovery of hidden gems is incentive enough to seek them.

Textures and colors are most alluring in cloudy light. Direct light makes distracting shadows and unnecessary highlights, and it destroys all detail in delicate whites. I can only make images like this when clouds cover the sky. Even a half-blue sky would have turned white petals blue and made greens less vibrant. Note the highlighted edges of the leaves and the resulting sense of depth.

INTIMATE LANDSCAPE

Between the angles of view defined by the grand scenic and the microcosm lies the intimate landscape. Eliot Porter's greatest contribution to the medium of nature photography was the revelation of the landscape without horizon (for example, the world within the forest or, in this case, within the canyon). His vision opened doors for many photographers, especially those who sometimes tire of traditional landscape photography.

The intimate landscape may be the easiest to find and the easiest to capture well on film. While rafting the Colorado River through Westwater Canyon, I hiked up the Little Dolores River side canyon. The day was dreary, and heavy showers has flash-flooded the gorge where ancient Precambrian schist lies under more typical sandstone. This black rock created quite a contrast with muddy waters. A polarizing filter reduced the glare off both rocks and water, improving the unique marriage of the blacks and browns.

THE LITTLE DOLORES RIVER, UTAH

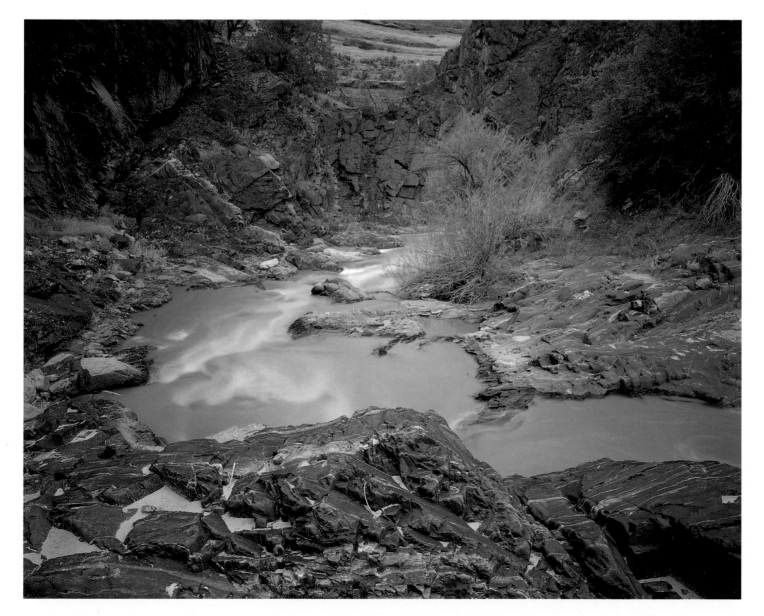

As the number of elements you employ increases, the magnificence and complexity of the image increases as well. The book of California landscapes I published in 1985 required two years of photography, and even then it was woefully incomplete. California is a large and diverse place. Nevertheless, this dramatic photograph was the very last one of several thousand made. I was on my way home to Colorado and decided to spend my final California night at Mono Lake. Awakening in the back of my Suburban that November morning, I could tell that a weather front had moved into the area overnight. There were clouds as far as the eye could see, and things looked hopeless. Never one to doubt nature's caprice, I got ready to photograph the dawn despite the weather.

Through the years, I have seen those hopeless moments turn quickly into glorious ones. Still, this one seemed more futile than most.

After slogging with the camera through cold, briny mud at the edge of the lake, I managed to reach tufa rocks that allowed me to skip from one to another and move from the shore into the lake. When I found a good spot I set up my camera and composed a scene not much different from this one. The light was as gray and ugly as I'd ever seen. But on my last day of two years of hard work I was not about to give up. I stood on a rock for 30 minutes, hoping the rising sun — which was invisible behind clouds — would somehow find its way through. I finally gave up and put the lens away, the pack on my back, and the camera

over my shoulder. Thoroughly dejected with this failure on my last day in California, I rationalized that I deserved a bonus for two years of travail and began to hop to shore from rock to rock.

Looking down to watch my footing, I had an adrenaline rush in mid-air. The water beneath me had turned blood-red. After landing on the next rock, I looked up and realized the sun was not as high in the sky as I had assumed, but it had only just now reached the horizon and found a way through the clouds. The underside of the clouds as far I could see were pink and red, and all of this color was reflecting on the still waters of Mono Lake.

I turned around and made a series of Olympic-sized triple jumps back to my rock. In one of the great panics of my life, I set up the tripod and camera and proceeded to drop the only lens useful for this composition — my 75mm (view camera). Only the adrenaline in my body allowed me to make a successful stab at it before it had a chance to become completely soaked. I dried it with my cotton dark cloth, slapped it on the camera, and began to make the first of four exposures before the sun disappeared behind the clouds for the rest of the sunrise. What a finale to my California tenure. This image contains color (red), form (rock silhouettes), moment (the superb sunrise), perspective (depth created by the rocks), and the angle of view of a grand scenic. It's a testament to the power of the basic elements of landscape photography.

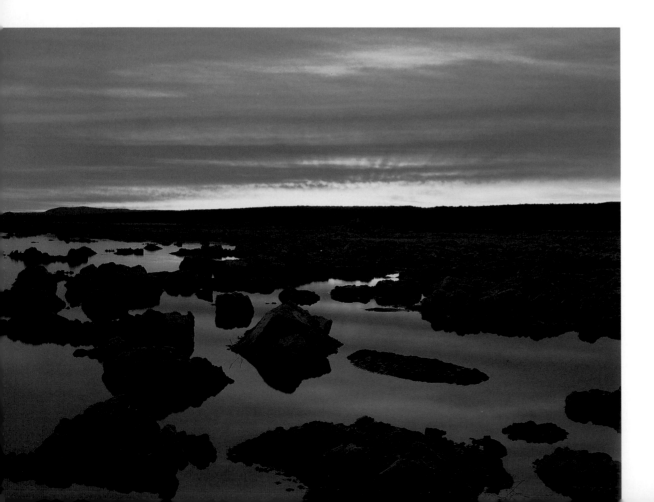

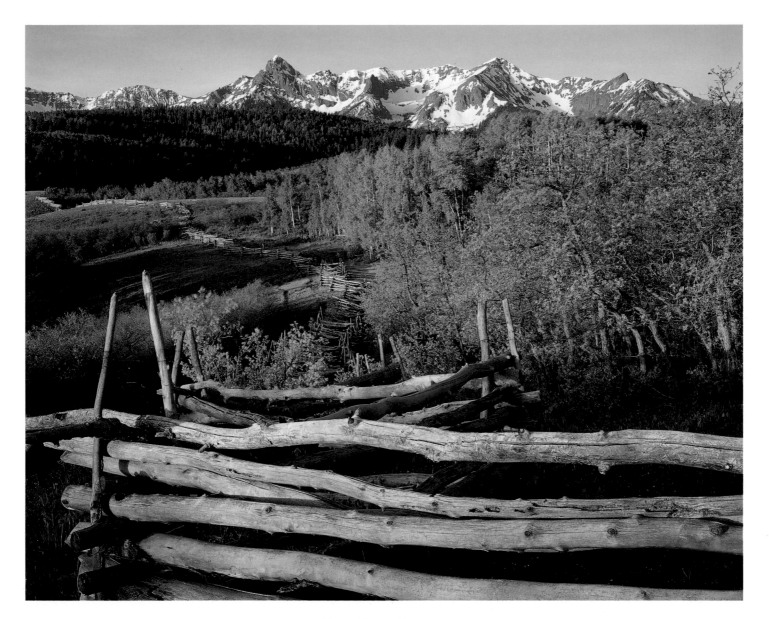

DALLAS DIVIDE, COLORADO

This moment was much more predictable, but no less visually delightful. Clear skies insured that warm, direct side lighting would allow this scene to appear just the way I had predicted. I had photographed this scene during other seasons, and I already knew the perfect composition.

This grand scenic contains color (earthy reds and complementary greens), form (that amazing aspen bole fence), moment (the warm sunrise light), and perspective (created by the shrinking fence).

COMPOSITION

Everything we've discussed to this point might be wasted if you do not arrange subject matter in a way that is pleasing to the eye. Just as it would be easy to burn the pizza in the oven, it would also be easy to ruin a scene that contains many beautiful features. By word and photographic example, what follows should make you comfortable composing a photograph. Though I attempt to be as complete as possible, remember that the ways to compose are infinite, and that one person's order may be another's chaos.

I, by nature, demand order in my life, probably a lot more than most people. I am a pain to have around the house. A pile of stuff laying in any one place for more than a day gets on my nerves. Psychologists offer theories (which I do not wish to discuss here!) about people like me who feel the way we do. I need to feel secure that there is structure and organization in my life.

The best thing about my urge for order is the fastidiousness with which I have always composed photographs. By some undefinable mental process, I have never allowed objects to be out of place, even unbalanced, in an image. Only when I began to study design theory did it become clear to me how I do what I do. Along the way, however, I realized that too much structure can also be a handicap. How ironic. At times my images were almost too perfect, too symmetrical. In addition, I had become comfortable with the ways in which I saw nature, failing to challenge myself to see her differently by composing differently. I was not making enough mistakes — yes, mistakes — in my photographs. If you do not fall down every once in a while skiing, you probably are not going fast enough; if you don't have to throw away a few images every once in a while, you probably aren't experimenting with composition and light frequently enough.

I've already mentioned how photographers can "paint" with their cameras. You can collect the objects in your view and arrange them into a photograph, just like the painter. Your ability to move around within the scene with the camera, seeing the composition of elements in the viewfinder change as you go, gives you nearly as much latitude as the painter. The photographer can choose from a variety of tools: camera types and formats, varying focal lengths, the ability to affect depth of focus and perspective, the ability to freeze motion or blur it, and the choice of many films.

Before we discuss specific kinds of composition, let's talk about four basic design elements: *dominant feature, balance, proportion,* and *rhythm.*

DESIGN ELEMENTS

Dominant Feature

I've said before that my ultimate goal in photography is to manifest the integrity of nature. This book is about that goal, and good composition allows me to achieve it. I've implied that I enjoy isolating nature's intimate parts in a photograph as much as I do portraying her grandness and majesty. Hiking and driving as much as I do, I am always finding that special rock or tree, cascade or flower. Perhaps it is the unique color in the flower or the patterns of water falling within the cascade that catch my attention. Whatever it might be, something strikes me as significant, and I don't automatically feel a need to show the complete environment in which it lays. Instead, I want the viewer to see this thing and only it, without other visual distractions. Usually I use a microcosm view.

Sometimes I want to include part of the place in which the object lies to help create perspective, or perhaps just to offer its mood. In this case I compose an intimate landscape. Or I may want to put the dominant object on display within its entire surroundings, sky included, suggesting a grand scenic. No matter which one of the the three viewtypes I choose, I compose the scene in a way that the viewer's eye goes first to the object, and then — and only then — elsewhere within the photograph. This defines the object as the dominant feature.

There are many ways to emphasize dominant features. Placing them in the bottom of the image and using perspective and extreme depth of focus to make them large is one. Using converging lines to direct the eye to an object is another. The use of extreme contrast to create black areas that attract the eye works, too. Except for microcosms that exhibit only pattern, most of my photographs have a feature to which the eye goes immediately. In my discussion of rhythm, I describe ways in which objects of secondary and tertiary importance can direct the viewer's eye to other places after the dominant feature.

Balance

Balance is not dependent upon *symmetrical* halves, or matching sizes or shapes. The relative "weight" of portions of a composition determines balance. The degree to which a viewer's attention is attracted by part of a photograph determines weighting. One-tenth of the square area of a photograph may be so conspicuous (perhaps it includes a single dark object with an interesting shape) that it balances with the other nine-tenths, which may be less intriguing and lighter in tone. Such scenes are *asymmetrically* composed. Whether symmetrical or asymmetrical, photographs with balance are pleasing to the eye because they promote a sense of stability.

Proportion

Proportion is defined as *a part considered in relation to the whole.* Before you position the horizon in landscape photography, consider proportion. In this case, the parts are always the land and the sky separated by the horizon. The relative weight of the two parts determines the best place to put the horizon.

In terms of ratio, I tend to work in thirds and sixths; for example, two-thirds sky and one-third land. I feel these proportions create good balance between different parts of a scene that may have similar values. Often the sky may be so dramatic, such as a blood red sunset, that it is clearly the dominant subject in your view. However, the sky by itself may not create a sense of place, for it could be anywhere above you and of unknown proportions. By merely placing a sliver of land beneath the sky, you can define its scope and relationship with the earth. Similarly, some land-intensive compositions might be better designed by including only a small amount of sky.

I increase the amount of sky in my compositions in proportion to its degree of interest. Interesting skies either have well-defined clouds or dramatic color with or without clouds. Such color may be deep blue after sunrise or consist of warm-colored banding after sunset. I only include hazy skies in photographs when I feel the need to define the horizon, and then only with a sliver's worth. Unless a sky is interesting, I tend to compose features in the landscape very close to the top of the image.

Rhythm

Rhythm implies time in musical composition. Rhythm also suggests time in the visual arts. When composition is carefully planned, the photographer can emphasize secondary and tertiary features along with the dominant feature. Actually, a good photographer can add as many other "stepping stones" in the scene as he or she can find. Effectively, the photographer takes the viewer on a journey, a visual hike, from one place to the next. This adds the dimension of *time* and helps viewers become involved in the place. As a photographer, you want to try to make viewers feel as if they had really been there to experience the moment.

DOMINANT FEATURE

This particular wilderness is unique from the others I know because of the red — or maroon — rock that dominates the landscape. Since the color red complements the vibrant greens of alpine flora, the visual nature of this place is more dramatic than most. I came across large rock after large rock during my hike with the llamas through Willow Basin. At one trailside point, I found this massive outcrop replete with multi-colored lichens. The light was overcast, and I was able to make an image of all this color without the handicap of deep shadows and bright sun.

I knew right away that I wanted the rock and its lichens to be the dominant feature in the composition. With a wide-angle lens, I was able to keep the rock in focus simultaneously with the mountains behind. The viewer's eye has no choice but to consider the rock immediately, before moving on to the other parts of the scene. Note that the mountains in shade create contrast with the lighted rocks, allowing a greater sense of depth in the photograph.

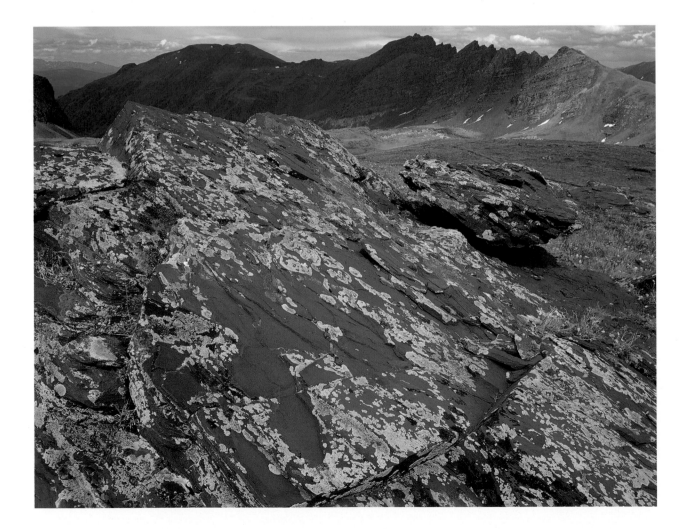

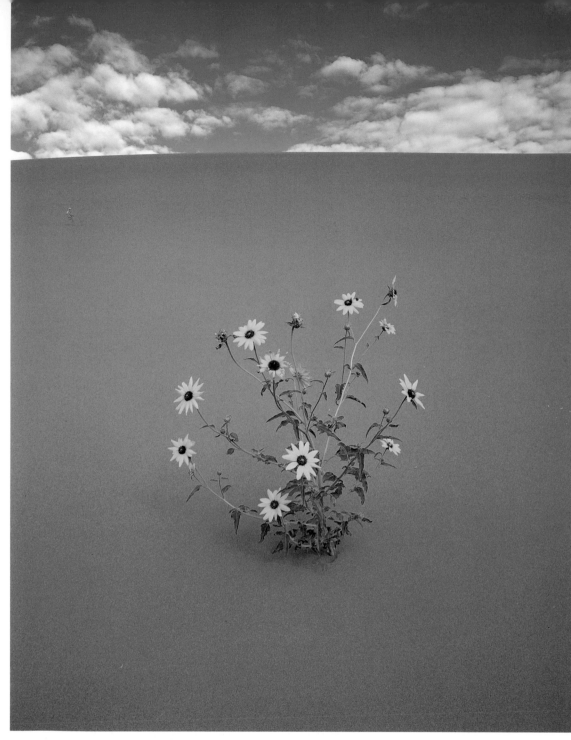

In the photograph at left, the sheer size and position of the red rock makes it dominant, while here the color and shape of the sunflowers create interest. The contrast of color and shape against such a neutral background instantly captures the eye, which tends to avoid untextured expanses of color.

Scattered high clouds in this scene blocked the sun, which reduced contrast in the highly reflective colors of the sand and flowers. Unfortunately, blue sky created a greenish cast on the sand that would not have occurred if cloud cover had been complete.

Great Sand Dunes National Monument, Colorado

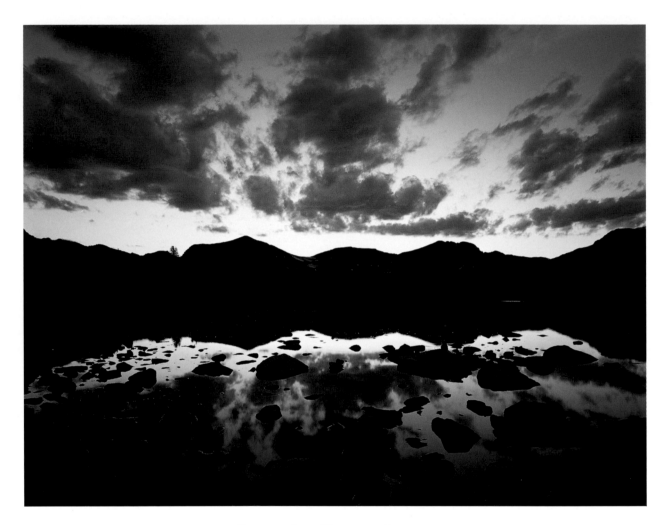

COLLEGIATE PEAKS WILDERNESS, COLORADO

SYMMETRICAL BALANCE

If he had been a nature photographer, Hall of Famer Yogi Berra might have said, "A sunset isn't over until it's over." I had been making sunset images of this scene only half as glorious as this one. Just as the color disappeared, I spent my last loaded sheet of film, confident that the day had ended. As I was about to head back to camp, the pink light reappeared more brilliantly than before. Knowing this was "the shot of the week," I performed the fastest film change in history — unloading and reloading 10 sheets inside the dark bag in less than five minutes. All the while I was watching the sunset, praying it would continue. This image was made just as the color disappeared the second time. The midpoint of the scene is in the middle of the silhouetted mountains; the elements of color and form are of equal interest in both halves, resulting in a symmetrically balanced photograph.

ASYMMETRICAL BALANCE

Though Paradise is a fictitious place, this particular landscape may be the next best thing. Bruce Ward and I were hiking the Colorado Trail when we came across this fertile field. The summer had been wet, and the alpine flowers on Indian Trail Ridge were as fecund as I had ever seen them. In this photograph I wanted to portray the flowers — the most important part of the scene — below serrated peaks, and I wanted to involve the element of moment by including my companions. Though the flowers occupy most of the scene, Bruce, Tommie, Pogo, and the La Plata Mountains are more conspicuous and create an asymmetrical balance.

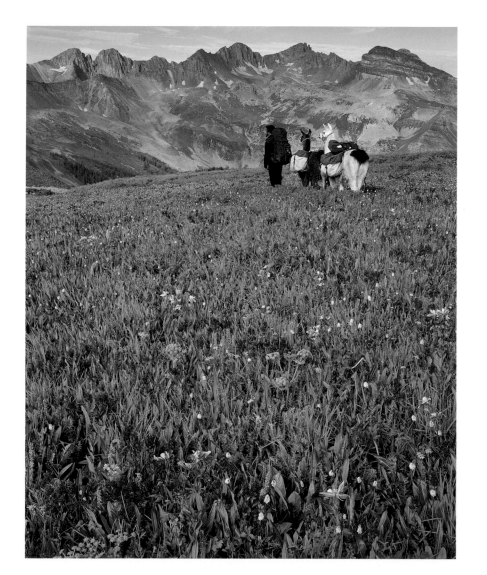

La Plata Mountains, Colorado

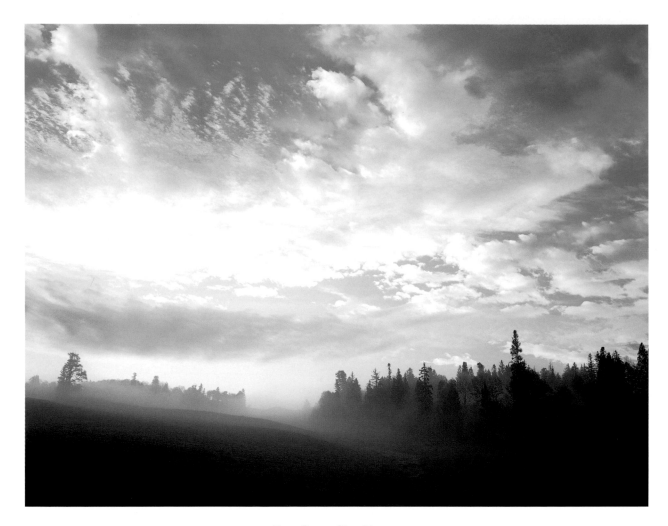

NEAR CHAMA, NEW MEXICO

PROPORTION

This image exemplifies the composition of more sky than land in a grand scenic, and it is divided in portions of thirds. Crawling out of my sleeping bag, I found myself in ugly weather. But by sunrise the clouds had broken apart and fog remained in the trees. The landscape was too dark, and too uninteresting, to feature — but thankfully the clouds were anything but dull. Nevertheless, the little bit of fog made a wonderful marriage with activities in the sky. Here the land occupies about one-third of the scene. Given the strength of the sky, I might very well have allowed the sky to occupy an even greater portion of the image. But the fog in the trees was unusual, so I decided to include most of it.

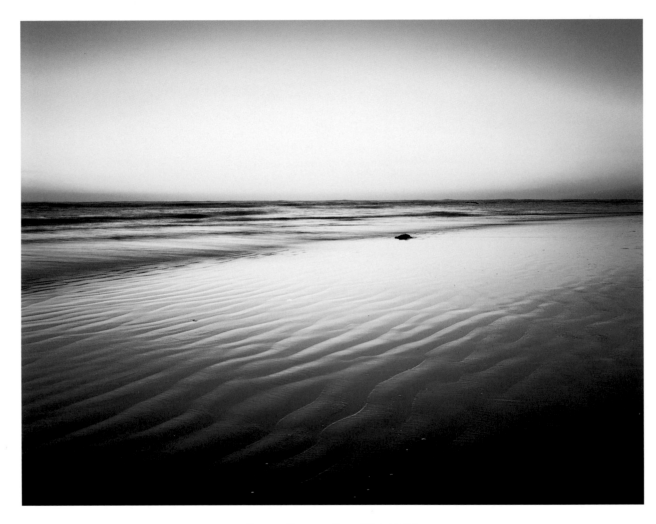

OLYMPIC NATIONAL PARK, WASHINGTON

Here I used proportion to feature the landscape, not the sky. The subtle ripples in the sand and warm light reflecting from the sky are very attractive, and I wanted the viewer's eye to begin on the beach and progress upward. I composed the sky to occupy slightly more than one-third of the image area in order to include some blue above the yellow and orange banding of dusk.

As with mountains, coastal environments have many faces. Except for torrential rain, I enjoy photographing seashores in any light — from clear sunsets such as this to the soft light found within coastal fog. Nature photography is the art form it is today, in part, because of the work done by great photographers near the oceans.

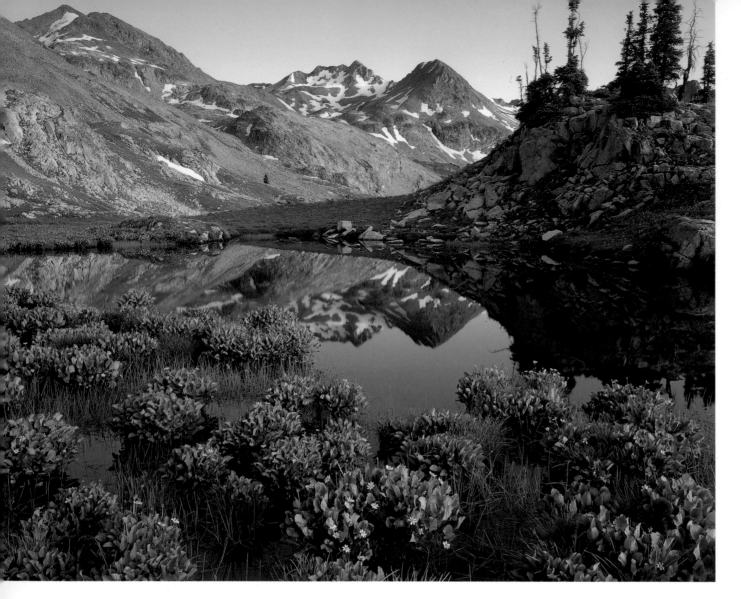

ELK MOUNTAINS, MAROON BELLS-SNOWMASS WILDERNESS, COLORADO

RHYTHM

When a photograph leads the viewer from one place to another in the scene, it provides rhythm and adds the dimension of time. It can also make the viewer feel as if he or she were present when the image was made. For photographers who care about sharing their experience with others, such imagery is the most satisfying of all.

In this photograph, the viewer's eye is first attracted to the marsh marigold plants in the pond in the foreground. The flowers are the dominant feature in the image because they appear so large in relation to the mountains and they contrast against water made blue by the sky. The eye is then led up and to the right by the very light color of the rocks and the conspicuous shape of trees silhouetted against the sky. Finally, the eye moves over to the peaks bathed in warm, end-of-day light. This is the rhythm of a well-composed photograph. Once this visual journey is complete, the viewer can seek and discover many other features offered by the scene. For example, look at the reflection of peaks in the water, and notice the patches of white snow upon them.

Though I don't often photograph them, sometimes buildings are so visually exciting I cannot resist "wasting" a few sheets of film. I am especially attracted to structures that have been attacked for many years by nature and weather — not so dilapidated that they lose their beauty but merely frayed on the surface. As with people, buildings such as these possess a character marked by the extra lines and tones that only accrue with age.

I never tire of viewing this image. The combination of many diverse shapes and angles is so pleasant, so perfect, that I feel peaceful when I look at it. Good composition employs order, precludes chaos, and manifests harmony. Such geometry can be the essence of design, and though I did not make the design, it was there for me to perceive and photograph. Add to this the dimension of time, as implied by the colors of age, and the viewer is compelled to ponder more than just visual considerations. You cannot help but wonder about the history of this place.

IN THE SALMON MOUNTAINS, CALIFORNIA

TYPES OF COMPOSITION IN

LANDSCAPE PHOTOGRAPHY

Now let's explore practical ways to put these composition fundamentals to use. I have always associated the following rudimentary types of composition with my landscape photography. This is by no means a complete list, but it's certainly a good place to start.

Two-dimensional Photographs

Two-dimensional photographs suggest length and width, but not depth. For example, microcosms that display pattern are usually two-dimensional. And intimate landscapes and grand scenics can be made "depthless" by avoiding foreground features.

Three-dimensional Photographs

In the context of two-dimensional paper, a photograph is three-dimensional when it conveys a sense of depth. I have already described this type of composition in our discussions about form, perspective, the grand scenic, and rhythm, so I won't belabor the concept.

Of course, each of our toppings can be used effectively in three-dimensional images, and perspective is requisite. All three viewtypes can be composed three-dimensionally, and all four design elements may be employed. Rhythm creates a four-dimensional photograph if you consider the time that the eye requires to visit one location after another in the image.

Subject in the Center

In addition to placing the dominant feature in the middle of a composition, I sometimes allow the dominant feature to occupy most of the entire image area. In such cases, I often place it exactly in the middle. I center the dominant feature in grand scenics, but only if it balances with the remainder of the scene.

Dominant features can be placed anywhere, so long as the placement doesn't violate the principles of balance. If you are uncomfortable with the symmetry of centering, use the one-third, two-thirds principle. Place your object one-third of the way from the left or right side of the composition. Make certain, though, that you balance the scene with something of equal weight. This does not necessarily need to be another object, but merely a background powerful enough to offset the dominant feature.

Layered Design

"Horizontal" is programmed into our brains from birth. The horizon is the original horizontal line, and all other angles are perceived in relation to it. In other words, vertical only exists because there is a horizontal. Most forms on the planet tend to suggest either a horizontal or vertical bias, including the right-angled geometry of photographs.

When we compose images of the landscape, horizontal lines are associated with things other than the horizon — mountain ranges in front of mountain ranges, cloud patterns, river and lake banks, or valley floors. Often we see scenes that contain layers of horizontal lines. These lines are approximately parallel — some perfectly straight, others curved or irregular. Parallel lines tend to be pleasing to the eye and attract our attention.

Horizontal lines can be composed into patterns in all viewtypes, with or without the actual horizon. Balance, both symmetrical and asymmetrical, and proportion should be carefully considered as you put these lines together.

Diagonal Lines

Nature has plenty of diagonal lines. Their appearance in a photograph tends to add tension, and diagonal lines can introduce asymmetry to a design. Even when diagonals occur in a scene without horizontal lines, they still play against the parallel lines forming the edges of the photograph.

Lead-in Lines

I have talked about the ways in which a three-dimensional photograph can be thrust into the fourth dimension, the dimension of time. By creating "stepping stones" that lead the eye into a scene, which implies time, a photograph is transformed from a static state to a dynamic one.

That same effect can also be created with lead-in lines. Rivers and creeks, trails, roads, even railroad tracks serve this purpose when properly employed. Placement of a creek, for example, in the bottom of the photograph is the best way to start viewers on their journey up into the scene. Parallax distortion — the convergence of parallel lines in the distance — makes the creek appear wider at your feet than at the end of the scene. The farther the creek edges go into your composition before they finally meet, the greater the distance your viewer will be led.

Leading the Viewer out of the Scene

Just as the photographer can lead a viewer into the scene, he or she can easily lead the viewer out. Dominant features may contain lines that connect with the opposite edges of the photograph. If they catch the eye early in the viewing process, they will lead the viewer out of the scene. Similarly, parallel lines that don't converge before they meet the top of the photograph will lead the viewer out at the top.

Why compose in this way? Compositions that contain lead-in lines that disappear inside the scene trap the viewer within a known space. Compositions that take the viewer outside the boundaries of the scene may leave more to the imagination about what may lie beyond.

Horizontal versus Vertical Composition

Even though not every scene composed horizontally can be composed vertically, many scenes can work both ways. Microcosm photographs of patterns usually work well composed either horizontally or vertically. Grand scenics and intimate landscapes require more careful study, but with a little shifting around, you can usually do both well. In Chapter Three, I talk more about using both compositions to be more productive with the camera.

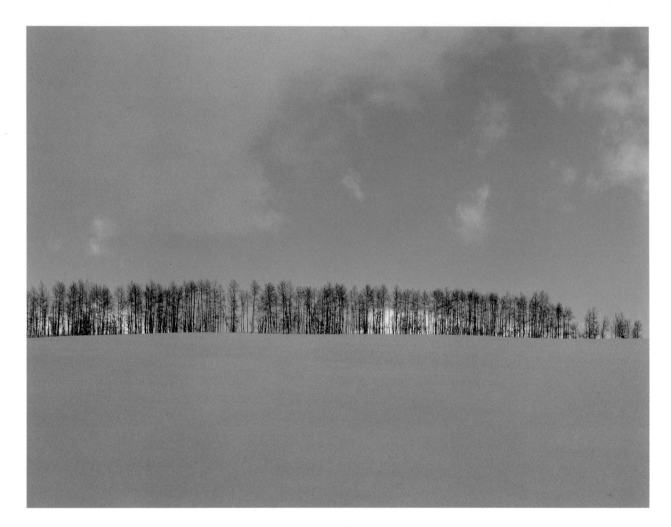

ASPEN TREES, COLORADO

TWO-DIMENSIONAL DESIGN

There is no perceived depth in this image. Though the snow in the foreground may, in fact, be far closer to the camera than the trees, it seems to be on the same plane because it has no detail. Nor do the clouds create perspective. However, if an elk had been standing in the bottom of the scene, this image would instantly become three-dimensional. Two-dimensional photographs possess length and width, but no depth. The eye is drawn to line, texture, shape, and pattern when volume does not exist. This image employs moment, too, as defined by the clouds and pale blue sky.

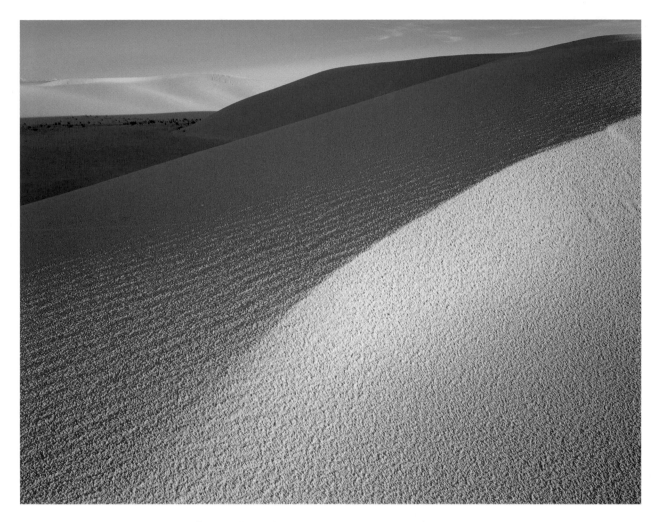

SUNRISE, WHITE SANDS NATIONAL MONUMENT, NEW MEXICO

THREE-DIMENSIONAL DESIGN

White Sands is one of the finest places on the planet to photograph because you can capture the element of form in so many ways. Also, the white landscape takes on a pastel version of whatever color happens to appear in the sky. If the sky is blue, as it is here, the sand will be light blue. If the sky is pink, the sand will be pink, too.

This image exemplifies extreme depth of focus technique. I placed the camera very close to the edge of the foreground dune, resulting in the ability the see the

grains of sand. The contrast of the sunlighted leeward side against the shaded windward side combines with the edge of the dune itself to draw the eye immediately. Then other dunes in shade and sunlight — expressed both as diagonal and horizontal lines — allow the eye to move on. This is a classic example of a photograph that creates depth with the element of perspective.

It is one of my favorite images because it employs all of the photographic elements.

DOLORES RIVER, COLORADO

This is the landscape devastated by the eruption of Mount Saint Helens in the early 1980s. Notice steam issuing from the still active crater. Also note how I have placed the mountain squarely in the middle of the photograph. Though I photographed other compositions of the volcano — some with it off to the side but balanced with other subject matter — this is the image I like best. I do not hedge on the statement being made: I think this volcano is so visually powerful that I do not want the viewer to be distracted by other features in the landscape. I want the viewer to digest the existence of this place and the raw volcanic power it represents.

LOCATION OF DOMINANT FEATURE

You can place the dominant feature anywhere within a composition so long as balance is achieved. Here I have located the ponderosa pine on the extreme left-hand side of the image. I wanted to create a sense of depth, and a good way to do this is by positioning an object very close to the camera. I usually place such foreground subject matter at the bottom of a photograph, but note that in this case I have put it to the side. The effect is the same. This is also an example of asymmetrical balance. The tree occupies a small part of the scene, but the Dolores River and its environment offset its dominance. Notice the rhythm in the scene, too.

MOUNT SAINT HELENS, WASHINGTON

LAYERED DESIGN

The eruption of Mount Pinatubo in the Philippine Islands cast millions of tons of volcanic dust into the atmosphere, where it stayed for several years. During that time, the extra particulates of matter made sunsets and sunrises, and the time surrounding them, dramatically intense. I was lucky enough to be hiking the Colorado Trail the summer after the eruption, and this image of Jura Knob is one of the most unusual I have ever made. Note that the blue of the Earth's shadow reflects in one lake, and the magenta sky reflects in the other.

This image consists of compositional layers: magenta sky, blue sky, mountain, blue lake, magenta lake, and landscape. In layered compositions, the most important consideration is where to begin and end the scene. Though there was more subject matter above and below the edges of the photograph, I thought that viewer interest would most likely begin at the magenta sky and end just below the magenta lake. Including more sky or landscape would have weakened the image.

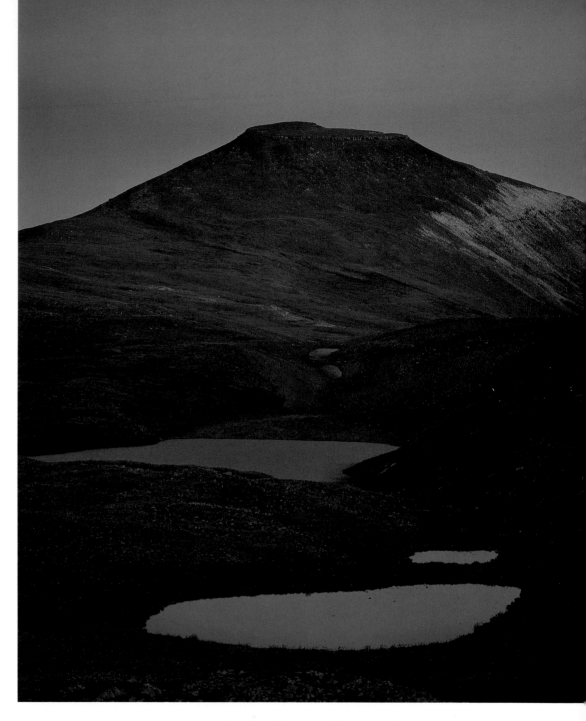

SAN JUAN MOUNTAINS, COLORADO

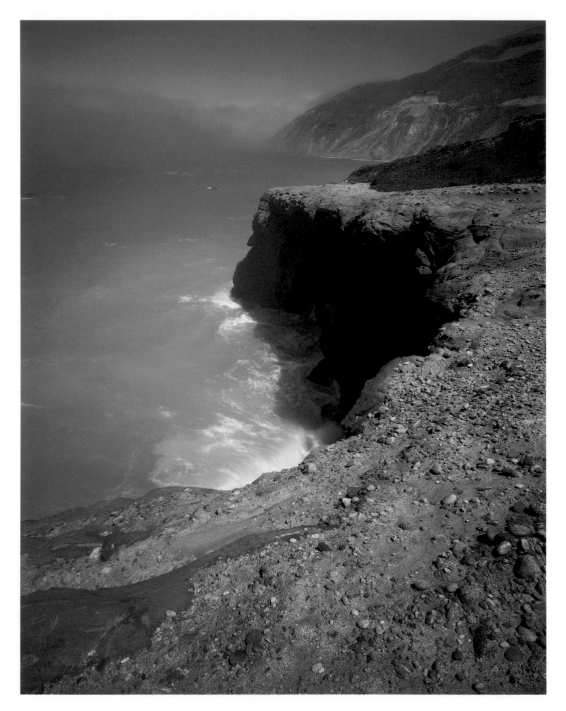

BIG SUR, CALIFORNIA

LEAD-IN LINES

Though you wouldn't know it, the wind was blowing about 60 miles an hour while I was making this image. I was very nervous standing on the edge of the cliff with the ocean 100 feet below. Nevertheless, I rationalized that this is the way nature photographers make their living and I would have to do the best I could. By using a larger aperture and faster shutter speed than I normally would, and by holding the tripod firmly as I pressed the shutter, I was able to make a sharp image.

The edge of the cliff is a convenient passageway to the rest of the scene. The viewer's eye is snagged right away by the rocks in the foreground, then led to the shadows below the cliff, then to the cerulean blue of Pacific waters, and ultimately to the coastal clouds and blue sky. If it weren't for my haste to get off that precarious perch, I would have stayed to enjoy the visual journey. Instead, I enjoyed it a week later on the light table at home.

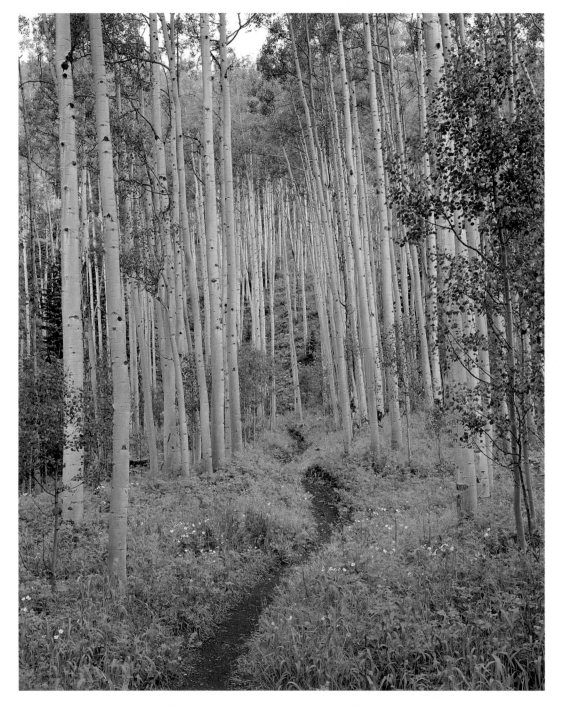

MAROON BELLS-SNOWMASS WILDERNESS, COLORADO

Trails and roads make wonderful lead-in lines because they attract the eye immediately and force the viewer to follow them into the scene. In addition, they always go some place, and most people are psychologically more secure exploring trails and roads than they are bushwhacking into the unknown.

A cloudy afternoon provided the perfect light in which to photograph the lightly colored aspen trunks, and it allowed good contrast between trail and undergrowth. The complementary colors of the brown trail and green plants further enhanced contrast and the prominence of the trail as a lead-in line. I made this image just minutes before the skies opened up. After the heavy rain it would have been impossible to make the photograph. It is important to act on photographic impulses as quickly as possible, for there is never a guarantee that atmospheric conditions will last long enough to allow you to be successful.

MAROON BELLS-SNOWMASS WILDERNESS, COLORADO

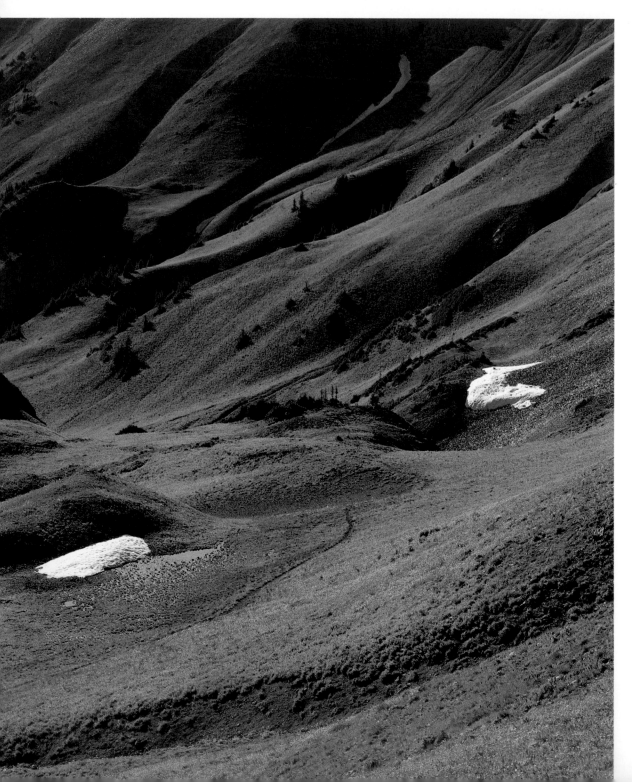

DIAGONAL LINES

The soil from the red Maroon Bells formation seems more fertile than most. The green cast of the back-lighted tundra grass supports my theory. When we were heading up to Avalanche Pass at 12,100 feet to enjoy our last night of a 28-day exploration, I spied both the color and the diagonal lines. The ridges plunging into Carbonate Creek were mostly parallel, and I liked the way they met the horizontally inclined landscape below.

An hour after this photograph was made, Tom Barron, Peter Stouffer, and I tucked the llamas safely away in the tall grass below the pass and celebrated the conclusion of a month in this wilderness. Sharing a dinner of beef bourguignon and a bottle of cabernet sauvignon while viewing mountains for 50 miles all around us was a fitting end to our quest to better know this remarkable mountainous place.

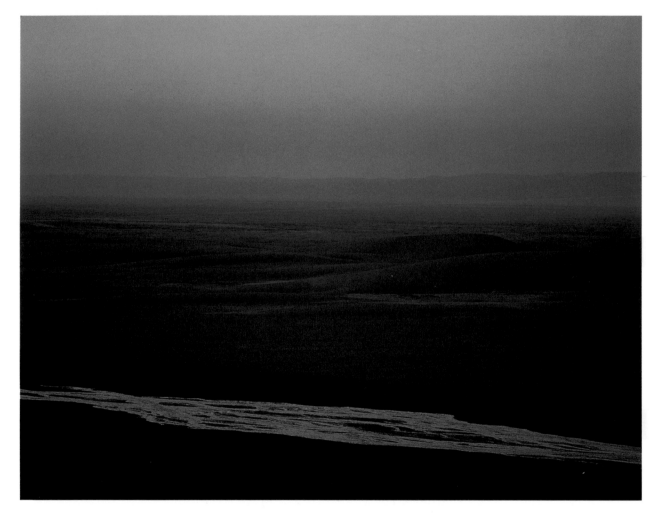

MEDANO CREEK, GREAT SAND DUNES NATIONAL MONUMENT, COLORADO

LEADING THE VIEWER OUT OF THE SCENE

I love to photograph before the sun comes up and after it goes down, and on clear days the atmospheric conditions can be spectacular. Even though light intensity is minimal, if you can see colors and form with your eye, the film can see them as well. It is too dark to hand-hold the camera at these times, so a tripod is mandatory.

Though direct light and shadows are a primary ingredient in sand dune photography, Medano Creek provided a twilight alternative. Note how the pink sky reflects on the water, making the creek the dominant feature in the scene. The viewer's eye follows the creek in both directions, leading you out of the scene and leaving you curious about what lies beyond the boundaries of the image.

HORIZONTAL VERSUS VERTICAL COMPOSITION

Both of these images are pleasing to the eye, yet they are composed differently. The horizontal version is asymmetrically balanced because the large sandstone wall on the left offsets the more interesting window. The vertical image centers the window and is symmetrically balanced.

Productive nature photographers always take advantage of interesting scenes by photographing them as many ways as they can. In addition to making vertical and horizontal images of the same scene, you can use different focal lengths of lenses to provide more versions of a particular composition. Don't let these rare moments and places escape.

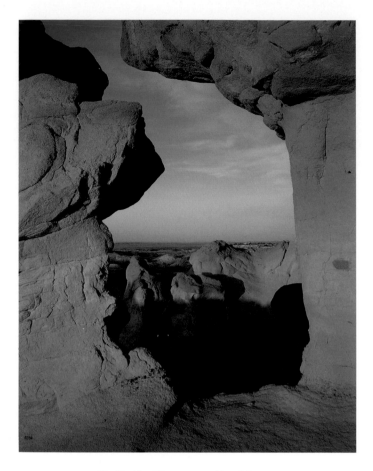

De-Na-Zin Wilderness, New Mexico

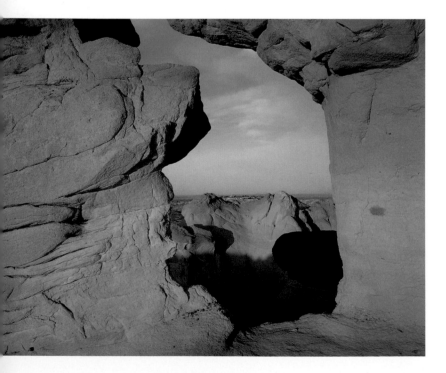

Here are a few ideas and techniques that relate not just to composition but to ways in which a photograph might appear in comparison to how the eye sees. You might find these useful when you wish to alter reality.

Compressing Distance and Selecting Focus

In our discussion of view, I mentioned that telephoto lenses compress distance, effectively eliminating some of the space in between features in the scene. Though this does not change perspective, it does make objects appear closer to one another than they really are. Often this heightens your awareness of the difference in size between objects of known proportions.

More often than not, this compression, which increases as the focal length of the lens increases, presents mechanical trouble for the lens. Since depth of focus decreases as the focal length increases, it may be difficult to keep features in both foreground and background in focus at the same time. This does not have to be a handicap.

Just as the eye tends to be directed to objects that are dominant because of color or form, it also gravitates toward things in focus in a scene that is otherwise out of focus. Long lenses commonly used in wildlife photography have limited depth of focus. It is common to see a photograph of a deer in the middle of a field in focus, while grasses in front of it and behind it are out of focus. This effect draws the eye to the deer more quickly than if the entire scene were in focus. I talk more about exactly how to make this happen in Chapter Two.

Typically our eye does not see parts of a scene out of focus, for its depth of focus is greater than the camera's. Personally, I prefer everything to be in focus, just like the eye sees.

Motion

I enjoy capturing the motion of water on film. The result is a photograph that does not depict water the way we see it. When photographed in the proper conditions, cascades and waterfalls take on a surreal quality similar to the texture of natural cotton. Wherever I teach, people ask me how to create this effect.

It's so simple — have a friend stand upstream and toss five pounds of cotton into the creek while you photograph it floating down. Just kidding. Or do this: On a cloudy day, set up your camera on a tripod below a white cascade or waterfall and make an exposure at one-quarter of a second or slower. The longer the exposure, the fewer the strands of detail in the water, and the more abstract it appears. Beware potential pitfalls: Direct sunlight reflects too brightly off the white water; and without a tripod, you cannot hand-hold the camera and prevent everything else from appearing blurry. If the length of the exposure that you want to use requires an f-stop smaller than what's available on your lens, put on a polarizing filter. This will decrease the amount of light entering the camera by up to two full stops, allowing even slower shutter speeds. Polarizers also reduce glare on wet rocks in the creek, providing more color in the photograph.

This type of image is not real, for our eyes do not see the motion and time compressed into a photograph. Just like the technique of selected focus, it produces only an impression of reality.

Overexposure and Underexposure

I am generally impressed with the ability of color films to record the intensity of natural colors, even when overexposed. Though I have never tried to make color more intense than it already is, I have always worked hard to insure that high contrast did not compromise that saturation. This is difficult to do when the film cannot see the full range of contrast seen by our eyes. In order to maintain detail in the shadows, you have no choice but to overexpose the highlighted areas, and vice versa. I talk about mitigating this problem in Chapter Two.

As my career progressed, however, I tended to worry less about reasonable overexposure. I have become more comfortable with slight overexposure in certain highlighted areas. Two things are gained: The shadows manifest more detail when I overexpose, and my highlights take on an ethereal, delicate quality that they wouldn't have with normal color saturation. The tops of mountain peaks especially benefit. They exhibit soft colors akin to those of mountains in Alfred Bierstadt's 19th-century paintings.

Intentional underexposure is effective in making shape and pattern more conspicuous in a photograph. I discuss exposure thoroughly in Chapter Two.

THE MOTION OF WATER

*One summer I hiked the Continental Divide
in Colorado's South San Juan Wilderness.
High on a ridge at 12,000 feet, I saw what
appeared as a thin white line many miles off
in a distant valley. I surmised that this was
either a dead tree turned gray or a waterfall,
so I filed the image of that place in my
memory for future reference.*

*Curiosity got the best of me. That autumn,
my family and I took off for a long weekend so
we could see the "white line" up close. Having
marked on my topographic map that summer
what I thought was its approximate location,
we set off from the nearest trailhead with the
llamas and provisions for three days in the
wilderness. I will never forget the simultaneous
roar of the water and the sight of this great
waterfall as we rounded a bend in the trail.
One hundred feet high and picture-perfect,
this most wonderful of waterfalls was not even
marked on the map. For three days I
photographed it a dozen different ways, each
image as impressive as the next. This particular
exposure was made for two seconds.*

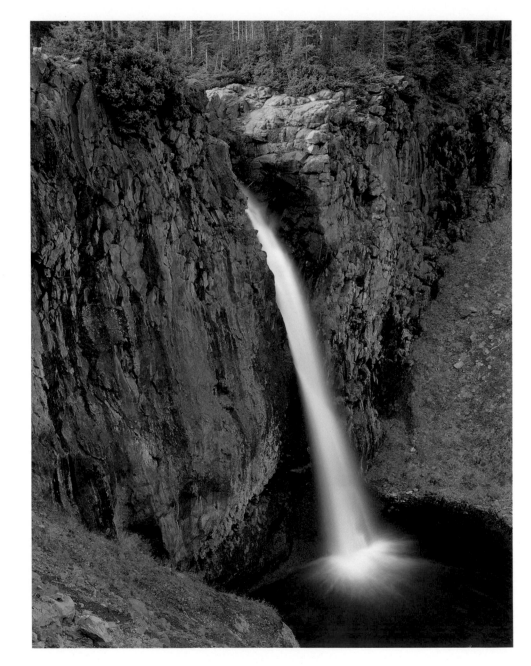

CONEJOS FALLS, COLORADO

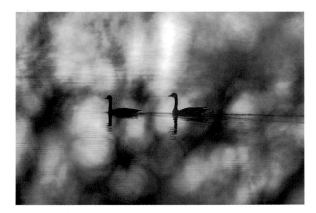

GRANT RANCH, COLORADO

SELECTED FOCUS

I was not intimidated by bushes only 20 feet away as I focused on geese in the lake with my 200mm lens. Since the camera remains open to the largest aperture until the shutter is pressed, I saw this scene through the viewfinder just the way it appears in the photograph. I chose to keep the aperture open wider than usual so the branches and leaves would be as out of focus as possible. I did not want the eye to be distracted away from the geese. The "soft" focus provides an abstract setting for the geese, and it allows the viewer to daydream about the beauty of the place.

THE MOTION OF WATER

This image includes several wave cycles. Each wave lapping up the beach takes several seconds to come in and retreat, and the total exposure was for 20 seconds. Afternoon light would have been too bright to make such a long exposure, even when stopped down to the camera's smallest aperture. Therefore, I waited until well after sunset to make the image. Overcast skies created a scene so devoid of color (it's almost a black and white) that it quickly attracts the eye to the surf and rocks.

Prepare to get wet when making this sort of photograph. The camera must stay put while waves crash into your legs. If strong enough, waves can erode the sand and cause the tripod to move during the exposure, ruining the photograph.

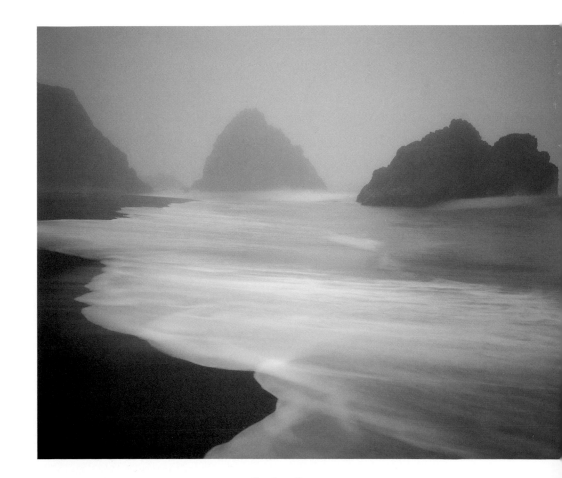

BIG SUR, CALIFORNIA

UNDEREXPOSURE

This photograph is underexposed, for it does not exhibit detail seen by the eye along the banks of the creek and in the trees. Nevertheless, underexposure serves a useful purpose. The creek is more prominent in the scene than it would be otherwise, creating a dramatic lead-in line and allowing the eye to concentrate on sky and creek rather than forest and shore.

As in the overexposed mountain scene at right, the contrast is too great to accommodate detail in the entire photograph, and the viewer must be willing to accept a lack of detail in certain places. Though the eye does not see this way, the effect is still quite pleasing.

GILA NATIONAL FOREST, NEW MEXICO

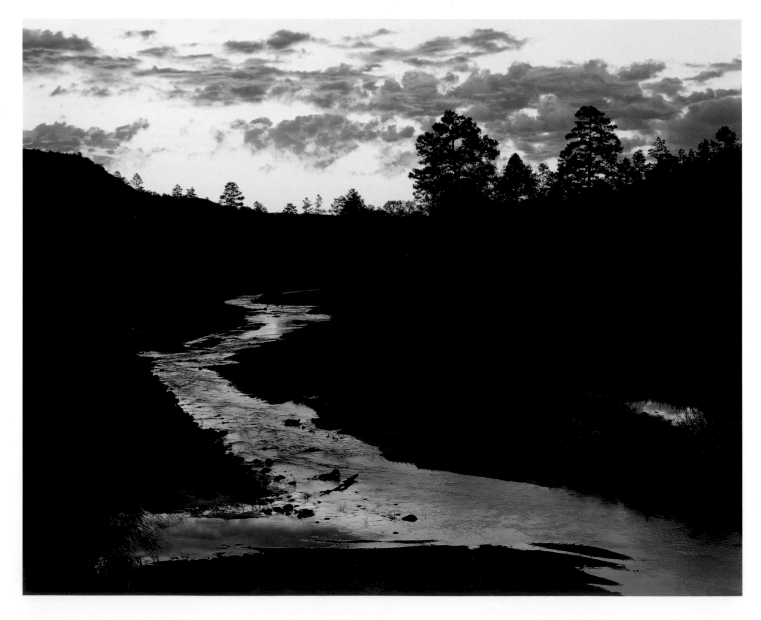

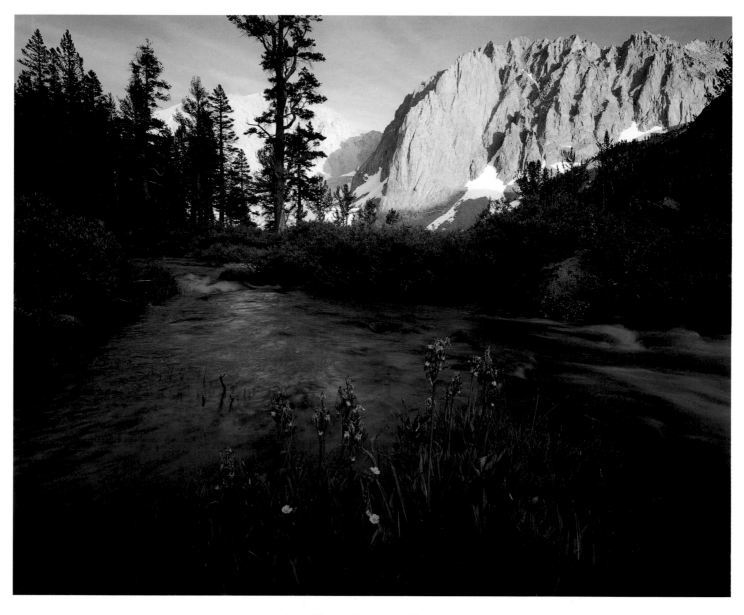

SIERRA NEVADA MOUNTAINS, CALIFORNIA

OVEREXPOSURE

When I made this image, the sun was high enough to light the mountains in the background, but it was too low to illuminate the landscape. I knew immediately that the high contrast would make this a difficult — if not impossible — scene to put on film. But I decided not to worry about the outcome and to experiment with exposure.

This was the only satisfactory image I made. It's acceptable if you are not distracted by the loss of detail in the mountains. In fact, the overexposure of the mountains makes them appear brighter and whiter than they would be otherwise, which makes them conspicuous. They seem ethereal and lofty — much as they appear in Alfred Bierstadt's 19th-century paintings of the American landscape.

LIGHT

With the five photographic toppings and a sense of composition, you can make a good photograph. To make excellent photographs, you must understand light. You might have some delicious toppings for your pizza, and an oven in which to bake it, but if you don't have a kitchen with electrical outlets, you'll never eat dinner!

Derived from Greek language, the word *photography* literally means *to write with light*. Different kinds of light contain waves, or pulses, of different lengths. We call the full range of wavelengths the electromagnetic spectrum. Some wavelengths of light can be seen by the eye, others cannot, and we associate each of the waves with a different color. For example, both relatively short ultraviolet wavelengths and longer infrared wavelengths are invisible to the eye. As wavelengths shorten they appear more blue, and as they lengthen, they appear more red. In between ultraviolet and infrared are the wavelengths that make up the colors of the spectrum we see. The combination of these wavelengths at high noon is seen as white light.

Three major characteristics of light require the photographer's greatest attention: *color, intensity,* and *polarization.* The reaction of light with objects in the landscape — rocks, clouds, plants, metal or glass (such as in our filters) — affects each of these characteristics. It is this interaction that determines how we see the landscape with our eyes. Let's talk briefly about each.

CHARACTERISTICS OF LIGHT

Color

Natural light from the sun actually changes color during the day. Artificial light sources produce different colors, too. Look at an incandescent bulb with a tungsten filament — what we commonly put in a table lamp — and then look at a fluorescent tube. The incandescent bulb appears yellow and the tube white. What you think might be a subtle difference in color is not so subtle when you see them side by side. Oddly enough, the fluorescent tube is not actually white. When you hold a color-corrected tube (one that has a pure white color temperature equivalent to daylight at noon) next to an ordinary fluorescent tube, you can clearly see that the common tube is slightly pink.

We already know that the amount of atmosphere through which sunlight passes can change the color of direct light. At the ends of the day, sunlight angles across the surface of the earth, passing through more air molecules, dust, moisture, and pollution than at noon. All of this matter allows only the longer wavelengths of light — the warm colors — to reach our eyes and cameras. When the sun is below the horizon, it is not capable of lighting the landscape directly, and it sends its rays into the sky above us. Clouds sometimes catch the color from this last light — occasionally in shades of red, yellow, and orange that defy the imagination. Even without clouds, the banding of color above the horizon can be overwhelming — from yellow to orange, red, fuchsia, magenta, blue, and finally black of night, all in one view. I have always thought that sunsets tend to be more intense than sunrises. Since man and weather stir up dust and moisture more during day than night, perhaps it's true.

Colored light affects colors in the landscape. Just as a painter combines colors of paint on his or her palette to make new colors, so too does direct light combine with colors in the landscape to make new colors. This can be good and bad. I hate to see the brilliant royal blues of larkspur and lupine wildflowers turn brownish-blue when a yellow morning sun paints the landscape. At the same time, I adore the warmth of early sunlight as it makes green fields more lively.

Photographers must not only be aware of the color of direct light. They also need to pay attention to light reflected from the sky. On a bright blue day, the sky will reflect its color intensely into all areas not receiving direct sunlight. Shaded areas appear bluish because of this reflection from the sky. If the shaded area is white snow, the snow will appear blue. Everyone of us who has ever photographed a skier knows this well. If the shaded area is green grass, the green color will appear less vibrant than normal both to the eye and on film. The blue from the sky combines with the green to make a new, less attractive color. When pink clouds of sunset reflect their color onto white snow or beige sand dunes, the land appears pink, and your camera and film will accurately record it. The more neutral the earth tones, the more tainted they appear by reflected color, which is fine when the resulting colors are warm and pleasant.

During the day, when clouds cover the sky, many photographers put their cameras away. They shouldn't, for this is one of the great times to photograph nature. The color of clouds, from black to gray to white, reflects upon the landscape. The most obvious benefit is reduced intensity of light, which eliminates the extreme contrast that can ruin a good composition. White clouds promote the best color viewing and photographing; dark gray clouds tend to dull colors.

Intensity

Light is brightest each day at noon when the sun is at its farthest overhead point. The sun has less atmosphere to penetrate at noon. Therefore, as it rises higher in the sky, the light becomes both whiter and brighter.

Clouds can significantly reduce light intensity and contrast. Intensity also is reduced as the day begins and ends, when light warms in color. Yellow light reflecting off an object is not as brilliant as white light reflecting off the same object.

Polarization

Light not only exhibits color and intensity, but by nature it can also be polarized or unpolarized. Sunlight is unpolarized light because all its waves do not necessarily move in the same direction. However, when light strikes a non-metallic reflective surface, such as water in a pond, the unpolarized part of the light is lost in the water, and polarized waves are reflected back to our eye. This allows us to see reflections of the image on the surface of the pond. On the other hand, when the water surface ripples, it cannot polarize the light, and we can't see the reflection.

A polarizing filter can block polarized light, thereby eliminating reflections and allowing us to see objects in the landscape more clearly. The scattering of unpolarized light when it is reflected off most features and colors in the landscape, especially wet ones, is called glare. I talk more about polarizers and other filters in Chapter Two.

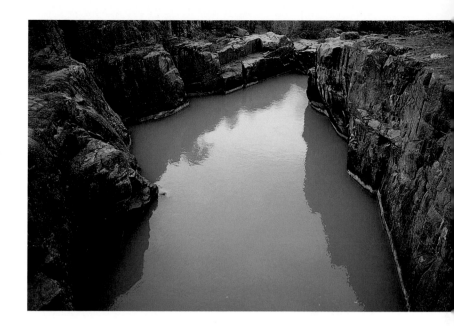

UNPOLARIZED

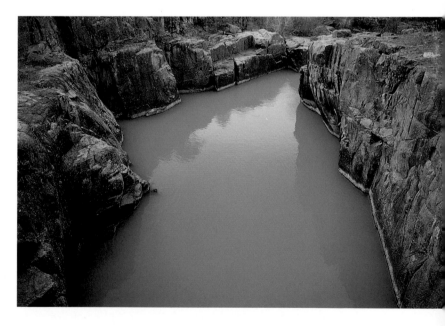

POLARIZED

Notice how the polarized photograph almost eliminates the reflection of rock walls, and the water appears more colorful as a result.

ANTORA PEAK, COLORADO

COLOR OF LIGHT

This mountain appeared gray during the day. In the evening, it turned orange because the color of the light was orange. The lay of the land to the west of Antora Peak was such that the sun could descend very close to the horizon before losing its view of the peak.

Evening rain showers left enough moisture in the atmosphere to thoroughly scatter the cool colors in the spectrum, leaving copper to coat the earth. Note the warm, reddish color of the trees in the forest, including the red color of the standing dead trees.

Red paintbrush, yellow sneezeweed, purple larkspur, and green grass and foliage cannot escape the rising yellow sun. Yellow light combines with bluish green to make olive green. Yellow light also turns red bright red, and it lightens purple. The effect is no different than if a painter had combined yellow oils with each of the other colors on the palette.

Colorado's San Juan mountains provide friendly terrain for wildflowers. Fertile volcanic soils and plenty of summer rain allow many species to grow together — and profusely. Finding fields like this is like opening the last and biggest package under the Christmas tree.

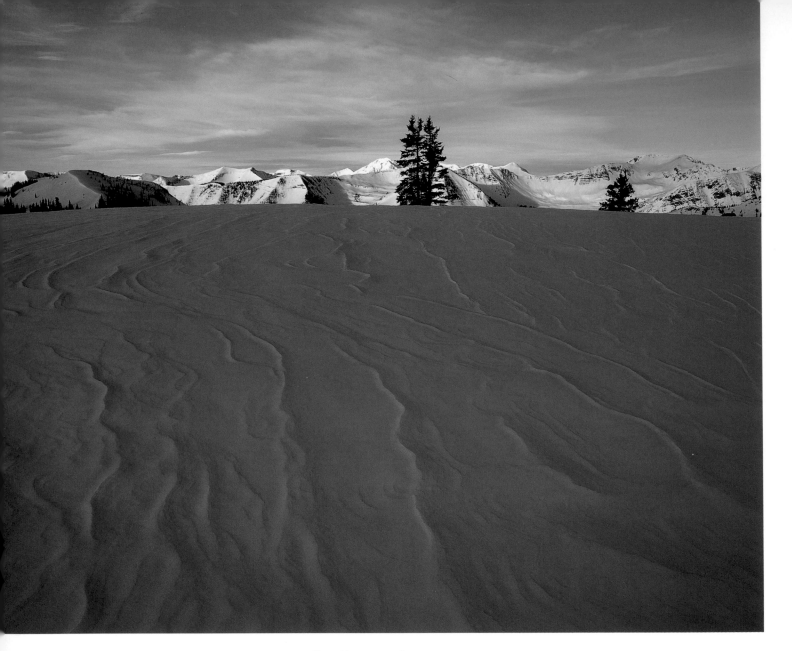

RUBY MOUNTAINS, COLORADO

LIGHT FROM THE SKY

Regardless of the color of sunlight, the sky always reflects its color on the earth. Sky colors are reflected more distinctly in areas not directly lighted. Neutrally colored substances, such as snow and sand, reflect the actual color of the sky better than others. In this photograph, the sun is not high enough to shine where I stand, and the clear blue sky turns snow from white to blue. The same scene photographed on a cloudy day would contain white or gray snow.

I made this image during my 80-mile, eight-day, above-timberline ski tour through the southern Rockies near Crested Butte. We photographed snow in many kinds of light, and we had fun skiing many different kinds of snow. The niveous environment — once you learn how to be comfortable in it — provides photographs unlike those of any other season. Working with only green, blue, pink, and white, photographing winter images tends to promote form more than color.

Sipping hot cocoa in the backcountry ski hut, I glanced outside to see if the snow showers had ceased. Not only had they stopped, but the sun had found its way between clouds and horizon, and a reddish color began to blanket the landscape. I grabbed the camera pack and tripod, raced outside to put on skis, and eventually made this photograph before the sun disappeared below the horizon. This image is a product of a wonderful moment — as well as proficiency with the camera — and there is no substitute for either. Note the color of the snow in the foreground.

SAN JUAN MOUNTAINS, COLORADO

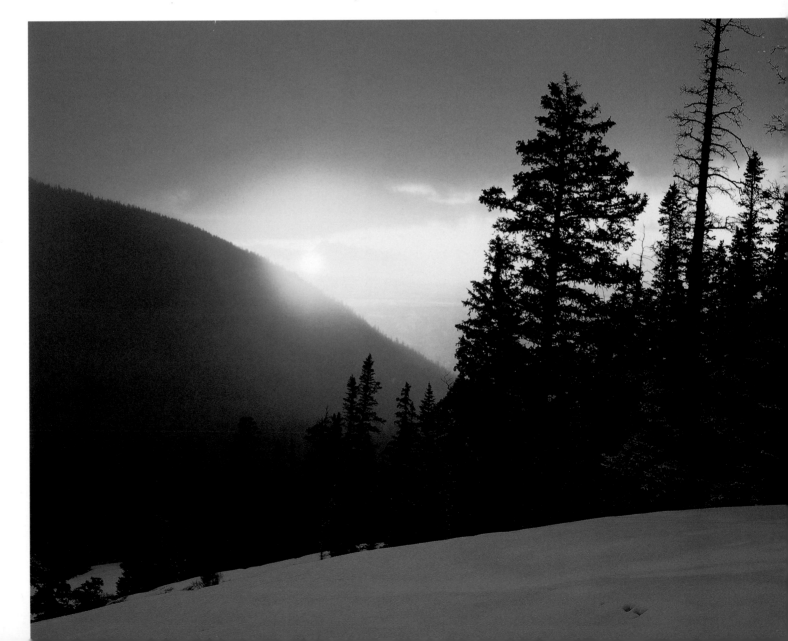

HIGH-INTENSITY LIGHT

I made this photograph in the middle of the day in clear weather when the sun was very intense. I sacrificed the detail in the shadows in order to expose the waterfall properly. Though large areas of solid black are useful in photographs depicting silhouettes, the globs of black in the rocks are distracting. This image would have been better made in cloudy light.

BANDELIER NATIONAL MONUMENT, NEW MEXICO

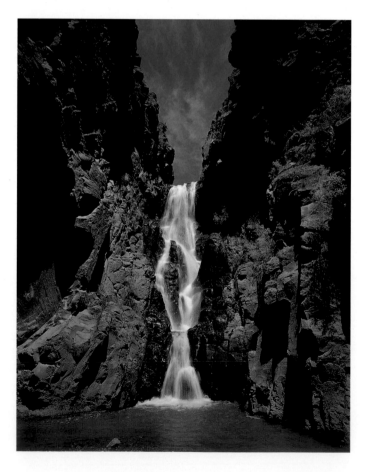

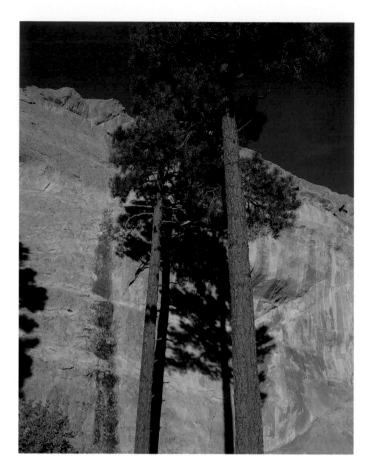

PONDEROSA PINES, NEW MEXICO

LOW-INTENSITY LIGHT

Direct light at the end of the day when the sun is near the horizon is "thick" and warm. Light intensity decreases as the sun sinks lower in the sky, reducing contrast between shadow and highlight areas. In this photograph, note how the shadows of the pines are not nearly as dark and black as those in the rocks of Bandelier.

THE COLORS OF LIGHT —

A TYPICAL DAY

The colors of a day fall into three categories: twilight, sunrise/sunset, and midday. Although many people think *twilight* only occurs after sunset, it is also a predawn condition.

Twilight

It is not uncommon for me to leave my warm sleeping bag at 4:00 in the morning to begin photographing by 4:30. That's when color begins to appear in the black sky during the summer solstice, even though the sun's rise over the horizon may still be an hour away. On clear days, the first color to show is a hint of blue in the lower sky. In time, bands of yellow and red juxtapose with blue, then black. Before all this color begins to fade, the sky might boast fuchsia and magenta as well, depending upon the day's atmospheric conditions. On cloudless days, especially when you have a view from higher elevations, the earth's blue shadow appears opposite in the west, topped with a band of pink.

The eruption of Mount Pinatubo in the Philippine Islands deposited an unusual amount of volcanic dust high in the earth's atmosphere. That dust, though invisible to the eye during daylight, managed to create colors in the sky before sunrise and after sunset unlike any I had ever seen as a photographer. Odd shades of red and magenta would dominate the sky and reflect on the landscape. The Earth looked as if a slurry bomber had dropped thousands of gallons of paint upon it.

Some days are more dramatic than others. Clouds that cannot be seen behind the curvature of the planet can block the passage of the sun as it tries to color the sky. If there are no clouds on the horizon, clouds in the sky begin to take on the color of blood, eventually turning orange, then yellow, and occasionally all three at the same time as the sun rises higher.

When the last cloud loses its color, the rays of the sun shine directly on the landscape.

Alpenglow refers to the rich red light lasting only minutes just before sunrise and immediately after sunset. At these two times, the light from the sun must penetrate the atmosphere twice: once on its way in toward the earth, and out again after only skimming its surface. High mountain peaks catch this light on its way back out, and only the longest red wavelengths of light are able to make it through. Alpenglow will turn a gray peak red. As the sun continues its rise, the red changes to orange, and by the time you can finally see the arc of the sun peaking above the horizon, yellow.

Sunrise/Sunset

My definition of sunrise is the moment sunlight finally hits the highest places in the landscape, which might occur at very different times even at the same longitude. If I am in the bottom of a river canyon, sunrise will happen much later than if I am high on a mountain ridge. In all cases, it is marked by warm, yellow light, and broad shadows cast by prominent features in the landscape. On long summer days, sunrise may last from 5:30 in the morning until 9:00 or 10:00. Its end is marked by the brightness and whiteness of the light, the shortening of the shadows, the high contrast that only gets worse as the day lengthens, and perhaps the breakup of cloud banks into symmetrical puffs that I call "buttermilk" clouds.

Midday

Morning photography sessions can last for up to five hours. Then it's time for breakfast. From 10:00 in the morning until 5:00 in the evening, when the sun is higher than 30 degrees above the horizon, photography on a clear day can be difficult. The shadows are chaotic, and the sunlight is extremely bright. The blue sky reflects its color in shade, and directly lighted colors in the landscape appear dull and "washed out." It is practically impossible to make excellent photographs in these conditions. We pray for clouds.

I can be productive throughout a clear day only during the shortest days of winter when the sun never exceeds 30 degrees of angle above the horizon. Shadows are long, and the light is white, but not intense. And with sunrise at 7:00 and sunset at 5:00, there is plenty of time to read and relax at day's end.

At midday the best hope for the photographer is to have weather and clouds; not cumulus clouds that allow sunlight through in places to create contrast, but clouds that cover the entire sky. White clouds reflect just the right intensity of light onto the landscape, allowing all of the natural colors of nature to be seen and photographed. Contrast only exists between the light and dark colors themselves, not enough to upset your film and just the right amount to record all of nature's detail.

In more humid environments, haze also mitigates contrast. The high moisture content of the atmosphere serves to moderate the amount of light penetrating during midday. The scattered light reduces the glare off lightly colored objects in the landscape, limits contrast, and makes good photography possible. And with less blue visible in the sky, shadows are not quite so blue.

After midday, the sequence of lighting events continues until dark in reverse of those I described about dawn's twilight, with a couple of exceptions. There are more thunderstorms in the second half of the day than the first, and my "extra dust in the atmosphere" theory could very well be true. These two conditions can dramatically affect the number of long red wavelengths that penetrate the atmosphere, resulting in spectacular sunsets and rainbows.

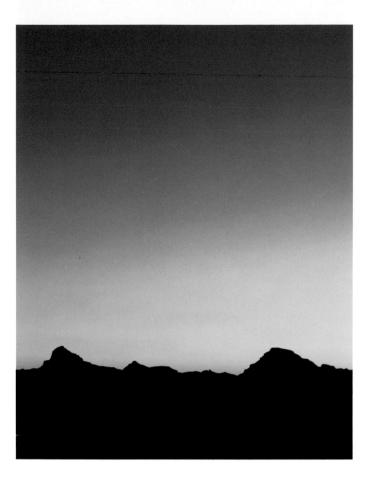

WETTERHORN AND UNCOMPAHGRE PEAKS, COLORADO

Sometimes I have a hard time finding a good place to park myself and camera for day-end photography and sleep. Before I realize it, I'm hiking or driving along and it's too dark to take any pictures at all. That's how this particular evening almost ended. Just as the clouds began to turn red, I spied this lone cottonwood tree and pond in the middle of a private meadow. I slammed on the brakes, backed up, and pulled into the ranch driveway where I was confronted by the rancher. He was very accommodating when I asked him if I could photograph in his field. Thirty minutes later I was back on the road with an excellent photograph in the bag (but still without a campsite).

WHITE RIVER NATIONAL FOREST, COLORADO

TWILIGHT

The banding of color from horizon upward on a clear day is remarkable. I usually begin photographing each day one hour before sunrise and end one hour after sunset. This photograph demonstrates why I choose these times of day to work. Because exposures usually last for several seconds — depending, of course, on the aperture chosen — using a tripod is mandatory.

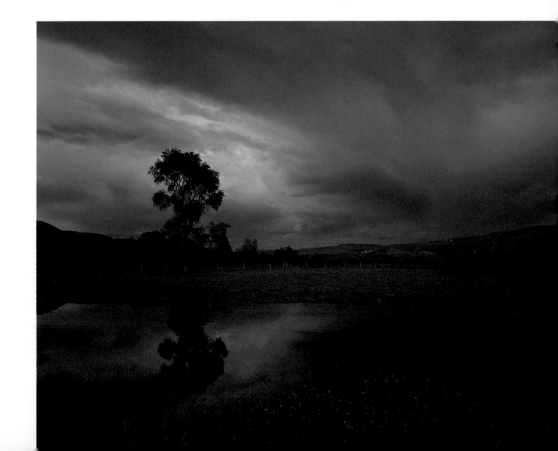

ALPENGLOW

The view from the top of Hagues Peak at 13,760 feet was very impressive. To the north I could see as far as Wyoming, and below us was Rowe Glacier — a body of ice that had been there since the last ice age some 15,000 years ago. When the sun turned the peak from gray to orange just before it set, it was icing on the cake.

Smoke from distant forest fires turned the sunlight a color I had not seen before. By themselves air molecules create intense warm light, but this was dramatically different. I made image after image right up to sunset, knowing that both vantage and moment were unique. To have been able to record it all with the detail that only comes from a view camera was a bonus.

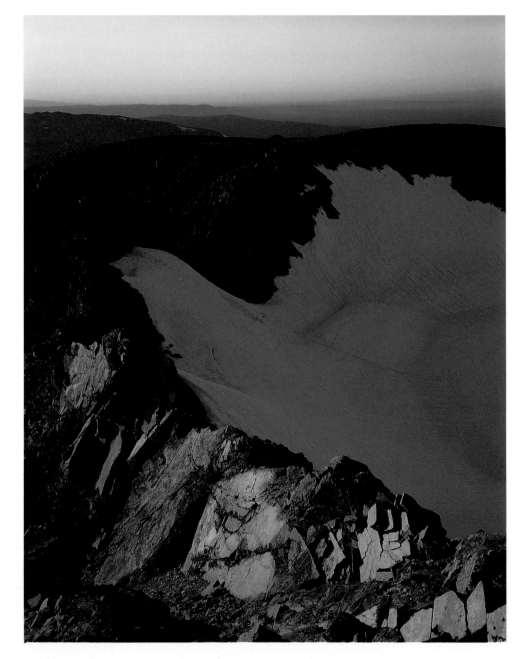

SUNSET, ROCKY MOUNTAIN NATIONAL PARK, COLORADO

SUNRISE

The upper reaches of the Alpine Lakes Wilderness of the Cascade Range is much like the Sierra Nevada of California — snow, ice, crags, and water abound. This mountain named the Temple was the dominant feature in the area, and I spent my evening in the tent praying for an interesting moment to photograph. Sometimes prayers are answered, sometimes not. In this case they were. Note the reflection of the pink clouds in the crystal clear waters of the creek.

The sun rises so quickly that partial blockage by mountains is a short-lived moment. Once the sun is fully exposed, shooting directly into it creates lens flares. Nevertheless, you should have enough time to make several good images if you work fast. In clear weather, the mountain would have created a sunstar, but in this case, clouds in the sky diffused the intensity of the sun and prevented that effect.

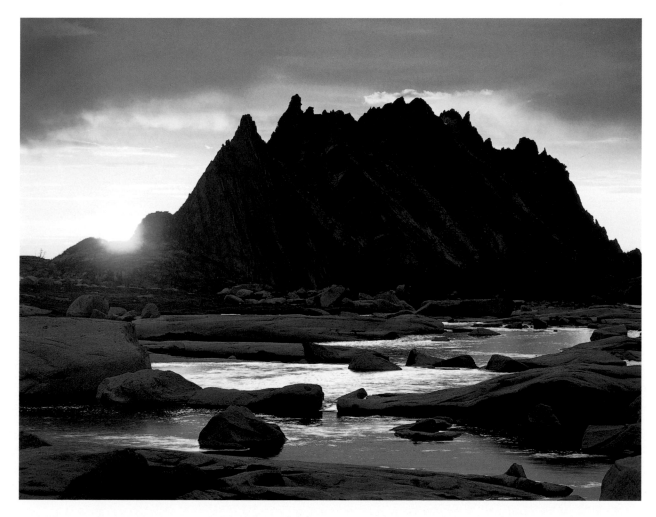

ALPINE LAKES WILDERNESS, WASHINGTON

SUNSET

Making this image required more patience than you would expect. Clouds and warm light intensified by moisture in the Pacific air provided the basis for a good photograph, but the reflection in the sand was the element that made it excellent.

Sometimes the waves ran up the beach much too far, and sometimes not far enough. I waited through many wave cycles *until just the right amount of sand was wet. Then, I had to wait until the ocean water had soaked into the sand to the degree that a glassy surface formed. Too much water — or too little — would not reflect clouds and cliff. The moment of reflection lasted only a few seconds, allowing time for only one exposure.*

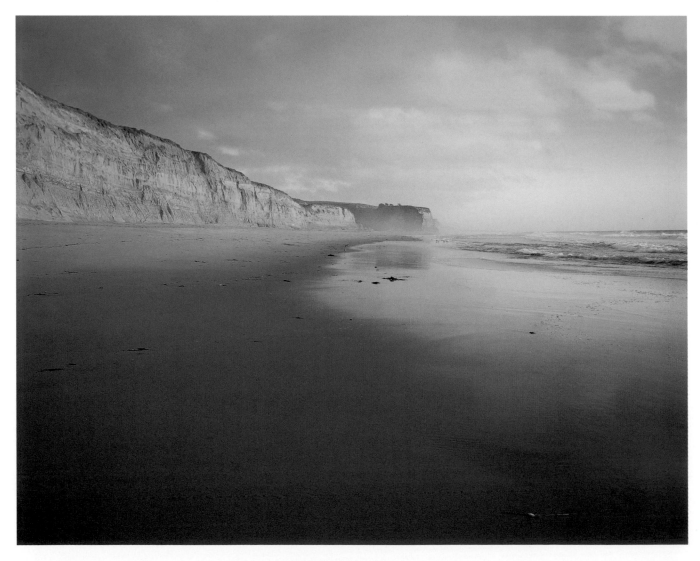

San Mateo County, California

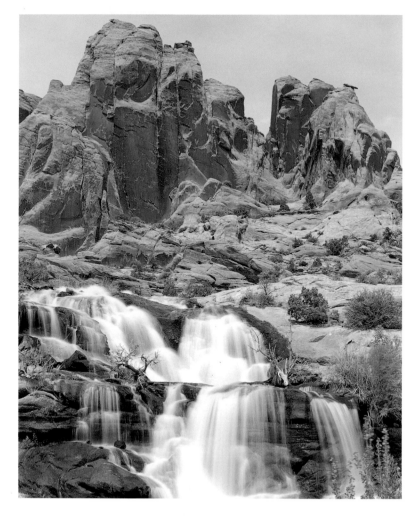

MIDDAY DIRECT LIGHT

This is an example of bright light in the middle of the day. Note how the harsh, direct light on the landscape washes out most of the colors. Even the clouded sky is mundane and lacks detail. This scene faces west, and I would bet that at one hour before sunset on a clear day you could make an excellent photograph of it. Also, in cloudy light, the red rocks would appear more saturated, and there would be more detail in the highly reflective white waterfall.

MIDDAY CLOUDY LIGHT

Cloudy light allows nature photographers to be productive all day long. The best clouds are pure white and cover the entire sky, allowing no blue to denigrate colors in the landscape. Under these conditions, nature's colors and detail are best portrayed on film.

These ponderosa pines, along with their bark and fallen needles, exhibit immense detail that enhance nature's integrity. The colors are warm and pure, and the composition of an intimate landscape allows the eye to focus on nature's form without being distracted by the sky. Such conditions of light usually last for a relatively long time, allowing the photographer to be more thoughtful and deliberate while making images.

BANDELIER NATIONAL MONUMENT, NEW MEXICO

The photographer must always be cognizant of the direction of sunlight. Light direction significantly affects color and form in a scene, and direction of light can produce distinctly different images of the same place. The three primary compositions are *back lighting, side lighting,* and *front lighting.*

Front Lighting

When the sun shines from behind the photographer in the same general direction as the camera is pointed, a scene is said to be front-lighted. Front lighting is even lighting, for shadows are projected away from objects and cannot be seen. No matter the angle of the sun, all features in the scene have the same illumination, and contrast is never a problem.

Scenes lighted from behind offer less opportunities for composition than those lighted from the side or front. There are no shadows, and lack of contrast makes it difficult to allow features to stand out from one another. In addition, when the sun is low, the photographer's own shadow can be projected into the scene.

Side Lighting

When the sun shines into the scene from either side, a scene is said to be side-lighted. This is the most common lighting used in landscape photography. Shadows are conspicuous, creating contrast and drawing the eye to form within the scene. Most plant matter, leaves, grasses, and flowers are thin enough to let direct light through. Translucent, side-lighted plants will glow as the sun sets, and their colors are consequently enhanced.

Back Lighting

When the sun shines directly toward photographer and camera, a scene is said to be back-lighted. This can be difficult to properly compose and expose, mostly because the eye and the camera do not like looking directly into the sun. Hexagonal lens flares — those red geometric shapes that appear both in the viewfinder and on film — can ruin the integrity of a composition. Nevertheless, shooting into the sun can make good things happen, too. Sunstars and shadows projected toward you together make marvelous compositions. The distortion of the parallax of shadows cast from tree trunks creates lead-in lines that almost — but never quite — converge in the distance. Contrast also tends to be greater in back-lighted scenes than in others. The side of objects facing the viewer are not directly lighted, and tend to be conspicuous against brightly lighted backgrounds. The translucency of grasses and foliage is never more apparent than in a back-lighted scene. As the suns sets and rises, colors become extremely vivid. I talk about making exposures in back-lighted conditions in Chapter Two.

Bounce Light

Sometimes scenes are illuminated not by direct light, but by light reflecting off other parts of the landscape. This is called bounce light. At the ends of the day in deep river canyons, the highest walls still catch direct light while everything in the canyon bottom is in shade. Canyon bottom features that might normally be color-biased by the blue sky actually appear warm in tone. Canyon walls reflect their own color into the shady canyon. The lighter the color of the wall, the more reflective it is. Conversely, black rocks such as schist and gneiss reflect almost no light and cannot bounce light into a canyon bottom.

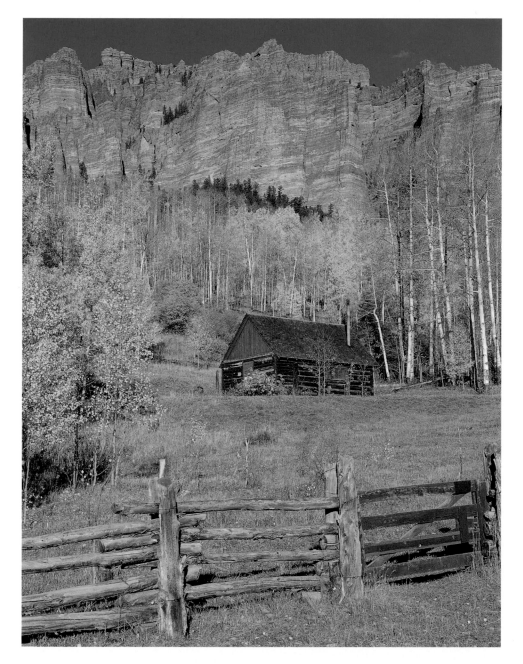

UNCOMPAHGRE NATIONAL FOREST, COLORADO

FRONT LIGHTING

The only evidence that this scene is front-lighted are the shadows behind the fence and gate. Nevertheless, they are projected away from the viewer and, for the most part, cannot be seen. If this scene were side-lighted, the shadows would be long and could be used to make a more interesting composition.

Photographs such as this lack contrast. The only contrast that occurs in front-lighted situations relates to color. In this photograph, the red cabin and barn contrast with complementary greens, and the yellow aspen complement the blue sky.

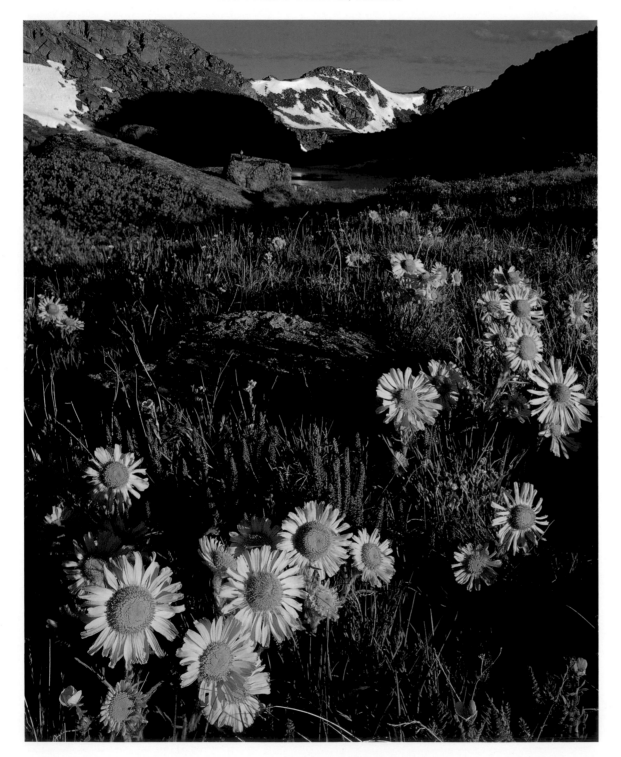

SIDE LIGHTING

Extreme depth of focus, along with the contrast caused by side-lighting, make these alpine sunflowers remarkably conspicuous. The pockets of black shadow allow the vibrant yellow petals to stand starkly against their background, creating the illusion of depth. Shadows in the farthest reaches of the scene add to that impression.

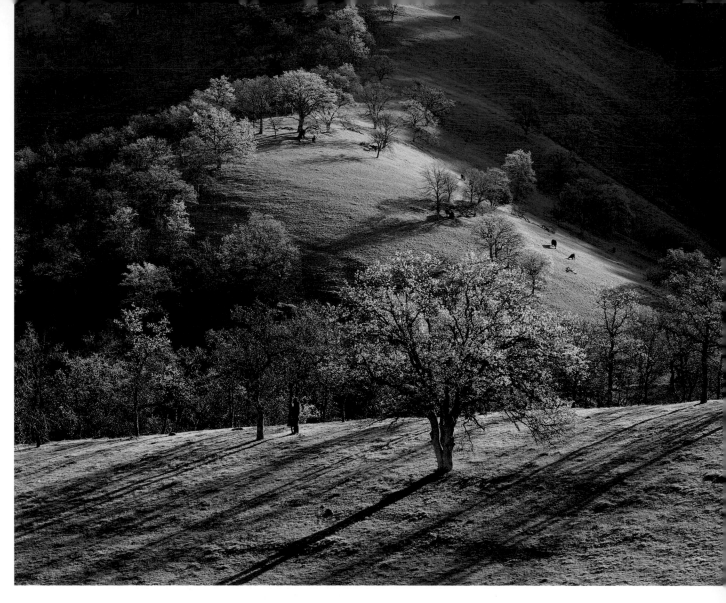

MENDOCINO NATIONAL FOREST, CALIFORNIA

BACK LIGHTING

Though the sun does not point directly toward the camera, this image exemplifies the effects of back lighting. Note the intensity of the greens in the grass and the freshly leafed oak trees, which only occurs when sunlight penetrates translucent matter from behind. Notice also the shadows projected obliquely toward the viewer. Find the cows in this scene and relax with its pastoral qualities.

ELK MOUNTAINS, COLORADO

LENS FLARE

Note the blue and red lens flares to the upper right of the sunstar. Only when the sun is placed in the middle of the scene can lens flares be eliminated.

My wife, three children, and I skied up toward Pearl Pass on a beautiful December day. When you can retreat to a nearby winter ski hut, you can easily negotiate ski trips into the alpine backcountry. Colorado has an abundance of ski huts available for public use, numbering 56 at the time of this writing.

BOUNCE LIGHT

Courageous rafters can leave the raft and negotiate fierce rapids in small inflatable kayaks called "duckies." Ducky use almost always leads to a swim — especially in Cataract Canyon of the Colorado River. Warm bright light bouncing off canyon walls above negated the effect of harsh blue skies reflecting on bright red boats.

CATARACT CANYON, UTAH

THE ESSENTIALS OF NATURE PHOTOGRAPHY

TWO

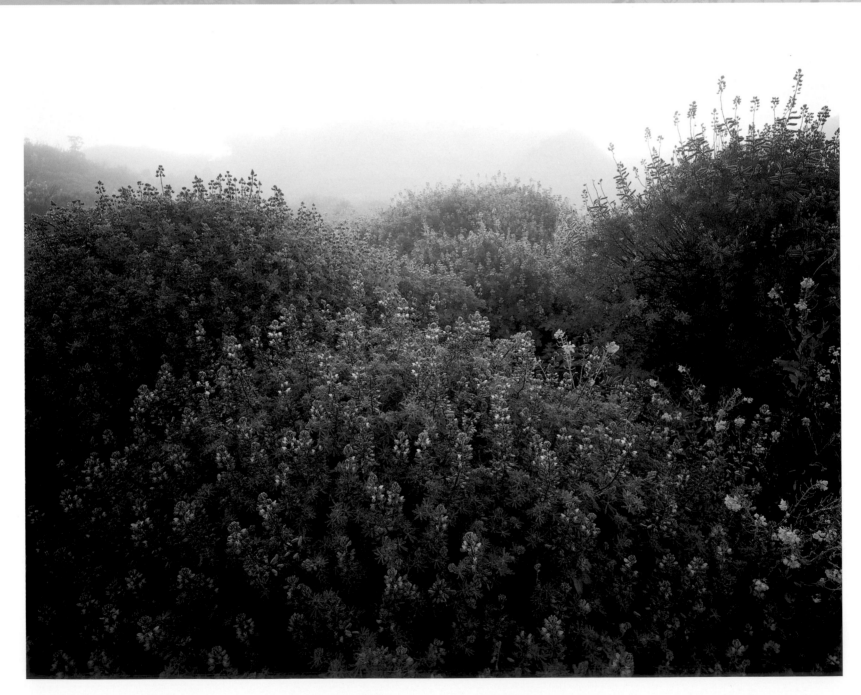

SHELL BEACH, SONOMA COUNTY, CALIFORNIA

Seeing what you ultimately photograph might be 90 percent of excellent photography; however, the remaining 10 percent is awfully important, too. After all, without camera equipment, photographers would not have evidence of nature's finest moments to show to their disbelieving friends. Once they have an adequate camera and understand how to get the most out of it, good nature photographers spend more time training their eye than they do worrying whether or not they have the best equipment.

I have always found that the fewer distractions you have to endure in nature photography, the more you see. Does this mean the less gear you have to worry about, the better off you are? Probably. I own fewer cameras than any professional photographer I know, yet I feel I have enough equipment to do nature justice. Using less gear is especially important if you have to carry your cameras on your back, but you may be surprised to learn that using less gear also helps when you keep everything in the trunk of your car. When you are forced to decide which camera system to use, this extra decision can inhibit your ability to respond to fleeting moments. In Chapter Three, I talk extensively about this topic in the context of maximizing productivity.

Before we delve into the different kinds of cameras you can use, let's begin by discussing the workings of the camera itself.

A camera is a box that lets light pass through a hole in order to expose film inside. By nature, light scatters, which is why we cannot simply hold a piece of film next to the subject and expect to make a photograph. The lens, which contains the hole, focuses the light and the image on the film. The amount of light entering the camera is controlled in two ways: by the size of the hole and by the length of time light is allowed through the hole.

The hole in a lens is called the *aperture* and is usually a diaphragm made up of overlapping leaves that can be adjusted to change its diameter. The shutter is usually a fabric or metal curtain between the diaphragm and the film plane. When the shutter button on the camera is pushed, the curtain is pulled up momentarily to allow light passing through the aperture to strike the film.

Single lens reflex cameras (SLRs) allow you to look through the lens via a mirror that sends the image up to the viewfinder. Rangefinder cameras let you look only through a secondary viewing device, not through the lens itself.

Lenses come in different sizes and are commonly measured by their focal length and maximum aperture. As focal length increases, so does magnification. The length of lenses is usually measured in millimeters. The barrel of a lens can be twisted to focus, which actually makes the lenses shorter or longer. When using a 50mm lens, as a rule the scene will be in focus at infinity when the diaphragm in the lens (the hole) is 50mm away from the film plane inside the camera. At any other distance, the image will be out of focus.

The diameter of the aperture is measured on a scale of various numbers called *f-stops*. The letter "f" does not correspond directly with the words "focus" or "focal length;" it's merely an arbitrary designation. And the numbers in f-stops are not units of measurement. Rather, they are proportional to the lens focal length. Whole f-stops commonly used are f/1.0, f/1.4, f/2, f/2.8, f/4, f/5.6, f/8, f/11, f/16, f/22, f/32, f/45, and f/64. As the number below the f gets larger, the aperture size gets smaller.

The diameter of the aperture on any given lens when set at f/2 is *always* one-half the focal length of the lens. Or, the diameter of the aperture on any given lens when it is set at f/8 is always one-eighth the focal length of the lens. Therefore, if you set a 24mm lens at f/8, its aperture inside the lens will be 3mm in diameter. Or if the aperture is set at f/8 on a 300mm lens, it will actually be about 37mm wide. However, f/8 lets through the same amount of light on both of these lenses. Why? The longer the lens, the more glass it contains, which makes it more difficult for the light to pass through it. Therefore, aperture diameter must increase along with the increase in focal length in order to let in an equivalent amount of light.

Why have cameras always used the particular f-stop numbers f/1.0 through f/64? From one f-stop number to the next, the amount of light allowed through the diaphragm is exactly one-half or double, depending on which way you look at the scale. Let's examine three consecutive f-stops — f/11, f/16, and f/22. An aperture set at f/16 allows double the amount of light through the lens as does aperture f/22. Conversely, f/16 only allows one-half as much light in as f/11. Most camera lenses allow you to use partial f-stops — usually in halves or thirds.

In photography parlance, a *fast* lens has a larger maximum diameter than a *slow* lens. Therefore, a lens with a maximum aperture of f/1.4 is faster than one of f/2. The phrase, *to stop down,* refers to making the aperture of the lens smaller, usually to increase depth of focus. *Opening up* refers to increasing the size of the aperture.

The second way to control the amount of light entering the camera through the lens is with the shutter, which is usually inside the camera, not the lens. The amount of time that the curtain is retracted can be adjusted; this is called the *shutter speed.* Cameras that are not fully electronic have dials that list shutter speeds ranging from one second or more down to about 1/1,000 second. Each successive speed is either twice as fast, or half as fast, as the next. Partial shutter speeds are only available on fully electronic cameras.

The word *stop* refers to both aperture and shutter speed. As you know, increments of both aperture and shutter speed alter the amount of light entering the camera — either twice as much or half as much. In both cases, these single increment increases and decreases in light are called stops. In my discussion about calculating exposures with the camera, I discuss the benefits of this *reciprocity.*

Most cameras have a light meter built into them. As we learned in Chapter One, one of the properties of light is intensity. Light meters measure the intensity of light at any given moment and decide how much light should be allowed into the camera in order to properly expose the film. Light meters give the photographer the information he or she needs to properly combine aperture and shutter speed settings in order to achieve the desired exposure. With information from the light meter, most cameras automatically set these two controllers of light flow.

Every kind of film — color, black and white, slide, and print — has a different sensitivity to light. Each film type requires a unique exposure of a certain intensity (or amount) of light in order to make the photograph look approximately the way it appeared to the eye. The relative sensitivity of films, or *film speed,* is rated by a numbering system called ASA or ISO (International Standards Organization). Common ISO ratings are 100 and 200, but they range all the way from ISO 25 to more than 1,000. As with shutter speed and aperture size, the ISO numbering scheme is not arbitrary. ISO 100 film is twice as sensitive to light (that is, twice as fast) as ISO 50 film, and ISO 100 film requires one-half as much light as ISO 50 in order to make the same exposure. Conversely, ISO 200 film is one-half as sensitive to light as ISO 400, and it requires twice the light. Film speed is either set manually by dial on the camera or automatically when the camera detects special coding on the film.

With the basics out of the way, let's now explore how the mechanics of the camera allow the nature photographer to make images on film appear the way they do to the eye. We'll focus on two methods: *controlling depth of focus* and *controlling exposure.*

UNDERSTANDING AND CONTROLLING DEPTH OF FOCUS

THE THEORY OF DEPTH OF FOCUS

In Chapter One I discussed the concepts of perspective and depth of focus (also called depth of field) as creative tools that relate to one another. Now let's talk about how depth of focus relates to — and is managed by — the camera. During my discussion, I will highlight three basic rules that together represent the essence of understanding depth of focus.

We learned that the photographer can increase the perspective and sense of depth in a scene by making features in the foreground look bigger than they really are in relation to features in the background by simply moving the camera closer to the foreground. RULE #1: *Depth of focus decreases as the camera is brought closer to objects in the foreground.* As the lens or eye gets closer to those foreground objects, both have difficulty keeping the foreground and background in focus at the same time. Don't forget that our eye is constructed like a camera: It has an aperture (the iris) and a lens, and the image of what we see is focused on the back of the eyeball.

One way to solve the focus problem is to move away from the foreground object; however, this changes the perspective. There is another way to solve the problem, and this method happens to be the most important rule necessary to understanding depth of focus. RULE #2: *The smaller the diameter of the aperture of the lens, the greater the distance in focus from foreground to background.*

Here's a simple exercise you can perform without a camera that proves rule number two: Curl your index finger up next to your thumb to make a small (about 2mm) hole. Place the hole right up next to one eye, and close the other. Sight an object 25 feet away through the hole. It will appear in focus. While keeping the hole next to your eye, hold the index finger of your other hand about four inches in front of the hole, but in a position allowing you to see both finger and background object. While keeping your eye focused on the object in the distance, move your curled-up finger so as to make the hole larger, then smaller. You will see the finger on your other hand come in and out of focus as the hole gets smaller and larger.

There is one more rule about depth of focus that you must remember. RULE #3: *The shorter the focal length of the lens, the greater the depth of focus.* With all three rules in mind, it is easy to understand why a wide-angle 24mm lens set at f/22 would be a better tool for making photographs with great perspective than a 200mm telephoto lens set at f/4.

MANAGING DEPTH OF FOCUS

WITH THE CAMERA

It is quite easy to determine the aperture required to achieve a specific depth of focus for any given focal length of lens. For purposes of this discussion, let's assume you have composed a scene in the viewfinder of your camera with a 50mm standard lens, and let's assume that when you focus on some feature in the foreground, the background appears out of focus. Let's also assume when you then focus on the background, the foreground loses focus. When you focus half-way into the same scene, both foreground and background are out of focus. Given the way grand scenics are composed, your camera will often be very close to some features in the landscape, while others in your view may loom far in the distance. Finally, let's assume for the time being that the aperture ring on the lens (or read-out in the electronic display) is set at the relatively small diameter of f/22, and let's assume this is the smallest available aperture. Let's say the largest available aperture is f/2.

Before I proceed with this example, you should be aware of a fact about your camera. All 35mm SLRs allow you to compose your scene in the viewfinder while the aperture is open to its widest setting, no matter what the f-stop reading says. Even when the f-stop setting is f/22, you will always view the image as it passes through the largest possible aperture of your lens. How is this possible?

Camera makers assume that when you compose a scene through the viewfinder that you want it to be as brightly lighted as possible so you can see all details in your scene from edge to edge. Therefore, cameras are constructed so the aperture setting of the lens is only achieved when the shutter is actually pressed. When you do press the shutter to take the picture, notice how the viewfinder appears black while the mirror inside the camera reflecting the image up into the viewfinder pops up, allowing the image to pass directly to the film. Also during this brief moment, the aperture of the lens changes automatically from f/2 to the setting you actually gave it, f/22, and back to f/2 again.

EXTREME DEPTH OF FOCUS

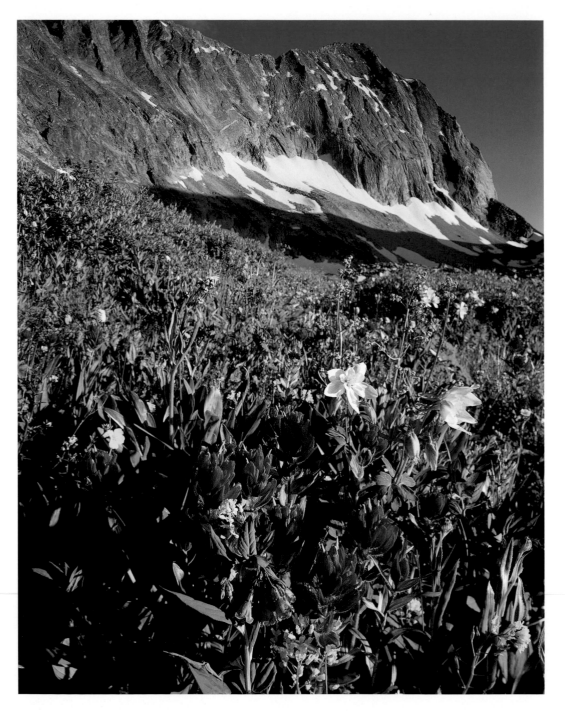

MAROON BELLS-SNOWMASS WILDERNESS, COLORADO

As soon as we arrived at this meadow below Capitol Peak I knew the photography would be productive. After exploring the Maroon Bells-Snowmass Wilderness for three weeks in rainy weather, the skies cleared on this day. This place was best photographed in the morning, which made my scouting the evening before a good investment of time. I predetermined that the peak would receive the light of the rising sun, and side-lighting would create depth with shadows.

Note that the clump of Indian paintbrush wildflowers are as large in the photograph as Capitol Peak itself. Though you may frequently see photographs with this perspective, images never look this way with the camera hand-held — or even on a tripod — at chest level. Extreme depth of focus can only be achieved by placing the camera within a foot or two of foreground features, and this requires getting your body and camera down in the dirt.

BISTI WILDERNESS, NEW MEXICO

AVERAGE DEPTH OF FOCUS

I will never forget rounding a curve in a remote backcountry road and coming upon a line of tractor-trailer rigs parked off to the side. Behind the trucks was a setting much like the one in this photograph, but with director's chairs scattered about and artificial lights on 20-foot-high stands connected to generators. I did not discover people until I rounded the next bend. On the edge of this pristine desert wilderness, 100 production personnel and actors were quickly having a catered dinner so they could resume filming in the warm evening light. I stepped on the gas to find my own location, hoping it would be far away from the Hollywood crowd.

This is the closest thing I've seen to a moonscape on this planet. Cap rock harder than the layer of sediment below it had created "mushroom" formations. If I had gotten down on hands and knees with the camera, as I had done with the flowers below Capitol Peak, I would have lost the complete view of mushrooms from foreground to background. Instead, I composed the scene with the camera at chest level, but as close to the mushrooms as I could get without making the view too narrow. Though extreme depth of focus would have made the foreground mushrooms appear larger in relation to those behind, I created a greater impression of depth with the camera up high.

Not all cameras force you to keep the aperture open to its widest setting when you look through the viewfinder. Advanced 35mm SLRs have what is called a *preview button*. When pushed, this button closes down the aperture from its widest diameter to the actual f-stop set on the lens or in the display — that is, you get to preview the f-stop setting before you actually take the photograph. I'll talk about the practical use of this feature shortly.

Let's continue with our original example. Our scene in the viewfinder cannot simultaneously hold foreground and background in focus. Now we know why. The image of the scene is passing through the widest diameter lens aperture setting of f/2, and we know that as the diameter of the aperture enlarges, the distance in complete focus in the scene — from front to back — decreases. Nevertheless, we have set our aperture at the smallest possible opening of f/22 (on this particular lens), hoping that it will bring our image into focus. (For the time being, let's not worry about what shutter speed we will be using.) Now let's maximize our depth of focus.

The Hyperfocal Distance Chart

The beauty of depth of focus theory is that we do not have to guess what aperture setting to choose in order to maximize depth of focus. There is a mathematical relationship between the focal length of the lens, the f-stop, and depth of focus. For any given lens, set at any given f-stop, you can calculate exactly what range of distance will be in focus. Expressed another way, for any given lens, for any given distance from foreground to background, you can calculate the necessary f-stop. In order to do this, you must understand one more term, *hyperfocal distance.*

In our example, the way to bring everything into focus is to focus on a feature somewhere between the foreground and the background. This middle ground position, called the *hyperfocal point,* can be calculated mathematically. The distance from your camera lens to the hyperfocal point is called the hyperfocal distance. The formula for calculating hyperfocal distance uses the known focal length of the lens and any f-stop available on that lens. The hyperfocal distance chart displays hyperfocal distance for any combination of commonly used lenses and f-stops. Notice that the only things the chart does not show are the closest and farthest points in the scene that will be in focus — the most important things we want to know. Don't worry.

The chart assumes that the farthest point in the scene you will want in focus is always infinity (symbolized on the distance scale of your lens barrel by a sideways figure eight). This makes perfect sense, since most grand scenic compositions include the farthest mountain, cloud, or tree that the eye can see, as well as those wildflowers closer to the camera. The distance from the camera to the closest point in the scene that will be in focus is determined merely by dividing the hyperfocal distance by two. Therefore, if hyperfocal distance is five feet on the chart, everything in the scene from two and one-half feet up to infinity will be acceptably focused. Note that within the parameters of the depth of a scene, hyperfocal distance is always much closer to foreground than background. Remember, too, that hyperfocal distances as a function of f-stop and lens focal length apply to all camera formats.

My favorite lens on a 35mm camera for composing grand scenics is a 24mm f/2.8. Through years of use, and by understanding hyperfocal distance, I know that at its smallest aperture, f/22, I can focus at just under four feet and have everything from about two feet to infinity in focus. By knowing hyperfocal distance for each fixed focal length lens I use, or for certain focal lengths commonly used on my zoom lenses, it's easy to compose a scene and know which features will be in

HYPERFOCAL DISTANCE CHART FOR 35mm FORMAT

Distances are expressed in feet and represent the point at which the camera is focused. At any given f-stop and lens focal length, everything in the viewfinder from as close as one-half of hyperfocal distance to infinity will be in sharp focus.

LENS	F/11	F/16	F/22	F/32
16mm	2.9	2.1	1.5	1.0
18mm	3.7	2.6	1.9	1.3
20mm	4.6	3.2	2.3	1.6
24mm	6.6	4.7	3.3	2.3
28mm	9.0	6.3	4.5	3.2
35mm	14	10	7	5
50mm	28	20	14	10
85mm	82	58	41	29

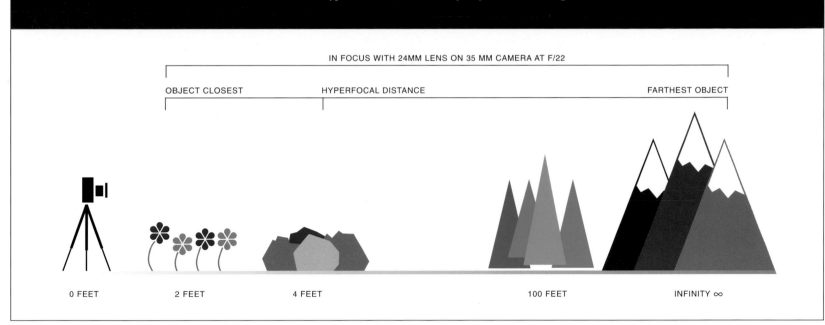

MAXIMIZING DEPTH OF FOCUS

This illustration shows that hyperfocal distance is actually very close to the foreground of a scene.

IN FOCUS WITH 24MM LENS ON 35 MM CAMERA AT F/22

OBJECT CLOSEST HYPERFOCAL DISTANCE FARTHEST OBJECT

0 FEET 2 FEET 4 FEET 100 FEET INFINITY ∞

focus. With the 24mm lens, or with my 20mm–35mm wide-angle zoom at the 24mm mark, any object I measure to be about two feet away can be the foreground in my composition. All I have to do is focus on any object about four feet away (that is, double the two feet) in order to guarantee total scene focus at f/22. If you are not comfortable with guessing short distances, step them off with your feet or bring along a lightweight tape measure.

You can also use two other methods to ensure that everything in a given view will appear in focus in the photograph. Consider them only as backup methods to using the chart, for they tend to be more difficult to employ and are less accurate in the field.

The Depth of Focus Preview Button

You can override the default setting of the aperture at its maximum diameter whenever you look through the camera viewfinder. Some advanced 35mm SLRs have a preview button that allows you to see what the scene looks like in the viewfinder when the aperture is set at less than its widest opening. And it's not a pretty sight. As the aperture decreases in size, the amount of light reaching the viewfinder decreases. A scene in the

viewfinder at f/22 is so dark that it is very difficult to see the features you've composed. You must concentrate for several moments while allowing the iris of your eye to open and accommodate the low light level.

Despite the reduction of light, "stopping down" the aperture still performs a minor miracle. As you hold down the preview button and rotate the aperture ring on your lens from wide open to fully stopped down and back again, you can see the foreground and background of your scene come in and out of focus. You witness the physics of depth of focus control right before your eyes, just like we did with our finger exercise. When you experiment with this feature, intentionally compose a scene that makes just one of either foreground or background far out of focus. For example, the visual contrast of a background in total focus against a blurry foreground will heighten the effect of bringing foreground into focus as you rotate the aperture ring. Holding down the preview button and rotating through the full range of aperture settings helps you examine different locations between foreground and background to ensure the whole scene ends up in focus in the photograph, independent of the depth of focus chart. Nevertheless, the chart can serve as a great point of comparison.

8 FEET AWAY

6 FEET AWAY

4 FEET AWAY

2 FEET AWAY

GETTING CLOSER TO THE SUBJECT

To illustrate how distance from the camera to the foreground subject affects perspective, I moved a 35mm camera with a 24mm lens closer to the sign between exposures. Notice how the sign appears larger in relation to the size of the hills in the background when the camera is positioned closer, yet the hills remain the same size.

View cameras require that you focus on a piece of etched glass rather than through a viewfinder. With a dark cloth over my head, I can eliminate most glare, allowing a wonderful, bright view of the image to appear on the glass. When I want to maximize depth of focus, I rotate the aperture control ring on the lens at the same time I focus the scene. By performing both tasks simultaneously, I can see clearly on the big glass what moves in and out of focus. I can even hold a special magnifying glass, called a loupe, up to the glass in order to finely focus the scene. This also helps me make sure the remote corners and edges of the scene are sharp as a tack.

Lens Barrel Depth of Focus Scale

Relatively few 35mm photographers still use fixed focal length lenses, as opposed to the ever-popular "zooms." If you still do, or if you use zoomless medium-format gear, you may have noticed the unusual multi-colored scale next to the distance scale on the lens. This scale contains two of every f-stop, each in a different color. This is the depth of focus scale and, just like the hyperfocal chart, it can determine not only hyperfocal distance, but how close and how far away features can lay in a scene without appearing out of focus — for any given f-stop.

If, for example, you compose a scene that contains mountains in the distance and flowers in the foreground and you want everything to be in focus and you don't care what your shutter speed is because your camera is on a tripod, go ahead and shoot the scene at f/22. The depth of focus scale will tell you where to focus. By rotating the focus ring on the lens to the point where one "22" is directly opposite the infinity mark on the distance scale, you can determine hyperfocal distance. Without twisting the ring again, note that the other "22" on the depth of focus scale is now opposite a closer point on the distance scale. If this happens to be 10 feet (this scale is usually expressed in both feet and meters — make sure you are looking at the right one), then you know that your foreground can be no closer than 10 feet if you want the entire scene to be in focus. Now look at the little diamond next to the distance scale that signifies the point at which the camera is focused. This is the hyperfocal distance, and from what we learned about the hyperfocal chart, we know that if the closest object can be no less than 10 feet away, then hyperfocal distance must be 20 feet. That's what the diamond will point to.

f/2.8

f/5.6

THE SAME PHOTOGRAPH MADE WITH FOUR DIFFERENT F-STOPS

To illustrate how aperture size affects depth of focus, I placed a 35mm camera two feet from the sign and focused the 24mm lens on infinity. I made the same exposure for each of the four stops. Each increment was equivalent to two f-stops. Notice how the clarity of the words in the bottom of the sign is different in each example.

f/11

f/22

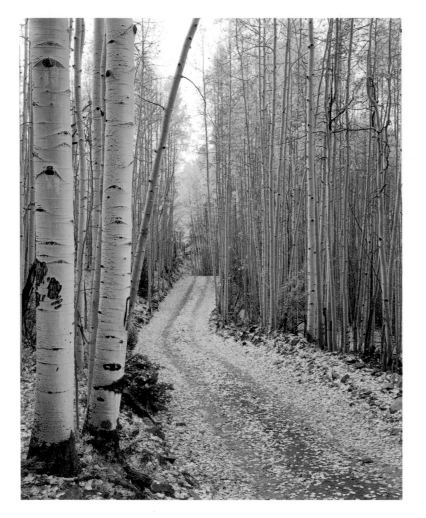

UNCOMPAHGRE NATIONAL FOREST, COLORADO

LENS BARREL DEPTH OF FOCUS SCALE

The scene will be in focus for distances in between the same two f-stops on the scale. Hyperfocal distance is indicated by the diamond-shaped focus mark on the scale.

SIDE TO SIDE DEPTH OF FOCUS

Though most compositions that have depth tend to lead the viewer's eye from bottom to top in photographs with a vertical orientation, they can also take the eye from side to side. Driving along Last Dollar Road near Telluride, I watched for just the right combination of trees to use as side foreground. When I found them, I employed the same rules of depth of focus that I would have used in a scene with a vertical orientation. Note how the trees not only create depth, but so does the road by leading the viewer's eye through the grove.

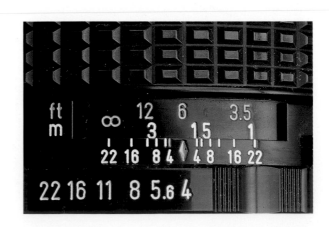

DEPTH OF FOCUS: AUTOMATIC AND

ELECTRONIC PROGRAMMABLE CAMERAS

Today's fully electronic 35mm SLRs are marvelous devices. Loaded with computer chips and sophisticated sensing systems, they do everything from automatically focus the scene to calculate myriad exposure possibilities. They even allow you to reprogram the functions of their various buttons. Most allow you to choose different "program modes" that are biased toward one type of photography or another.

Commonly provided modes accommodate landscape, action, and portrait photography. Landscape mode assumes you want relatively broad depth of focus and a slower shutter speed, whereas action mode assumes the opposite (less depth of focus and a faster shutter speed). Programmable cameras also allow you to choose *aperture-* or *shutter speed-priority* modes; you set the aperture or shutter speed, and the camera calculates the other automatically. Non-programmable *automatic* cameras do not always provide the choice of both aperture- and shutter speed-priority modes. For landscape photography, use automatic cameras that have an aperture-priority metering system.

When perspective and depth of focus are high priorities, most 35mm format landscape photographers immediately put the camera into aperture-priority mode, stop down to f/22, and calculate hyperfocal distance. Good landscape photographers always work on a tripod, thereby eliminating the need to worry about shutter speeds. More often than not, especially in the relatively dark conditions of morning and evening light, a small aperture will require a shutter speed too slow to hand-hold the camera. The only other thing you must worry about is wind. If you want flowers blowing in the breeze to appear still in the photograph, you have to quicken the shutter speed.

Even though they are biased to set small apertures, landscape program modes do not always automatically stop down the lens as far as possible. They are programmed to worry about the hand-holdability of the camera at slower shutter speeds, as well as depth of focus. For purposes of maximizing depth of focus, learn to work with either manual modes or aperture-priority mode. Also, be aware that some programmable cameras can even calculate hyperfocal distance for you. If I point my Canon EOS camera separately at the closest and farthest objects in a scene, it will calculate actual distance to them, stop down to the required f-stop, and refocus automatically at the hyperfocal distance. Programmable cameras may or may not include depth of focus preview buttons.

DEPTH OF FOCUS: TILT LENSES

AND LARGE FORMAT CAMERAS

Camera format refers to the size of the exposure made on the film. I happen to use three formats of camera — 35mm (1-1/2" x 1"), medium (2-1/4" x 2-3/4"), and large (4" x 5" view camera). With the ability to tilt the lens, the 4 x 5 provides the most opportunity to control depth of focus and perspective. However, some 35mm and medium-format camera manufacturers make tilt and shift lenses that possess some of the capabilities of the 4 x 5.

On wide-angle lenses, which are used more than any other to maximize depth of focus, the smallest aperture in 35mm format is typically f/22, in medium-format f/45, and in large-format f/64. By nature, the smaller the aperture, the greater the depth of field; therefore, one would think that view camera lenses potentially provide more depth of focus than those used in smaller formats. This would be true if it were not for the fact that at any given aperture, as focal length increases, depth of focus decreases. In addition, as the camera format increases in size, longer focal lengths are required to provide the equivalent magnification and angle of view as smaller format lenses (see Lens Angle of View chart on page 53). Therefore, the advantage of having very small apertures on larger format cameras is nullified by the longer focal lengths required.

For example, I can accommodate my favorite angle of view, around 73 degrees, with a 24mm lens on a 35mm camera, a 45mm lens on the medium-format camera, and a 75mm lens on the 4 x 5 view camera. I see approximately the same amount of landscape with all three setups. To achieve the same depth of focus, however, I must stop down the 35mm to f/22, the medium-format to f/45, and the view camera to f/64. So what is the advantage of the 4 x 5, at least with regard to depth of focus?

With the 4 x 5 I can also influence depth of focus by "tilting" any lens mounted on the view camera body away from the viewing and film plane. Because the front standard, to which lenses are attached, contains a horizontal central axis, I am able to tilt the lens forward or backward. A vertical axis also allows me to "swing" the lens to the left or right. In both cases, the very middle of the lens stays approximately stationary because tilting and swinging occur around that point.

When a lens is tilted forward, objects in the foreground of a scene can be brought into focus simultaneously with objects in the background, depending on the amount of tilt. Here is what happens: As the lens is tilted, its vertical plane becomes closer to parallel with the approximately horizontal plane of the landscape. What originally might have been about a 90-degree angle formed by lens and land could now be as little as 60 degrees. By simultaneously focusing and tilting, you can increase depth of focus substantially. However, there is one catch to this method: If you draw an imaginary straight line

between the closest and farthest objects now in focus in your scene, only the objects, or parts of objects that touch the plane along that straight line will be in focus. Everything above or below that line, or plane, will not be in perfect focus.

This process is completely independent of the depth of focus achieved by making the aperture smaller. Nevertheless, with a view camera you can stop down the lens to a small aperture in order to bring everything into focus that wasn't made sharp by tilting. These combined actions of the view camera are unique in photography. With certain lenses, when I focus on flowers only six inches from the front of my lens, mountains a mile away can be brought into focus as well. This technique is called extreme depth of focus, and I talk more about it in Chapter Three.

You can choose from a number of tilting lenses for both 35mm and medium-format systems, so you do not necessarily have to invest in large-format equipment to take advantage of this feature. However, large-format cameras provide opportunities other than perspective control, which I discuss later in this chapter.

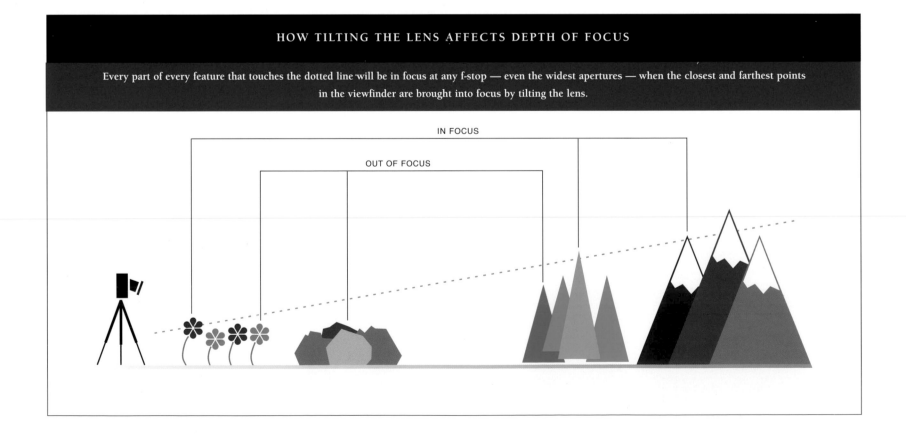

HOW TILTING THE LENS AFFECTS DEPTH OF FOCUS

Every part of every feature that touches the dotted line will be in focus at any f-stop — even the widest apertures — when the closest and farthest points in the viewfinder are brought into focus by tilting the lens.

IN FOCUS

OUT OF FOCUS

DEPTH OF FOCUS WITH THE VIEW CAMERA

Large-format view cameras allow you to control depth of focus with the plane of the lens, as well as the size of the aperture. When the lens is tilted forward, depth of focus is increased, but only along a line drawn between the closest and farthest features in the scene.

In this photograph, I tilted the lens forward to the degree necessary to focus on both the white sandstone below my feet and the red sandstone in the distance. However, at my widest aperture — f/6.8 on this wide-angle 115mm lens — the features in the valley were completely out of focus because they are below the imaginary line drawn from foreground to background. Nevertheless, I was able to bring them into focus by stopping my aperture down to f/45. This combination of aperture adjustment and lens tilt can produce perspectives not possible with other cameras.

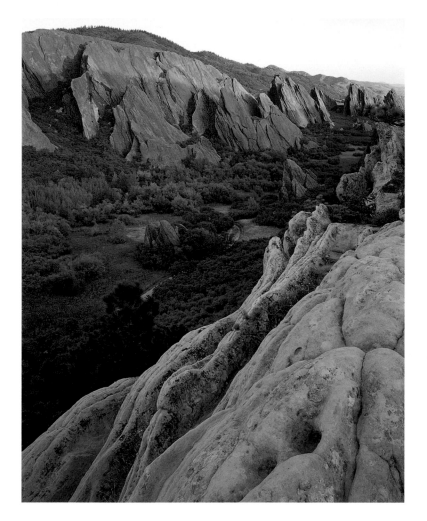

SUNRISE, ROXBOROUGH STATE PARK, COLORADO

VIEW CAMERA LENS TILTED FORWARD TO INCREASE DEPTH OF FOCUS

UNDERSTANDING AND CONTROLLING EXPOSURE

THE THEORY OF EXPOSURE

With today's sophisticated, computer chip-laden programmable cameras, making good exposures is easier than ever. Most cameras can make a good photograph in all but the most extreme lighting situations by simply letting the light meter do its job automatically. Nevertheless, the creative photographer can step beyond automation and make unique compositions the camera would never allow by itself.

A light meter measures the intensity of light. There are two basic types of meter: One measures *incidental* light, and the other measures *reflected* light. Incident-light meters, which are always hand-held, measure ambient light intensity in front of a subject. Reflected-light meters, which measure light that bounces off of the subject, can be hand-held or built into the camera. Most 35mm cameras, both point-and-shoot and SLR, have a built-in reflected-light meter.

I mentioned in my discussion of color that all colors reflect light at different intensities. Ambient daylight is incidental light that has only one intensity at any moment at any given location. However, the intensity of reflected light is determined by the source of the light, as well as the color of the feature it bounces off. Reflected-light meters don't recognize colors, only the intensity of light.

In photography, we usually measure the intensity of light in increments of stops and their common fractions — one-half or one-third. Indirect light reflecting from white features in the landscape under a cloudy sky will be recognized by a reflected-light meter as approximately two stops more intense than light bouncing off green, red, or blue features. Similarly, light from black objects will be two stops less intense than the light reflected from green, red, or blue. Therefore, white objects reflect light four stops more intensely than black ones. Direct light from the sun can cause glare, which may extend the potential range of contrast from four stops to six or seven.

Every color has a different density that is easiest to understand in the form of a scale of gray tones with black and white on its ends. All colors have an equivalent gray tone for purposes of measuring reflectivity. Red, blue, and green each have about the same density, and they occupy the same middle position on the gray scale at 18 percent of the density of black. In fact, 18 percent gray is the baseline for the way light meters measure light intensity. *All light meters are programmed to make any color from which a reflected-light reading is taken, even black or white, appear on film as if it were a medium density 18 percent gray color.*

For example, if you were to aim your camera at an area of white snow, your light meter would say to itself, "I don't perceive color, but I do know that whatever this substance and color is, it is reflecting light two stops more intensely than medium-toned colors in the landscape. This suggests to me that any viewer of this scene will probably not be able to see all the detail within it because it is overexposed by two stops. Therefore, I will underexpose the scene by two stops to preserve this detail."

This light meter has been programmed to recognize that 18 percent gray reflects light two stops more intensely than black and two stops less intensely than white. It has also been programmed to realize, just like we do, that you tend to see less detail and texture in light and dark objects than you do in medium-toned features. It is programmed to make dark scenes lighter and light scenes darker so they appear as an 18 percent gray-colored scene would in the same conditions of light.

However, reflectivity values are only accurate in indirect light. Unpolarized direct sunlight will cause glare, and glare makes all colors seem lighter than they really are. What is deep green in the tree leaf under cloud-cover today might be light green in direct light tomorrow. The lighter the color, the greater the chance for glare, and glare can misrepresent reflectivity by a full stop or more. White snow in sunlight throws a meter reading off to a greater degree than green grass in sunlight. Meters are fooled by glare, and they want to underexpose more than you want them to.

What does reflectivity mean in practice to the photographer? Simply, your light meter is programmed to do what it wants to, not necessarily what you want it to do. In a scene that contains an even mixture of light and dark colors, the meter will recognize the sum of the density of all colors, all places, in the scene to be about 18 percent gray. The light meter can be trusted to expose this kind of scene properly. It's an 18 percent gray scene already and doesn't need to be made any lighter or darker.

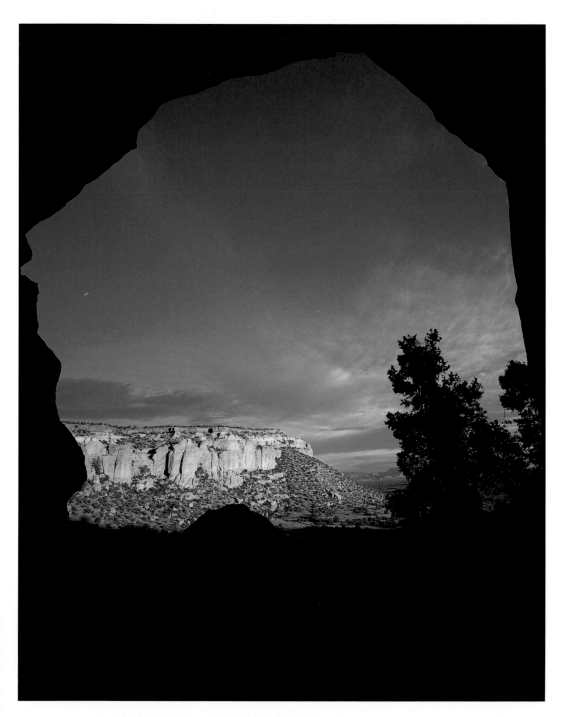

SUNRISE, LA VENTANA ARCH, NEW MEXICO

WHEN HIGH CONTRAST IS AN ASSET

This 60-foot-high arch has eroded away from the adjacent sandstone cliff. To make this photograph, I scrambled under the arch and positioned the camera slightly behind it. Using my widest angle lens, I positioned the entire arch to frame the landscape beyond.

This image is an example of the highest contrast in nature. I was in deep, early morning shade, and the rest of the scene was receiving bright sunlight one-half hour after sunrise. The contrast in the scene was equivalent to six stops of light intensity. Nevertheless, my eyes could see all detail in the highlighted areas, as well as the color and texture on the back side of the arch. Obviously, the film could not. Since I knew the arch would create a conspicuous black frame, I exposed the film to allow normal color saturation of the bluff in the distance, and I wasn't concerned about losing detail in the arch.

What will the meter do if the scene exhibits a wide range of contrast with an equal amount of extremely dark colors in shadow and very light colors in sunlight and with very little area of medium tone colors? Even in this high-contrast scene, the average of all the values would still be 18 percent gray, and the meter won't try to make it any lighter or darker than it already is. Nevertheless, it is a high-contrast scene, and the viewer may not be able to see much detail in the dark and light areas. This may be acceptable if detail is not important to the composition. As we discussed in Chapter One, some images, such as silhouettes, do not depend upon detail. On the other hand, how do we capture the detail we see with our eyes when the detail is important to the composition? The answer: We override the meter and intentionally underexpose or overexpose.

The creative photographer always considers a light meter reading in relation to what he or she, not the camera, wants the photograph to look like. In the previous example, if you want the viewer to see more texture and detail in the dark, shadowy areas, you would overexposure the photograph in relation to the meter's own intent. Conversely, if you want more detail revealed in the highlighted part of the scene, you would underexpose. Bear in mind that color films perceive less contrast than any other kind of film, and color film perceives contrast four times less than the eye. Detailed features in a high-contrast scene your eye perceives may not have detail in the photograph. Black and white processes accommodate at least twice as much contrast as color. Conceived by Ansel Adams, the Zone System recognizes 10 different reflectivity values (tones of gray including black and white) equal to one stop each. Therefore, 10 total stops are recognized by black and white negative film compared to four stops in color transparency film, and as much as five stops in color negative film.

By far, high-contrast scenes are the most challenging to photograph. I talk about meeting this challenge later.

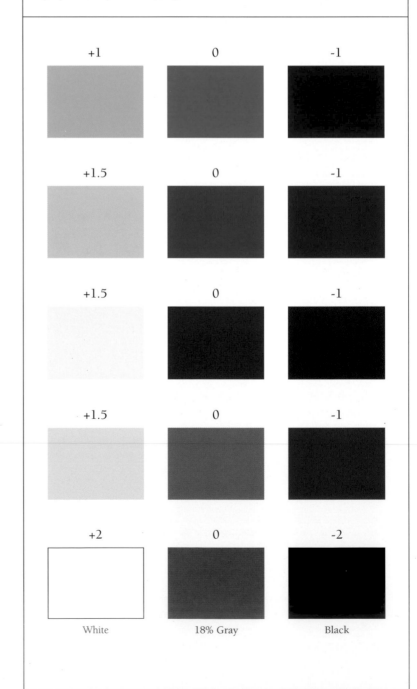

THE REFLECTIVITY OF COLORS

Each color in nature reflects light back to the camera in different intensities. Eighteen percent gray is the benchmark reflectivity upon which all light meters are based, and for purposes of this illustration it is designated zero. The reflectivity of colors that reflect light more intensely than 18 percent gray is expressed in fractions of stops of light preceded by a plus (+) sign. The reflectivity of colors that reflect light less intensely than 18 percent gray is expressed in fractions of stops of light preceded by a minus (-) sign.

+1	0	-1
+1.5	0	-1
+1.5	0	-1
+1.5	0	-1
+2	0	-2
White	18% Gray	Black

Hand-held Incident-Light Meters

Most nature photographers do not use incident-light meters. The measurement of ambient light is the best way to learn the average intensity of light in one's immediate environment; however, this might not provide enough information to make the photograph. In some field situations the photographer may be standing in direct sunlight, even though most of the scene to be photographed is in shadow far away from his or her location. With an attachment, many incident-light meters also can measure reflected light. Ambient light readings provide a good baseline from which to work, but they can just as well be obtained with reflected-light meters and a gray card by a method I discuss later.

Built-In Reflected-Light Meters

Most landscape photographers use reflected-light meters, either built into their cameras or hand-held. Those built into the camera work with the aperture and shutter, the only two camera mechanisms that control the flow of light into the camera. The meter reading of light intensity is used to calculate aperture and shutter speed. Completely manual SLR cameras require the photographer to set both aperture and shutter speed. The light meter connects with both aperture ring and shutter speed dial, and they achieve correct exposure by matching a "needle" to a mark, or by matching graphics in programmable cameras. Automatic cameras are different from manual cameras in that they will automatically set either shutter speed or aperture once the photographer has set the other (aperture-priority or shutter-priority).

Averaging, Center-weighted, and Matrix Metering

Certain compositions may contain areas of extremely different light intensities. Light meters are designed to calculate disparate values throughout the scene. In TTL (*through the lens*) meters, light enters the lens of the camera and is reflected by the mirror up into the prism of the viewfinder where separate solar cells measure light intensity from different parts of the scene. The meter calculates an *average* reading from what could be a scene divided into two parts or 20. Metering might also be unevenly *weighted* toward one place or another, such as the center of the scene, where important subject matter often lies. Sophisticated matrix metering considers many places in the viewfinder and employs several biasing formulas.

Spot Metering

Many built-in light meters have two or three metering modes, one of which is usually spot metering. The small circle located in the middle of most viewing screens is the area of light measured. This circle remains the same fixed size in the viewfinder, without regard to lens focal length. Therefore, as the focal length of the lens increases, angle of view in the circle decreases. Depending on the lens, the spot can represent as little as one degree or as much as 10 degrees of view.

Hand-held Spot Meters

With regard to nature photography, if you do not use a camera that contains a light meter, or if you simply desire more control of your exposure calculations, you would most likely want to use a hand-held spot meter. Spot meters are made with either analog or digital components, and most of them provide one degree of view measurements of light intensity. Digital spot meters are usually smaller and easier to operate than analog, but they are more expensive.

As with a camera, the photographer sees part of the scene through the viewfinder in the meter, but light is only measured within a small, centrally positioned circle. Hand-held spot meters measure intensity of light on a linear scale. The EV scale is a progression of numbers, zero to 20, representing one-stop increments of light measurement. When the trigger is pulled, the meter displays the numerical EV reading, usually in whole and one-third stop increments. A zero reading means the meter cannot perceive any light, and 20 indicates too much light for making a photograph.

After setting ISO for your film with one of the meter's two rotating rings, the photographer twists the other ring to the EV meter reading. This aligns all potential f-stops with their reciprocal shutter speeds for that reading. In a quick view, you are able to see a shutter speed for each f-stop available on your lens, each combination of which allows the same amount of light to enter the camera. Depending on the effect aperture and shutter speed will have on the composition, you can choose the best combination for the scene.

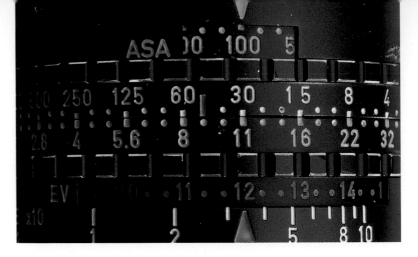

DIGITAL SPOT METER, EV SCALE

DIGITAL SPOT METER, GRAY CARD,
AND LOUPE

MEASURING LIGHT IN

LANDSCAPE PHOTOGRAPHY

We already know that most nature photographers use reflected-light metering systems, either built-in or hand-held. Let's discuss the practical use of meters in order to achieve proper exposure, as well as to manipulate the view.

Measuring Light with Non-spot, Built-in Metering

Most averaging and matrix metering systems are remarkable devices that guarantee a good exposure in evenly lighted situations, such as scenes under overcast skies. These metering systems also do their best in directly lighted, high-contrast scenes. Even though the film, by nature, may not be able to accommodate high contrast in some circumstances, the light meter will do its part.

When a meter encounters an image with significant areas of both highlight and shadow, its averaging capabilities calculate the proportions of each and find a median point at which to expose. For example, if one half of the scene is very dark and the other half is very light, the meter will find the midpoint exposure between the two. If one third of the image is

dark and two thirds light, the meter will bias the reading toward underexposure to accommodate the larger amount of bright area. In other words, averaging and matrix meters do their best to bring out the detail in both highlighted areas and shadow areas in relation to the ratio between the two. By doing this, meters always provide an excellent starting point to expose a photograph that you see with your "mind's eye" ("mind's eye" is a phrase coined by Ansel Adams to describe the imagination of the creative photographer).

Measuring Light with Spot Meters

We know that every color reflects light at a different intensity. Using averaging meters rarely isolates any one particular color in the scene, unless the composition is a microcosm. Therefore, it is difficult for color to bias a meter reading. This is not necessarily true in the case of spot metering.

A one-degree spot meter might be pointed at a part of the scene significantly different in color or light intensity than the rest of the scene. If this portion of the landscape is especially dark or bright, your meter reading may be inconsistent with the vast majority of the scene. For example, when you know that the color yellow reflects light one and a half stops more intensely than blue, and when you know that light in the shade could be four to seven stops less bright than directly lighted areas, you will take several spot-meter readings within a scene that includes these colors and conditions. Sometimes I may take as many as half a dozen different readings within one view. The photographer must average them together in his or her head in order to

get the same reading that an averaging meter would produce. Practice and linear EV numbers makes this process easy.

Spot meters are especially useful when the light intensity where you are standing is different from the place far in the distance that you intend to photograph with a long lens. They enable you to read values of color and light intensity in places that you might never be able to get to on foot. However, even if your metering system does not have a spot metering mode, if your subject matter is within reach, you can still meter on spots. Just walk into your scene before you shoot, hold your camera close to any 18 percent gray color illuminated by the average intensity of your scene, and take a meter reading. Go back to the place from which you want to shoot and make the exposure according to the reading you just took, not the one your meter now demands.

I commonly use my spot meter in two different ways — and by a third method with a gray card. First, in order to determine the full range of contrast in a scene, I meter the brightest and darkest areas. This range tells me if there is a probability of losing detail in highlighted and shadow areas, based on the four-stop limit of the film, in which case I may not want to make the photograph at all. Secondly, I try to find a color in the landscape I know from experience to have the reflectivity of 18 percent gray. Such a color will give me a point of comparison to other readings I may take.

Measuring Light with a Gray Card

With a hand-held spot meter and a gray card, the photographer can provide a point of reference for all other reflected-light readings. Using an 18 percent gray card and spot meter duplicates readings obtained by an incident-light meter; both measure ambient light where you stand. Gray cards are usually just that — stiff card stock printed on one side in a non-reflective 18 percent gray ink. They come as sheets that can be cut to any practical size, which for me is about three inches square (small enough to stuff in a pocket). Here's how you use it.

First point the spot meter in the direction the camera faces. Holding the gray card in your right hand, position it directly in front of you so it faces at a 45-degree angle to the left (the gray side will be pointing just past your left shoulder), then take a reading on the card with the spot meter. Repeat this exercise with the card facing right. Average the two readings together (remember that your readings are in the form of EV numbers, not f-stops or shutter speeds). With this average EV number, you can find the appropriate aperture and shutter speed combination on the meter. When you photograph at sunrise and sunset in side lighting, one gray card reading catches sunlight, the other does not. Be aware that an old card can become polished and cause glare, which will affect the accuracy of the reading. You can also buy special gray cards with a textured surface that prevents glare.

For the serious photographer, a gray card offers another way to double-check the meter's impression of the intensity of light reflected by the landscape. When I cannot find an 18 percent gray color in the landscape from which to meter, the gray card saves the day. It may take a while to feel comfortable using a gray card, but with practice it will ultimately save time when you compose and shoot.

METERING A GRAY CARD

BRACKETING

Bracketing is simply the act of making different exposures of the same scene, which is a great way to increase the chances of making excellent photographs.

Even professional photographers can't be sure which exposure will make a scene appear the way they want. The higher the contrast, the more difficult it is. Only practice will teach you how much detail will be lost in directly lighted areas and shadows within the same image. To make certain that I bring home the best exposure possible of that moment, I bracket in increments of either one-third or one-half stop. Most cameras allow you to expose halfway between whole f-stops, or even one-third of the way — and sometimes in between shutter speeds. Most programmable cameras allow multiple bracketing strategies.

Camera lenses that rely on manual aperture rings usually have a dedicated "click-stop" at each marked full f-stop. Nevertheless, the ring can be left somewhere in between f-stops, which still allows the aperture to be opened up and closed down in partial stops. Most non-programmable cameras have shutter speed dials that only allow bracketing at full click-stop speeds. Medium-format cameras are designed that same way — they only provide bracketing in less than full stop increments with the aperture ring. View camera lenses provide smooth, continuous movement of the aperture ring, with no click-stops and plenty of space between whole stop marks for making minute changes. Most even have markings at one-third stop increments. View camera shutters are on the lens, not the camera, and only work at full stop speeds.

Some 35mm cameras have an exposure "compensation" dial that contains a plus range of f-stop fractions that signifies overexposure and a minus range that represents underexposure. Usually divided in one-half stop increments, these settings let you automatically overexpose or underexpose the correct meter reading in order to compensate for an unusual situation. For example, you may be shooting an entire roll of film while skiing. You know that snow is very reflective, and you decide to set the camera for automatic one-stop overexposure to compensate for the meter's propensity to darken the scene. Programmable

cameras even have an auto-bracketing mode where you can tell it to automatically bracket the next two exposures around one reading.

When I bracket an image, I typically make the first photograph at my "average" meter reading, or my gray card reading. Then I bracket over and under that reading in whatever stop increments I think are needed to make significantly different exposures. The increment may be one-half, one-third, or even one full stop in extreme contrast scenes. I may make five different exposures of the same scene: right on, over and under one-half, and over and under one full stop. In the end, I may have spent more money than planned, but if the scene is at all photographable, I know I will have made at least one acceptable photograph.

In evenly lighted situations, I often bracket in one-third stop increments. If I bracket three exposures, all three will usually be acceptable. Then I can pick my favorite based on what are usually very subtle factors, and I still have two more good ones to add to my files. I frequently discover that some delicate zone of lighting within the scene is better in one bracket than another.

PRACTICAL LIMITS TO

UNDEREXPOSURE AND OVEREXPOSURE

We learned earlier that the relative reflectivity of colors spans the equivalent of four stops from black to white. In practice, when glare is factored in, the range in light intensity within one scene can be as much as six or seven stops. (At night with a full moon in a black sky, the reflected light from the landscape can rate zero on the EV scale while the moon might read 18. That's 18 stops of contrast.) Slide (transparency) film has a difficult time maintaining detail simultaneously in shadows and directly lighted areas when contrast is greater than four stops. Color print film is a little better.

Experience in the field is the only thing that will ultimately allow you to predict the photographable range of contrast when you don't want to lose detail. Nevertheless, you can use the following five rules of thumb in relation to 18 percent gray colors:

1. Any feature two stops underexposed, in relation to the correct meter reading, will appear almost black on film — no detail.
2. Any feature two stops overexposed will appear very faded — no detail.
3. Any feature one stop underexposed will be significantly darker than how the eye sees it, and detail or texture will be difficult to see.
4. Any feature one stop overexposed will be significantly lighter than how the eye sees it, and detail or texture will be faded.
5. Features one-half stop underexposed or overexposed will appear darker or lighter than how the eye sees them, but detail and texture will be clearly visible.

In my discussion of composition, I mentioned that completely dark or light areas in a scene can contribute to the success of a photograph under the right circumstances. It is also true that parts of a scene with a small amount of detail may also be acceptable. For the most part, overly dark or light features or regions in a scene can be very distracting to the eye, and their use must be considered carefully.

These exposure rules of thumb can be useful when you want to predict what portion of the scene you have composed will have plenty of detail, very little, or none at all. Spot meters can determine such conditions, and in higher contrast situations, it is critical to take several readings. Knowing these rules also allows you to predict the visual effects of underexposing or overexposing in relation to the light meter's average reading. By remembering bracket settings, and by studying your photographs after development, you can quickly develop a "third" sense for the capabilities of your film in relation to how your eye perceives contrast.

THE EFFECTS OF UNDEREXPOSURE AND OVEREXPOSURE

This comparison shows the effects of underexposure and overexposure when using 50 ISO slide film. The comparison could be slightly different with other films. Photographs in the minus (-) range are underexposed, and those in the plus (+) range are overexposed.

-2.0 STOPS

-1.5 STOPS

-1.0 STOPS

-0.5 STOPS

CORRECT EXPOSURE

+0.5 STOPS

+1.0 STOPS

+1.5 STOPS

+2.0 STOPS

UNDEREXPOSURE TO INCREASE

COLOR SATURATION

Rumor has it that professional nature photographers purposely underexpose about a third of a stop to increase color saturation. True or not, underexposing may not necessarily be advantageous. Today's color films do a good job reproducing most of the color we see in nature. Some films may be underrated or overrated with regard to their speed, or ISO rating. For example, Fujichrome Velvia processes about one-third of a stop more darkly than most other films (I talk about films later). Always "get to know" the films you use, and be prepared to adjust for their quirks. I do not consistently underexpose my photographs. As I mentioned at the beginning of this book, with some exceptions, my personal goal is to make nature look on film the way it does to the eye — no better, no worse. If I feel that a scene needs to be exposed either darker or lighter than any other, it is usually in reference to the way I see the scene with my eyes. When making photographs that I know will be impressionistic (that is, not the way the image appears to the eye), I may very well overexposure or underexposure to increase the effect.

EXPOSURES WHEN SHOOTING

INTO THE SUN

Earlier we talked about composing images with the sun facing into the camera. This can make it difficult to determine the proper exposure. Sun shining directly into any meter can overload it and make a reasonable exposure calculation impossible. The EV scale of the spot meter will often read the maximum of "20," at which the settings would cause complete underexposure.

Instead of metering on the view with the sun, walk into your scene and take meter readings on its features and colors while avoiding the direct sunlight. Or find a way to "put" the sun temporarily behind an object, such as a tree, by shifting your location slightly left or right. In both cases, move back to the place from which you want to shoot, and make the exposure you first calculated, not the one your camera now indicates. Most programmable cameras allow you to save meter readings with the push of a button. Unless you intend to make silhouettes of your subjects with underexposure, sunless meter readings are a good place from which to begin bracketing.

When shooting into the sun, even when not intending to include it in the composition, beware of hexagonal lens flares. Block the sun's rays by holding your free hand over the lens while composing and making the exposure. But don't photograph fingers!

EXPOSING FOR REFLECTIONS

I don't think there is anything as beautiful as a reflection of nature in water. You can make reflection photographs anywhere water stands still — in tidal pools on the coast, after thundershowers in the desert, and especially near mountain lakes and ponds. Let's discuss a few rules associated with making the best images of reflections.

Reflections appear most sharp when the water is still and when sunlight does not shine directly onto the reflecting surface. But slightly moving water also makes wonderful impressions of the reflected scene. Though I often prefer the reflection to be as sharp as the landscape itself, sometimes this seems boring, so I wait for a gust of wind to disturb still water.

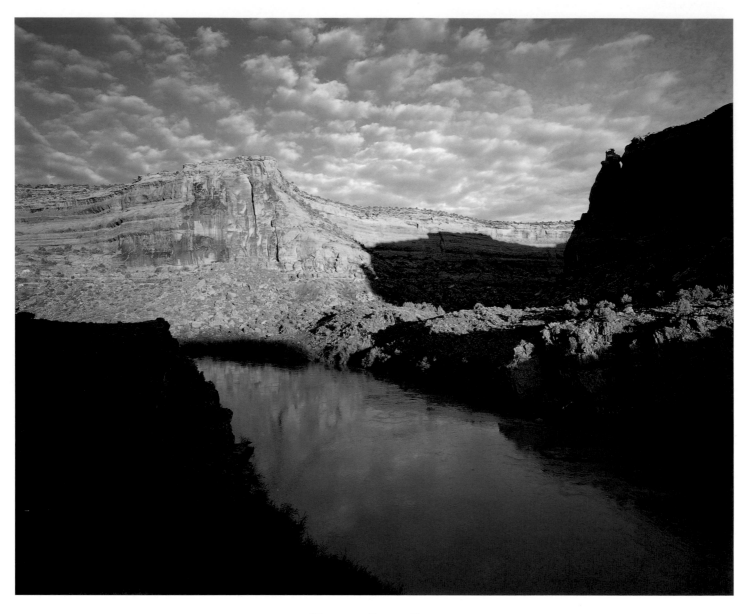

WESTWATER CANYON, UTAH

UNDEREXPOSURE

By nature, film both underexposes and overexposes the landscape in high contrast scenes. The greater reflectivity of light colors in nature, along with glare, can understate colors. Intentional underexposure of the film maintains detail and color saturation, especially in highlighted areas.

While making this image, I worried about two things: the soft "buttermilk" clouds of sunrise would not contrast properly against the subtle blue sky, and the color of the red sandstone cliffs would be too light. Therefore, as part of my normal "bracketing" process, I underexposed the scene slightly. Though this made the shaded areas in the scene darker, I felt they would not be excessively conspicuous.

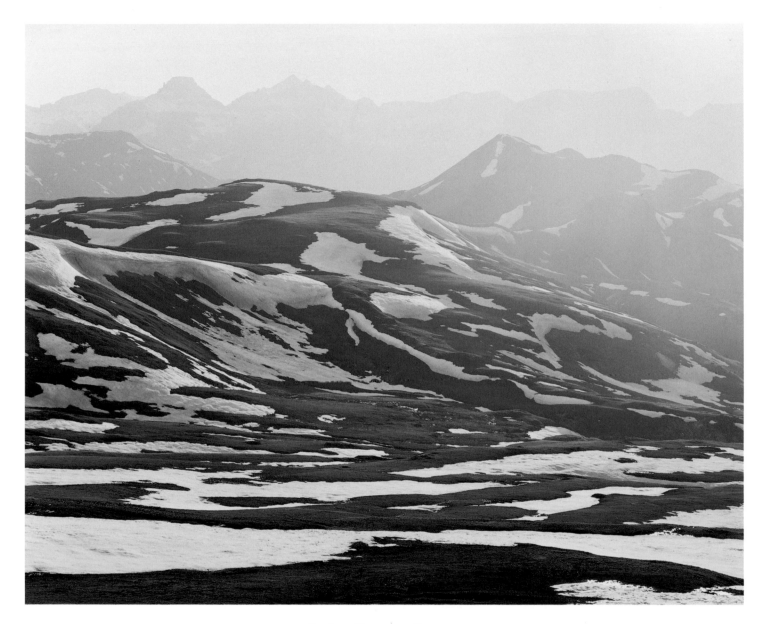

San Juan Mountains, Colorado

SHOOTING INTO THE SUN

From Engineer Pass — one of Colorado's most spectacular old mining roads turned four-wheel-drive recreational road — you command a broad view of the San Juan Mountains. In early July, the contrast between winter's leftover snow and the lush summer tundra is beautiful. Back-lighted by the setting sun, grasses glow, and soft silhouettes of mountain ridges create a great feeling of depth.

Though the sun was high enough in the sky for me to avoid including it in the photograph, it could easily have created lens flares on the film. However, at the moment the image was made, the sun was partially blocked by clouds. This left me in the shade while the scene remained in sunlight, which eliminated the chance of lens flare.

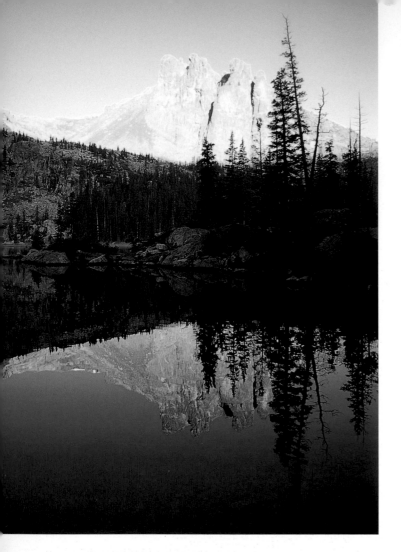

ROCKY MOUNTAIN NATIONAL PARK, COLORADO

EXPOSING FOR REFLECTIONS

This is an unsuccessful photograph and would normally be discarded in the trash. Note the total loss of detail in the mountains. The bottom two-thirds of the scene is exposed properly, but the mountain is too bright (and overall contrast too great) for the capability of the film. At least one full stop of additional underexposure would have been needed to add detail to the mountain, but at the expense of the rest of the scene. The reflection of the mountain, and the part of the landscape in shade, would end up excessively dark. I could have used a graduated neutral density filter to mitigate contrast range, or I could have taken the photograph earlier in the morning.

I usually make reflection images early in the morning and late in the evening. At these times the air and water are relatively still, and the contrast is minimal. The sun is too low in the sky to shine on the water, but it's high enough to highlight the part of the landscape being reflected. Within 10 minutes of the time that sunlight first hits the landscape, when I am still in the shadow of a mountain ridge or coastal bluff, the difference in light intensity between the land and its reflection will be at least one stop, but no more than two. I know this because I can take a spot meter reading on the same feature in both places. Depending on the amount of matter in the atmosphere, this contrast can increase quickly and dramatically as the sun rises higher. When the contrast range reaches four stops, I know I can't hold detail in the reflection and the highlighted part of the landscape at the same time.

To make matters worse, the reflected image in the water is typically much brighter than the landscape around the water, which is in shade. When the surrounding land is important to the composition (perhaps flowers on the edge of the water catch my eye) I avoid underexposure. Total contrast range could be as much as six stops if I wait too long to make the photograph. Graduated neutral density filters, which I discuss later in this chapter, can mitigate this problem.

Your chances of making good reflection photographs are greatest within 30 minutes of sunrise or sunset. Begin making exposures based upon the shaded, ambient light at your location. Such exposures will provide wonderful detail of the reflection and its environs and will capture that ethereal, soft quality I have discussed before by slightly overexposing the portion of the landscape in sunlight. From there, bracket your exposures in partial stop increments up to one full stop of underexposure for the shaded area. If you cannot take spot meter readings, start exposing with your camera's initial reading based upon the entire scene; then bracket up to one full stop of overexposure.

This tranquil morning produced an excellent image of mountains reflecting in Lake Nanita. Though there is a slight loss of detail in the mountains, it is not distracting, and it provides pleasant counterpoint to the shaded parts of the peaks. The sun is low enough in the sky that light intensity does not require the use of a graduated neutral density filter. The actual range of contrast between mountain and its reflection is about three stops.

Two of three sherpas had become ill the night before this particular morning — the last of a week's worth in the park — so my healthy sherpa and I prepared breakfast. Our 14-mile hike back to the trailhead was difficult for the sick men, and progress was very slow.

ROCKY MOUNTAIN NATIONAL PARK, COLORADO

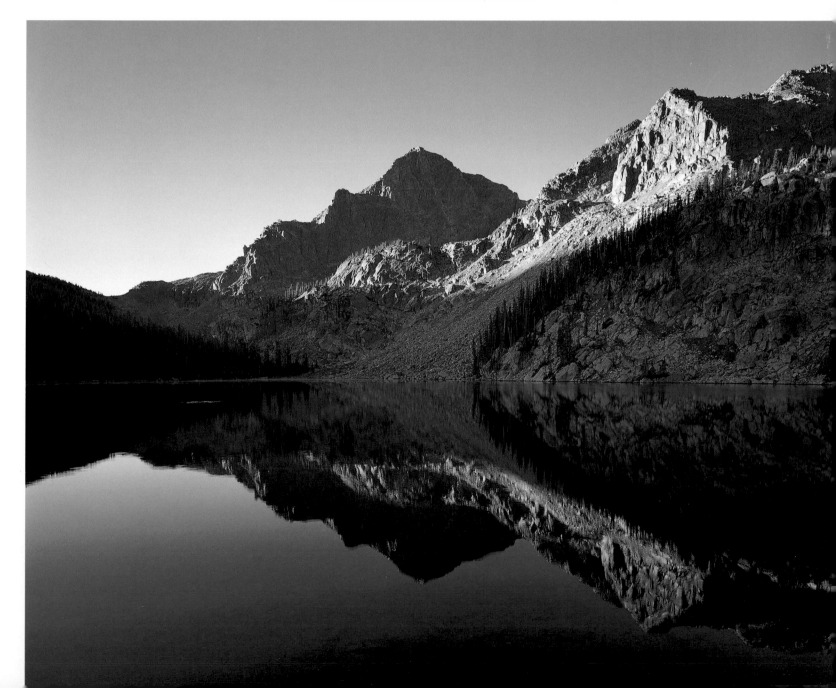

PHOTOGRAPHY EQUIPMENT

This section is not intended to be a handbook of photography equipment. Nor is it a manual for using cameras. Rather, it is a guide to help you understand what kind of equipment will make you a better landscape photographer. Good equipment cannot replace a good pair of eyes. Nevertheless, when your eye and mind are in tune with nature, the appropriate gear (and right amount of it) can improve your photography significantly.

The amount of gear you carry with you should be consistent with your mode of travel. This doesn't mean you should take all the gear you own when you are photographing out of your car. When that magic moment of light occurs, you might easily miss it if you cannot decide which format, camera body, lens, or filter to use. If you do like to use more than one camera system or format, make sure you have predetermined the circumstances under which each will be used.

I happen to use my large-format camera for all serious landscape work, with few exceptions. Even when I cannot predict the length of the moment at hand, and knowing full well that the use of the 35mm camera may increase the chance of making the image before the light disappears, I still use the 4 x 5. I only bring along my medium-format camera on back-country winter ski trips, and I use the 35mm system for everything else (photographs of wildlife and people in nature and close-up photography of flowers). With these decisions made long before I leave on an excursion, I don't have to worry about losing time deciding what to use, and when to use it.

Let's now discuss the different formats of camera systems, categories of equipment, and the parts they play in making excellent landscape photographs.

CAMERAS AND FORMATS

Thanks to high-quality color film, format considerations are less important than ever. The small grain structure in low ISO (slow) color films allows any size format to preserve all of nature's detail. Because this film is so good, a well-made 35mm image can make a 16" x 20" print almost as sharp as one from a 4 x 5 transparency. There are things to think about other than detail when considering what format is appropriate for you.

Large-format Cameras

I believe that the sharpness of detail in a landscape photograph may be the least important of all the ingredients that make an image excellent. If you don't understand color, form, moment, perspective, view, composition, and light, detail won't do you a bit of good. Still, if you can employ most of those things, detail will do nothing but enhance the entire image and the integrity of your subject matter. I hope my discussions in this book have instilled an appreciation for things small and large, obscure and conspicuous. Nature contains much of the small and obscure, and the added detail larger film provides helps us see this diminutive world better. Large-format cameras record detail best.

LINHOF TECHNIKA 4 X 5 FIELD VIEW CAMERA

Large-format cameras are usually view cameras that accept cut sheet film instead of roll film. (However, you can buy special backs that allow you to use larger roll films on view cameras.) View cameras are constructed either as field or mono-rail styles. Field cameras fold into a relatively small size for portability, while mono-rails have a central rail upon which all of the parts are mounted. Mono-rail cameras are more flexible than field cameras, but they are also more unwieldy. Mono-rail view cameras are best used inside studios, and field cameras are best for work outdoors.

View cameras usually accept sheet film formats of 4" x 5" or 8" x 10", but they can accommodate even larger sizes. A 4" x 5" sheet of film has 13 times more square area than

a 35mm frame. Therefore, it's not difficult to understand why reproductions of 4 x 5 film, especially poster-sized, can be dramatically sharper than those of other formats.

View cameras allow much more than larger film size and detail. In my discussion of depth of focus, I talked about the ability to change the plane of the lens in relation to the plane of the film to alter depth of focus. The back of the camera, which contains the focusing glass and the slot for the sheet film holder, can also be manipulated to change its relationship with the plane of the lens. This manipulation affects depth of focus, and you can use it to make parallel lines converge or diverge.

A dark cloth must be placed over the back of the camera in order to prevent light from shining on the focusing glass. Glare obscures the image. And, yes, the image is projected upside down and is flopped from left to right on the glass. All lenses for any format do this, but only the view camera lacks a mirror to put it right. It does not take long to get used to the upside-down perspective when you compose your photographs.

View cameras do not contain light meters, and they are relatively simple in construction. They have either a bed or mono-rail to which front and rear standards attach. The front standard holds the lens, and the rear standard holds the frosted focusing glass. The two are connected by a light-tight, coated

THE ACTUAL SIZE OF DIFFERENT FILM FORMATS

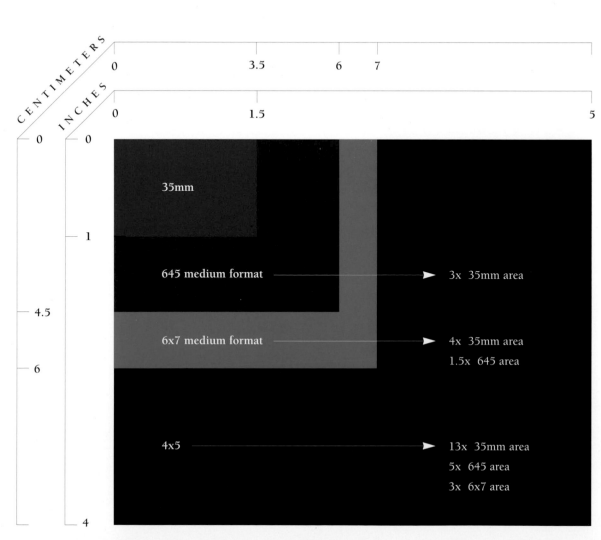

CENTIMETERS

INCHES

0 3.5 6 7

0 1.5 5

35mm

645 medium format ⟶ 3x 35mm area

6x7 medium format ⟶ 4x 35mm area
1.5x 645 area

4x5 ⟶ 13x 35mm area
5x 645 area
3x 6x7 area

bellows (cloth or leather) that can be stretched while focusing as the front standard moves along the bed or mono-rail. Field cameras have a housing into which all of this is folded for protection, and they are made of either wood or metal. Wood construction is more beautiful, especially with brass fittings, but metal is more durable. Wood field cameras will survive photography from the car but not the rigors of wilderness photography.

View camera lenses contain a front and a rear element with a lens board and a shutter that has both diaphragm and shutter speed controls. Their focal lengths must be proportionally longer than the lenses of other formats because the square area of film is greater. For example, in order to equal the angle of view of a 50mm lens on a 35mm camera, the view camera would need at least a 150mm lens. As a result, view camera lenses must be "racked out" so far for focusing that wind can blow against the bellows and vibrate the camera. View camera telephoto lenses are constructed so the actual distance that the lens must be racked away from the film plane is less than the focal length of the lens. For example, I have a 500mm lens that allows objects at infinity to be focused by racking out to only 360mm. This permits less bellows extension and, as a result, less wind disturbance. Lenses have f-stops ranging from f/4.5 to f/90 (at which point resolution begins to degrade), and shutter speeds are usually limited to 1/500 second. Since you can't hold a view camera in your hand while you shoot, you have to mount it on a tripod. Also, you have to control the shutter with a cable attachment. With no built-in meter, hand-held meters are mandatory for the view camera photographer.

Cut sheet film holders hold two sheets at a time — one on each of two sides. You remove plastic or metal slides from the holder to allow the film to be exposed. In the field, film holders are usually reloaded inside light-tight dark bags that keep light out while you work with your arms and hands.

The weight of the system, the expense of the film and its processing, and the perspective controls all combine to make large-format equipment very unwieldy. On the other hand, no other format can reproduce the landscape on film as well. Popular brands include bodies made by Linhof, Wista, Toyo, and Horseman, and lenses made by Symmar, Rodenstock, and Nikkor.

PENTAX 6x7 MEDIUM FORMAT SINGLE LENS REFLEX CAMERA

Medium-format Cameras

For the most part, medium-format SLR cameras are just overgrown 35mm cameras. They often contain built-in TTL light meters, and you can hold them in your hand when you make exposures. Viewfinders either require looking through an eyepiece or waist-level shaded screen.

Medium-format cameras typically use 120 size roll film (or the 220 version which has twice the length and number of frames). This film is 60 millimeters (2-1/4 inches) wide, and depending on the model of camera, it will make 10 to 15 frames of the following lengths: 45mm, 60mm, or 70mm. For example, a Hasselblad brand camera only makes images 2-1/4 inches square, where Pentax medium-format cameras make images 45mm x 60mm or 60mm x 70mm. I happen to prefer the latter format because it is proportional in length and width to that of the 4 x 5 view camera format. I am able to compose with the same relative dimensions in both systems. The medium-format (2-1/4" x 2-3/4") contains a little less than one-third the square area of a 4" x 5" sheet of film and about four times the square area of a 35mm frame.

Small format systems typically use 35mm film, the frames of which measure 35mm by 25mm, or 1-3/8 x 15/16 inches. This proportion of length to width makes a longer rectangle than that of any other format. Therefore, when shifting from 35mm to any other formats, you are usually forced to change your compositional mindset. Most photographers have a loyalty to a certain format, be it square or rectangle, or proportion of rectangle. As you consider stepping up in format,

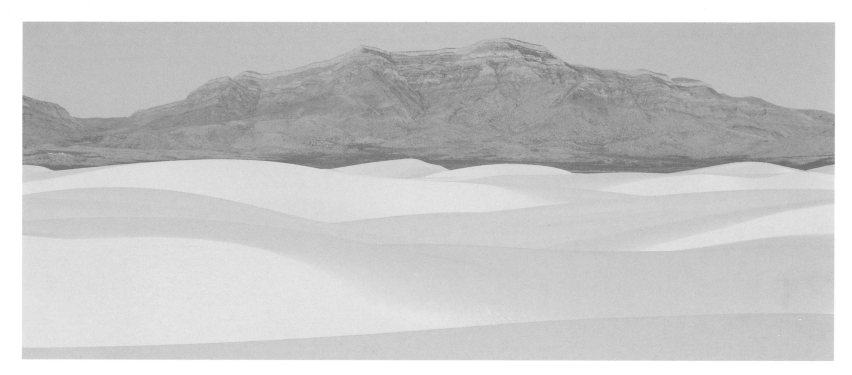

PANORAMIC LANDSCAPE

This photograph is slightly overexposed (note the complete loss of detail in the highlighted areas of the dunes), and the element of color is not a contributing factor to the success of the image. Nevertheless, the photograph is interesting because of the element of form, the panoramic format, and the layered composition.

you may want to retain boundary proportions similar to those you've always used.

As with view cameras, medium-format cameras require longer lenses than those used with 35mm format in order to provide similar angles of view. For example, a 50mm lens on a 35mm camera has the same angle of view as a 100mm lens on a 60mm by 70mm medium-format camera. Zoom lenses are not commonly available for medium-format cameras.

Medium-format cameras are best for the landscape photographer who wants more detail than he or she gets with the 35mm. Yet, without the perspective control afforded by front and rear standards, medium-format is no substitute for large-format. Common brands for medium-format systems include Pentax, Mamiya, and Hasselblad.

Panoramic Cameras

Cameras that make panoramic images of the landscape are more popular than ever. Typically they use 120 roll film and produce a frame about 6-1/2" x 2-1/4", and they require wide-angle lenses. Panoramic cameras usually provide a rangefinder, not SLR, design.

35mm Cameras

The most popular small format is 35mm. With fine-grained, low ISO films, 35mm SLR cameras can make outstanding images of nature. Size, weight, electronic and programmable features, auto-focus, built-in modal metering, built-in flash, a multitude of compatible lenses, and endless accessories make 35mm the first choice for most nature photographers. The task of deciding what camera brand to use, much less which model and features, can be daunting. Let's discuss only the features that are important to the landscape photographer.

From auto-bracketing to being able to change the function of buttons, programmable cameras have a myriad of options and features, none of which will affect the quality of the patiently planned and composed landscape photograph as much as the few I'm about to mention.

Focus Control — Auto-focussing cameras are terrific for action and general interest photography. Even though in some ways they can focus better than you, this mechanism is not perfect. Sometimes the lens does not know where to focus in a scene that may contain features at various distances. The problem worsens as focal length increases and magnification compresses more distance.

Fortunately, most auto-focussing cameras and lenses have a manual mode. The landscape photographer is usually concerned with depth of focus and must be able to manually focus at the hyperfocal distance.

Exposure Control — Whether your camera is automatic or programmable, make sure it allows you to control your own exposure, regardless of what the light meter says you should do. Fully manual cameras require manual exposure control, and most automatic cameras provide a manual mode. In manual mode, you have the ability to determine an average meter reading, and you can depart from this reading by setting both aperture and shutter speed to accommodate your creative needs. Some older cameras don't have a manual mode. Use cameras that employ an aperture-preferred metering system, and use it instead of a shutter-preferred system so you can control f-stop settings.

Exposure compensation allows you to overexpose or underexpose each frame differently. This feature is controlled either by an additional dial on your camera, or it is a programmable feature of your fully electronic camera.

Depth of Focus Control — You must have the capability to maximize depth of focus for all types of composition. Consider the following three camera features: the depth of focus preview button, lens focal length, and type of lens.

If you can afford it, use a camera with a preview button. As I discussed before, it allows you to see what's in focus at any aperture on your lens. And remember, the shorter the focal length of the lens, the greater the potential depth of field. Wide-angle lenses are best. Finally, fixed focal length lenses with the depth of focus scale on the lens barrel make maximizing depth of focus easy. And with the hyperfocal distance chart in hand, zoom lenses work just as well.

PENTAX K-1000 35MM SINGLE LENS REFLEX CAMERA

Mirror Lock-up — When you press the shutter button, the mirror that reflects the image up into the viewfinder must flip up momentarily for the light to reach the film. Though most mirrors have a dampening system to prevent vibration, at slower shutter speeds the image on film can be blurred by this action. A mirror lock-up feature allows you to put the mirror up before you press the shutter, and keep it there until after the exposure is made.

The large mirrors on medium-format cameras can sometimes vibrate so much it can blur the image. Thankfully, most have the lock-up feature. As the focal length of the lens increases in any format, so does its weight distribution and resulting balance on the tripod. Because of this balance problem, and the fact that angle of view decreases as focal length increases, you need to use mirror lock-up with longer lenses at shutter speeds slower than 1/15th second.

Remote Shutter Release — Most landscape photographs are made with small apertures and relatively long shutter speeds. The tripod and cable release are as important as the camera itself. With both programmable and non-programmable cameras, always use a cable release to take the picture. If you don't have one, or don't want to invest in the electronic variety for programmable cameras, use the timed delay mechanism that all cameras offer. In fact, on my 35mm camera, that's all I use. I set it on the two-second delay option, which saves time over the usual 10-second delay but gives the camera enough time to stop shaking after I press the shutter release button.

LENSES

Lenses are usually categorized by focal length. Focal length is defined as the distance from lens to film and focal plane when focussed at infinity. On 35mm format cameras, fish-eye lenses range from about 8mm to 18mm, wide-angle lenses from 20mm to 35mm, normal or standard lenses from 50mm to 55mm, medium telephoto lenses from 85mm to 135mm, and long telephoto lenses from 200mm to 1,000mm in focal length.

The three primary considerations when choosing which lenses to use or buy are quality, speed, and angle of view. Let's discuss each of these before talking about lenses in relation to the different formats.

Lens Quality

Though the untrained eye may not notice it, the construction of a lens of any format, and the anti-glare and anti-flare coatings that are painted on its surface, can affect color, contrast, and sharpness in your photographs. Camera lenses contain multiple glass lens elements, all of which must work together to create a sharp image on film. For this reason, I tend to trust only the most highly rated brands, which unfortunately tend to be the most expensive. Nevertheless, where the price of one lens may be double another, the difference in image quality may be only 10 percent. Only you can decide the value of that 10 percent.

Lens Speed

Every lens has a maximum diaphragm width signified by an f-stop referred to as the speed of the lens. An f/2 rated lens is faster than an f/4 rated lens. Lens speed is important only in relation to the maximum amount of light you want available through the aperture. For landscape photographers using a tripod, lens speed is not particularly important. On a tripod you can shoot at a slow shutter speed — even 10 seconds — and not have to worry about camera shake. Furthermore, landscape photography usually demands greater depth of focus and smaller apertures. Lens speed is important only when hand-holding the camera.

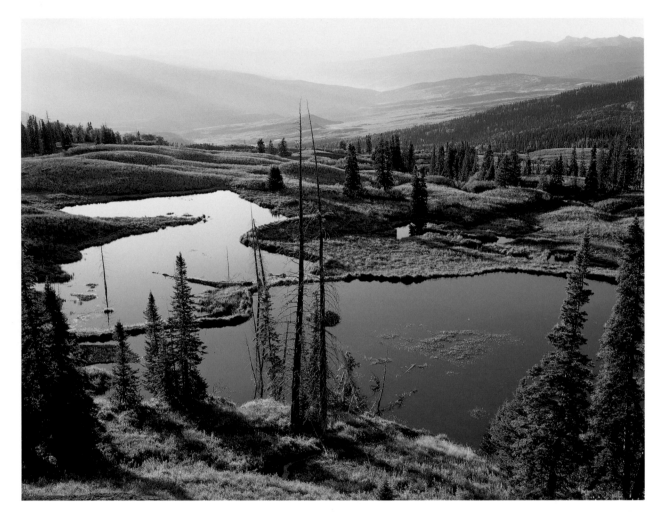

BEAVER PONDS, COLORADO

The discovery of beaver ponds is always a welcome happenstance. They not only provide great fodder for photographs, but their brook trout are a wonderful reprieve from ramen noodles.

These ponds are some of the largest I have visited, and I found them in a place I would not have expected them to be. The country is relatively dry and without the canopy of trees that usually accompany the wetlands where beavers make their ponds. Note how this image contains each of the five photographic elements: complementary colors, form (pond edges, hills, and ridges), moment, perspective (created by the ponds themselves), and a grand scenic view.

Fast lenses need larger diameters of construction and wider elements of glass to allow the extra light to enter. In addition, the longer the lens, the more difficult it is for light to get through the elements. Therefore, the longer and faster the lens, the bigger and heavier it will be. Those 600mm lenses you see on the monopods at football games have apertures of f/4 or better. Their barrels may be six inches or more in diameter and weigh several times more than a 600mm lens with a maximum aperture of f/5.6. Within lenses of the same focal length, there is usually a choice of maximum f-stops. In general, as the f-number gets smaller, the lens gets larger and more expensive. This should affect your decision about what lenses to carry on photography excursions.

Lens Angle of View

Every focal length of lens has a particular angle of view. We see about 180 degrees of view with our eyes. Lenses might see all of that with a fish-eye lens, or as little as a few degrees with extreme telephoto lenses. Most photographers become comfortable with certain specific angles of view, even as they move from format to format. In 35mm photography, zoom lenses eliminate the need for loyalty to particular angles of view.

While learning photography, I settled into the following 35mm format lens family: a 24mm wide-angle, 50mm standard, and 100mm and 200mm telephoto lenses. The spacing in between each of these focal lengths was about double or one-half of the angle of view of the next lens. This congruity increased the chances that for any given composition, I would have the right lens to cover the view that I wanted to see on film, without having to physically move into or away from the scene. No matter which format of camera system I use, I tend to be most comfortable with those same angles of view.

Lenses for 35mm Format

The two greatest developments in lenses in the past few years have been the evolution of auto-focussing capabilities for 35mm SLRs and increased zoom lens quality. I don't recommend auto-focussing for serious, tripod-based landscape photography, but I do think that zoom lenses can make a nature photographer more productive.

I have a couple of zoom lenses in my 35mm system that I believe are every bit as sharp and colorful as my older fixed focal length lenses. High-quality zoom lenses provide not only the sharpness, but the color and contrast of high-quality fixed focal length lenses. But these finer zoom lenses are generally more expensive.

Zoom lenses give nature photographers much more compositional latitude than they will find with a collection of

80MM-200MM F/2.8 CANON L-SERIES TELEPHOTO ZOOM LENS FOR 35MM

200MM F/4 PENTAX 67 TELEPHOTO LENS FOR MEDIUM FORMAT

fixed focal length lenses. With a 20mm–35mm wide-angle zoom, a 50mm standard lens, and an 80mm–200mm telephoto zoom, three lenses can provide me all the angles of view I will ever need in the field. And I can carry the entire system in a waist-style pack.

Lenses for Medium-format

A 100mm medium-format lens provides the same view as a 50mm lens on a 35mm format camera. Because medium-format lenses must cover a larger film format, they tend to be about twice the size of a 35mm format lens of the same focal length and three or four times larger than a 35mm format lens with the same angle of view. Most medium-format lenses have fixed

focal lengths, and they tend to be slower than 35mm lenses. Maximum apertures are usually a stop less than their equivalent 35mm format lens. Common lens focal lengths begin around 35mm and range up to 600mm. The bulk and speed of medium-format gear will affect how much you take on a photography excursion — or whether to use medium-format equipment at all.

Macro Lenses

Macro lenses provide an easy way to photograph close-ups (that is, microcosms). Without them, you'll need unwieldy extension tubes, rails, and bellows. In any event, this gear does the same thing: It allows you to place the camera within an inch from your subject matter.

Remember: every lens has a specific focal length (the distance the diaphragm in the lens must be from the film plane in order for the lens to be in focus at infinity). If a lens can in some way be moved farther than its rated focal length from the film plane, then the farther away it is moved, the closer it can be brought to subject matter. For example, if you attach a bellows to a 50mm lens and move it 100mm from the film plane, that lens can be used to make a flower one inch in diameter in real life appear one inch in diameter on the film. This is called 1X (life size) magnification. A 100mm lens extended to 150mm will make that one-inch wide flower appear one-half inch in diameter on the film. This is called 1/2X magnification.

Any lens can be attached to either bellows or extension tubes to perform macro photography. Macro lenses allow the elements in the lens to be extended without having to detach the lens from the camera. Most macro lens are either 50mm or 100mm focal lengths, and they achieve up to either 1/2X or 1X maximum magnification.

You pay a price for close-up capabilities. As magnification increases, depth of focus decreases dramatically. Three-dimensional objects can only be photographed close-up — and in focus — when the lens is stopped down to its smallest aperture. Even then there is no guarantee of complete depth of focus. Additionally, for every doubling of the rated focal length of the lens, two additional stops worth of light are necessary in order to make the proper exposure. For example, a 50mm macro lens in focus at 75mm would require one stop of additional light, and a 100mm macro lens in focus at 200mm would require two

stops more. Of course, TTL meters automatically add the necessary extra light. All others require the mental calculation. Small apertures and extra stops combine to make macro photography very difficult in anything but the brightest of conditions. And breezes blowing flowers can ruin long exposures.

Macro photography with a view camera is easy. You merely employ your bellows to extend the lens past its rated focal length until you have achieved the magnification you desire. Then focus, stop down, and calculate exposure according to the rules.

Lenses for Large-format

View camera lenses employ an altogether different design than lenses of any other format. They contain both shutter and diaphragm — and controls for each — sandwiched between front and rear lens elements. Maximum apertures begin around f/4.5, even on wide-angle lenses, and they tend to get smaller as the lens focal length increases.

You can usually choose different lens speeds of the same focal length. For example, a 90mm wide-angle lens may be available both in a fast f/5.6 version and a slower f/8 version. The former will be a larger lens because it needs bigger elements of glass to accommodate the wider maximum aperture. Despite the extra bulk, I prefer faster view lenses because of their coverage. Coverage is the diameter of the circular image being projected through the lens and out the rear element onto the film plane. As the speed of the lens increases, so too does the diameter of the image circle. This can be important when you employ the tilt capabilities of front or rear standards. Smaller image circles are more likely to vignette the rectangular viewfinder, causing dark, imageless shading in the corners of your scene. I demand tilting flexibility, so I think it's worth the effort required to carry heavier lenses.

As I mentioned earlier, telephoto view lenses demand less bellows extension than the actual focal length of the lens. They are constructed in such a way that you only need to rack out about two-thirds of the rated focal length. A shorter bellows reduces the chance of camera movement in wind. Some telephoto lenses can even be increased in focal length by changing the rear element. I have a 360mm/500mm lens that comes with two rear elements that mate with the same shutter and front element in order to change overall focal length.

500MM F/11 NIKKOR LENS FOR
VIEW CAMERA

2X TELE-CONVERTER FOR
PENTAX 67

Tele-converter Lenses

When you must achieve greater magnification than is provided by your longest telephoto lens, use a tele-converter lens. Common tele-converters increase focal length by factors of 1.4 and 2. For example, a 1.4X converter will change a 200mm into a 280mm lens, and a 2X converter will transform a 300mm into a 600mm lens. Tele-converters are usually much smaller than the lenses they convert, and they don't add a great deal of weight to the lens.

As advantageous as they might seem, using a lens converter is sometimes not as effective as using the longer lens itself. Only the best of tele-converters can maintain overall image quality. In addition, for every 50-percent increase in focal length, one more stop's worth of light is necessary to make the exposure. For example, if you use a 300mm f/5.6 lens with a 2X tele-converter, the new maximum aperture, or lens speed, becomes f/11. The 100-percent increase in focal length requires two additional stops to make the exposure.

People frequently ask me if I use filters. I do, but only to make nature look on film the way it does to the eye. As I've said before, the eye and film see differently. In general, as the amount of glass in front of the lens increases, the quality of the photograph decreases. Lenses are sophisticated, computer-designed devices that work best all by themselves.

Skylight and ultraviolet (UV) blocking filters are very subtle warming filters. In effect, these filters add a little yellow to the landscape in order to make it appear more pleasant. Good film doesn't need warming, and the extra glass compromises the integrity of your lens. Some photographers leave skylight or UV filters permanently on their lens in order to protect it from being scratched. A scratch on a lens does not necessarily affect the image. I regularly use a particular lens that has hideous damage on its surface that does not affect my photographs in any way. No lens could ever achieve the depth of focus necessary to allow the scratch to be visible at the focal plane. Though I try to clean my lenses once a day in the field, I do not worry if they are slightly dirty when I photograph.

Colored filters do not enhance color; they change it. Even strong warming filters, such as the 81 series, are not needed with today's warm films. Some photographers like to make sunsets appear more brilliant than they really are by using red or magenta filters. They can certainly make sunsets more red, but they can also alter other colors in the scene. In our discussion about color, we learned that green is the complement to magenta. Consequently, a magenta filter will absorb — or block — green, which effectively eliminates it on film. Red sunset clouds reflecting their color on a green landscape will cancel much of the green, and a magenta filter might kill it completely. Color filters are most useful in black and white photography. For example, a red filter absorbs blue in a clear sky, which makes the sky appear darker on black and white film.

Because they are one more thing to worry about in the field, filters can restrict your ability to react quickly to changing conditions of light. If you cannot be quick with them, you might lose both the benefit of the filter and the photograph itself. Nevertheless, two filters are particularly useful in color photography: the *polarizer* and the *graduated (split) neutral density filter*.

California's redwood trees are good for photography because they grow where the soft light of coastal weather is perfect. Though direct light makes wood more red, tree shapes more conspicuous, and shadows more elongated, I prefer the mystical moods of the redwood forest. Note the pastel blue-green foliage and subtle rust trunks and how well these colors complement one another. Ironically, understated images of nature are often more arresting than their more ostentatious cousins.

Use of a polarizing filter would have made the greens darker by eliminating glare on the foliage, thereby compromising the scene's pleasant softness.

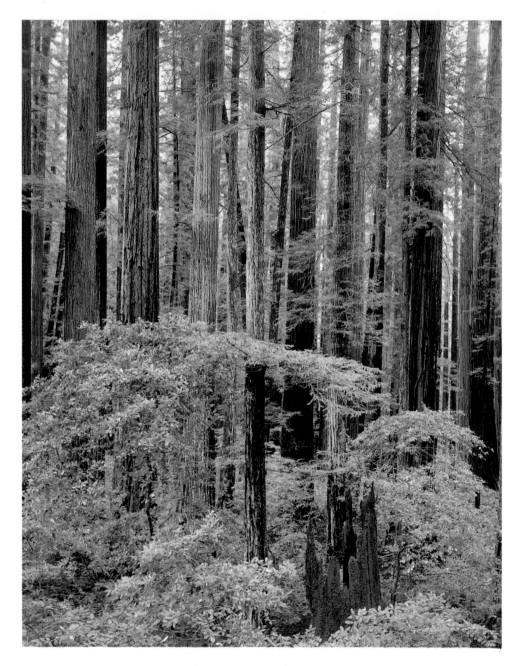

Redwood forest, California

Polarizing Filters

We learned in Chapter One that sunlight is unpolarized light; its waves do not necessarily move in the same direction. When sunlight strikes features in the landscape, it may cause glare. A polarizing filter can polarize unpolarized light and reduce glare, which allows us to see objects in the landscape more clearly. Polarizers are constructed with two pieces of glass, which when rotated in relation to one another, polarize light.

The surface of bodies of water, such as lakes and creeks, create a great deal of glare. Wet foliage tends to be less colorful. Polarizing filters make the color of the rocks below the surface of the lake and the flowers beneath the coating of raindrops both visible and photographable. Still, polarizing filters make blue skies appear darker when the sun is low in the sky. At high altitudes, where ultraviolet radiation and thinner atmosphere already make skies more blue, a polarizer can make the sky blue-black and unattractive.

All filters reduce the amount of light entering the camera — and to different degrees. A polarizing filter, depending on the degree of rotation, will reduce light intensity by up to two stops. A camera with built-in, TTL metering automatically considers this impediment. If you use a hand-held meter, or a rangefinder camera, you must factor in this filter obstruction yourself. Filter exposure factors are printed on the filter's information sheet.

Filter quality varies. Always use polarizers with a neutral gray color that does not affect overall color in the landscape. I have seen many polarizers with a green cast that mutes the warm tones in nature. Lay two different brands of polarizer on a sheet of white paper and you will see a variation in color.

UNPOLARIZED

Note the more saturated colors in the landscape, as well as the unnaturally dark blue sky in the polarized photograph.

POLARIZED

Graduated Neutral Density (ND) Filters

The greatest handicap of film is its limited range of contrast. You can't photograph certain scenes because highlighted areas and shadows contrast too much. However, you may be able to salvage these scenes. The graduated neutral density filter can allow the detail in a scene to appear on film as it does to the eye.

The best of graduated ND filters are rectangular, not round, pieces of glass or plastic with both dark and clear halves. The dark half is coated with a neutral density dye, which can impede light by one, two, or more stops, and graduates into the clear half. By mounting the filter in front of the lens and aligning the dark half over the highlighted area of the scene, the range of contrast is effectively reduced by the number of stops of the coating. Graduated ND filters only work well where you see a reasonably straight division between the highlighted and shadow areas. Distracting blobs of black result when the dark half of the filter covers shadow instead of highlight.

I rarely use more than a one-stop graduated ND filter. Except in scenes of the very highest contrast, I have found that two-stop filters tend to make the bright area too dark and the dark area too bright in relation to how the eye sees each. For example, you can always recognize the inappropriate use of a graduated ND filter in reflection photographs when the mountain appears darker than its reflection in the water. Reflections themselves are typically one to three stops darker than the features they reflect, and it is distracting to see otherwise.

Since graduated ND filters are intended to solve the contrast problem all by themselves, bracketing exposures is not as necessary when you use them. I usually allow the detail and color in the shaded portion of the scene to appear bright by exposing for the dark parts of the scene. If you are metering with the camera, before you compose the scene you must first take a reading of only its portion in the shade. Remember the settings, for this will be your exposure. If you allow the camera with the filter mounted to make its own exposure, the reading will be biased toward underexposure. The camera will average the highlighted and shaded areas of the scene together. When using a hand-held meter, I calculate exposure taking an ambient light — or gray card — reading in the shade. If I have used the correct stop filter, it will reduce the intensity of light reflecting from the highlighted area and allow contrast on film to appear as it does to the eye.

Graduated ND filters require quite a bit of time to use, and it's easy to lose the moment if you are not fast. On the other hand, use this filter when you can't successfully capture the image without it. As with polarizers, beware of neutral density coatings that are not completely neutral in color. Glass filters tend to be more neutral than plastic ones.

I am always dismayed when I see an ad in a magazine or on television that employs a scenic backdrop photograph made with a colored graduated filter. You know the ones: a gaudy magenta sunset sky above a landscape that carries the colors of noon. Since colors in the sky always reflect on the landscape, such scenes quickly appear unreal, unbelievable, and unpalatable. This is no way to depict nature.

GRADUATED NEUTRAL DENSITY FILTER AND HOLDER

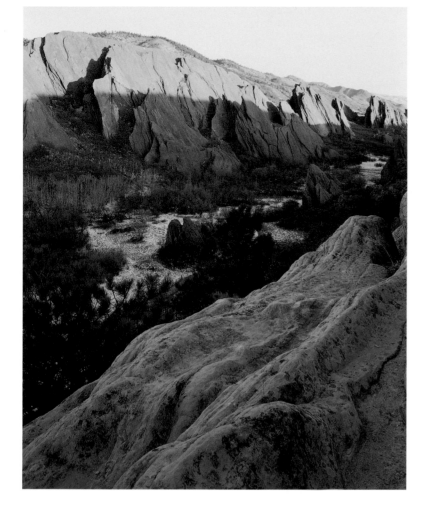

WITH TWO-STOP GRADUATED ND FILTER

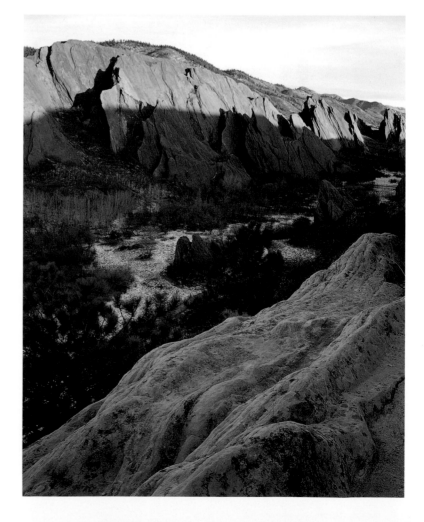

WITHOUT GRADUATED ND FILTER

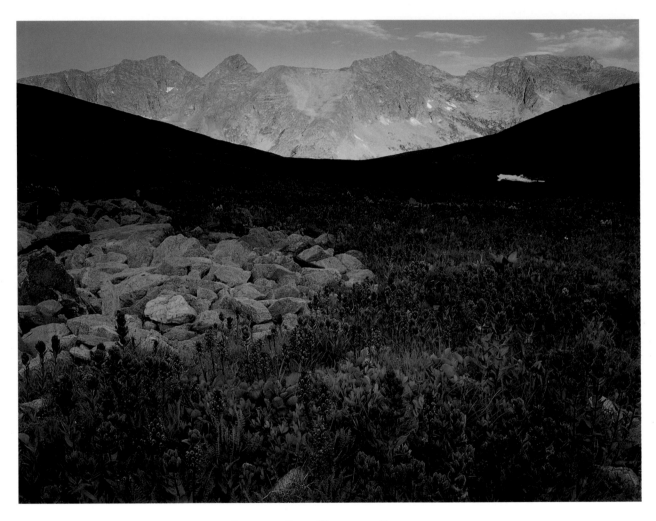

COLLEGIATE PEAKS WILDERNESS, COLORADO

POOR USE OF A GRADUATED ND FILTER

Though the scene itself is eye-catching, it has been ruined by improper use of the graduated neutral density filter. The amount of detail in the foreground wildflowers is approximately equal to that in the mountains in the distance. Despite the fact that the flowers are in shade and the mountains are in direct sun, the two-stop filter has made the photograph appear just as the scene did to my eye. Unfortunately, the division between the highlighted and shaded areas is not a straight one, and the coated portion of the filter has rendered the sloping ridges almost black. These ridges are distracting and compromise the otherwise natural look of the scene.

TRIPODS

You can make good photographs while hand-holding the camera, but you won't achieve excellence. A tripod and cable release of the shutter are as important to the landscape photographer as the shovel is to a ditch digger. Good landscape photographs are usually made in relatively low light, and with small apertures that require longer shutter speeds. My average shutter speed using 50 ISO film is around one-half second. I don't recommend hand-holding cameras at shutter speeds less than 1/60 second.

Tripods come in two styles: light and worthless, heavy and useful. The tripod's job is to keep the camera *completely* still for exposures from 1/30 second up to all night long. Wind, water, and uneven, spongy surfaces demand weight to keep a tripod motionless. Use at least a five-pound tripod with 35mm cameras — medium- and large-format require no less than an eight-pound tripod. The heavier the better.

As with every other piece of equipment, you must be able to use the tripod quickly in changing light. I find that latch-release legs are faster than twist types. Use tripods that allow the legs to be angled as close to 90 degrees from vertical as possible. This capability requires a removable center shaft, and the combination of the two allow the camera to be lowered close to the ground for macro-photography. Avoid tripods with hinged support legs that prevent flattening.

Use tripod heads that allow the camera to move four ways: up and down, forward and backward, side-to-side, and 360-degree panning around the center shaft. Ball heads allow you to quickly position the camera at any angle. However, beware of ball heads that don't clamp tightly enough to stop all camera movement. Most ball heads are not sturdy enough for my large-format camera.

Quick-release mounting plates are handy when you use different camera bodies or can't leave the camera on the tripod. As with ball heads, make sure they clamp tightly and operate quickly.

FLASH, DIFFUSERS, AND REFLECTORS

I do not take any kind of artificial lighting equipment, flashes, diffusers, or reflectors in the field. Serious landscape photography demands speed and agility, and I don't use them frequently enough to justify carrying them along the trail. However, having them in the back of the car isn't a bad idea. It's important to realize that all these items can only affect lighting within a small area, and they tend to be most useful when you shoot microcosms.

I do not like the effect of fill-flash in an outdoor daylight setting. Especially in scenic compositions, where foreground is lighted by flash and background by natural light, the photograph appears contrived and unnatural. Fill-flash in close-up photography can wash out colors because of its proximity to subject matter. I prefer a reflector (a two-foot diameter fold-up foil screen), which when held at an angle will reflect sunlight onto the scene. However, it can cause the same excessive lighting as flash if the photographer does not control light intensity. Of all the light enhancement devices, the diffuser is the most useful in the field. A circular sheet-like screen, it can filter direct sunlight in the same way cloud-cover does, which reduces contrast within small areas. On a clear day with the sun overhead, a diffuser may provide the only means with which to photograph wildflowers close-up.

CAMERA PACKS

I cannot overstate the importance of what you choose for carrying your gear. Though protection alone is important, the ability to extract and replace equipment quickly is of equal value.

I do not recommend using suitcase style camera cases for field work. I use only fanny packs or backpacks that allow me to keep my hands free, whether I am hiking 50 miles or simply changing planes at the airport. (You never know when you will have to fend off beast or solicitor!) My packs are made to carry only cameras, and each of them allows me to unzip the entire front or top of the pack to reveal every piece of gear in

one view. I carry my 35mm system in a large fanny pack, but my medium- and large-format cameras go into backpacks. I can lay each one on the ground, unzip it, and immediately extract whatever I need. I can rotate my fanny pack to the front and work while I stand.

In the old days, you had to cut slots out of sheets of foam in order to accommodate pieces of gear. If you acquired a new piece for which you hadn't allowed space, you had to buy new foam. Now my packs have a myriad of velcro-fastened, padded nylon cloth dividers that allow me to change configuration as often as I want.

For serious backpacking with camera gear, look for pack makers that have experience with harness support systems. My LowePro packs were designed by a cinematographer-mountain climber who knew exactly what was needed for comfort over long hauls. My view camera system weighs 70 pounds, including the tripod. Speaking of tripods, use packs that have a way to attach the tripod, or you will tire quickly of carrying it in your hands. My LowePro packs have a detachable sleeve that holds and protects the tripod.

LOWEPRO PACKS FOR 35MM, LARGE, AND MEDIUM FORMATS

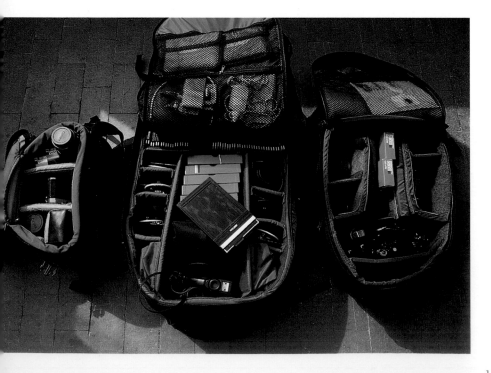

THE CAMERA EQUIPMENT I FREQUENTLY USE

35MM FORMAT	Canon EOS 1N Body
	Canon 20–35mm f/2.8 Zoom Lens, L-Series
	Canon 80–200mm f/2.8 Zoom Lens, L-Series
	Canon 100mm f/2.8 Macro Lens
	Bogen 3010 Series Tripod
	Heliopan Polarizers
	Fujichrome Velvia
	LowePro Orion Fanny Pack
MEDIUM FORMAT	Pentax 6 x 7 Body
	TTL Meter & Hand Grip
	Pentax 45mm f/4 Lens
	Pentax 105mm f/2.4 Lens
	Pentax 200mm f/4 Lens
	Pentax 2x Lens Converter
	Bogen 3020 Series Tripod
	Heliopan Polarizers
	Tiffen Graduated ND 1- and 2-Stop Glass Filters
	Pentax 1 Degree Digital Spot Meter and Gray Cards
	Fujichrome Velvia
	LowePro Trekker Backpack
LARGE FORMAT	Linhof Super Technika V Field Camera
	Nikkor 75mm f/4.5 Lens
	Rodenstock 115mm f/6.8 Lens
	Rodenstock 150mm f/5.6 Lens
	Rodenstock 210mm f/6.8 Lens
	Rodenstock 300mm f/9 Lens
	Nikkor 360mm f/11 Lens
	Nikkor 500mm f/16 Rear Element for the 360mm
	Bogen 3020 Series Tripod
	Heliopan Polarizers
	Tiffen Graduated ND 1- and 2-Stop Glass Filters
	Pentax 1 Degree Digital Spot Meter and Gray Cards
	Fujichrome Velvia
	Fidelity Sheet Film Holders (30)
	Dark Bag
	Various Repair Tools
	LowePro Super Trekker Backpack

MISCELLANEOUS EQUIPMENT

Depending on the duration of your journey away from civilization, always take tools that you might need to service your gear. "All in one" tools for repairs, rubber bands, extra batteries, and of course, duct tape, are must-have items in the field. I talk more about this in Chapter Three.

If you are a view camera photographer and you don't use ready-load film, *dark bags* are mandatory in the field. Dark bags have a double layer of light-tight fabric, a zippered end for removing supplies, and elastic sleeve-like holes for inserting your arms. You can change film in broad daylight with a dark bag.

FILM

Of course, people always ask me what film I use. There are so many brands and types that even the seasoned professional sometimes wonders if he or she is using the right one. Because all films perform differently, I recommend testing them yourself. Then use the film you like, not the film that other photographers tell you to use.

How does color film work? All film — black and white, color, negative, or transparency — contains microscopic grains of silver compound mixed into a gelatin emulsion, which is coated onto a sheet of acetate (in the old days the emulsion was coated on glass). When film is exposed to light, grains of silver capture the light. Both color negative and color reversal (transparency) film contain three different layers of silver, and each layer is sensitive to different wavelengths of light. Negative film reacts to red, green, and blue colors; transparencies react to magenta, cyan, and yellow. Modern color films can perceive and record most visible colors.

NEGATIVES VERSUS TRANSPARENCIES

Photographers should always consider the end use of their film. If you only make prints, use negative film. If you want to have your work published in books or calendars (basically anything printed by any graphic arts process), you should shoot transparencies. Devices called scanners separate the three primary emulsion colors from the transparency in order to make plates for printing presses. Though scanners can scan color prints, prints are lower quality, second-generation versions of your original negative.

FILM CONTRAST

Color negative films tend to have more exposure latitude than transparency films — as much as a full stop's worth. Negative films tend to make photographic prints that exhibit less contrast than prints made with transparencies. This fact is a function of both the film and the papers used to make prints. However, low ISO transparency films depict more resolution, sharpness and detail than low ISO negative films.

FILM SPEED

Fast films (greater than ISO 200) contain larger grains of silver than slow films (ISO 25 to 100). Larger grains are more sensitive to light, and they require less light to make a correct exposure. On the other hand, fast films with large grains have a "grainy" appearance in the photograph, especially in areas with solid colors, such as skies. Graininess also reduces the sharpness of detail.

In landscape photography, slow films make better images. Though resolution of detail is the least important ingredient in photography, when all else is done well, sharpness only enhances the integrity of your photograph. Most serious landscape photographers use films with speeds of ISO 25 or 50. Since you work mostly on a tripod, film speed is not important in relation to making exposures. Many films of ISO 100 are acceptable and can be used more often in hand-held situations.

FILM COLOR

All film brands and speeds render color slightly differently. Some films depict colors more brilliantly than they actually appear; others just about the way the eye sees them. Some films understate color. Older Ektachrome films tended to have a bluish cast and needed color correction with warming filters.

The color in photographs of the landscape made with Fuji film is slightly more intense than how it appears to the eye. However, in flat, gray light when colors are naturally muted, such films can make colors appear as they might under better circumstances.

COMPARING FILMS

The best way to determine what film to use is to shoot with them under the same conditions in the field. With the view camera, I can put one type of film on one side of my two-exposure sheet film holder and another type on the other side, which effectively makes a comparable image in a short period of time. Shooting whole rolls of film with a 35mm or medium-format camera takes longer.

In order to discover the full potential of a film, I expose it in many different kinds of light. I will shoot from before sunrise to noon and make images of many colors and degrees of contrast. After processing, I sit down at the light table and compare shot after shot. I can always see distinct differences in color, contrast, and resolution from one film to the next. This process gives me the ability to choose the film I want to use based upon my own analysis, not somebody else's.

Processing inconsistency can compromise your test, especially when you are dependent not only on the quality of the processing of the negative, but also the way in which the print is made. If you operate your own darkroom, you might be able to judge the difference between negative films and their prints. If you are dependent upon a photo lab, it will be much harder to make your comparison. Transparency films are much easier to compare. You will end up with a good test if you ask the photo lab to "run" all the film together.

SHEET FILM

Raw sheet film for the view camera comes packaged in boxes of 10 or 50 sheets. It is extremely difficult to keep film holders and changing bags completely clean in the backcountry, especially when you change film holders every day.

Ready-load film circumvents the dirt problem. Each sheet of film is contained inside of a light-tight envelope with its own dark slide. The envelope is inserted into a special holder that fits into the back of the camera. Ready-load sheets are not removed from the envelope until you take them to the lab for processing. Nevertheless, ready-load film packs are heavy and bulky, and you can't carry as many inside a camera pack.

PHOTOGRAPHIC PROCESSING

In black and white photography, the way in which the negative and print are processed is critical to the outcome of the image. Therefore, the involvement of the black and white photographer in development is mandatory.

In color processing, chemicals are closely monitored in order to allow images on film and prints to duplicate as accurately as possible the way the scene looked to the eye. It is less critical for the photographer to be involved if someone else can be trusted with the processing. I have chosen not to spend much time in the darkroom because I would rather be in nature photographing (and because I have found a photo lab that holds my high standards).

Not all photo labs have the same standards. As with film testing, you should experiment with different labs until you find one you can trust. One-hour photo labs and drugstore processing services may be fine for one person but abominable for another. The best processing and print making is available from labs that cater to professional photographers. Most accept work from amateur photographers, too. Major cities usually have several of these labs, and smaller communities often have at least one.

Professional photo labs charge more for the same services you can get at the supermarket photo counter, but they provide better quality work. Professional photo labs constantly monitor chemicals and their temperatures, and photographic prints are made by hand. In addition, the variety of services available from a professional photo lab is extensive, from scanning services to restoration of old photographs.

ARCHIVAL QUALITIES OF

PHOTOGRAPHIC MATERIALS

Eventually, most color photographic material, both processed and unprocessed, will fade. Film and print material fades most quickly in direct sunlight, but it also fades in the dark. Temperature and humidity affect the speed and degree of fading. Cooler, dryer environments allow processed film and prints to retain their color longer.

Most negative and transparency film will not fade in dark storage for 50 to 100 years. Some print materials will fade

in a few years, others not for several hundred years. Henry Wilhelm tests new photographic materials by accelerating the fading process so he can determine archival quality. His book, *The Permanence and Care of Color Photographs*, comments on the archival quality of most films and papers. Consult it if you want to find out which materials last the longest.

COMPARING FILMS

In order to test a new Kodak film, I placed a sheet of my regular 4 x 5 Fujichrome in one side of my film holder and a sheet of new Ektachrome in the other. I was able to make the same exposure on both in less than 15 seconds, insuring that the condition of light was identical for each. When comparing film color, the most neutrally colored parts of a scene will reveal film color biases very quickly.

In this image, notice how the narrow pinkish band of color both above and below the horizon is almost non-existent in the Kodak film. The color of the snow on the left bank of the irrigation pond is more red in the Fuji film. Note the distinct difference in sky color caused by Fuji emulsions that are more sensitive to red colors than those made by Kodak.

You can make color prints from either negatives or transparencies. Prints made from negatives tend to have less contrast than prints made from transparencies. The colors in some print materials last significantly longer than others. Colors in prints made from negatives fade most quickly.

The *dye transfer* printing process, which requires making separations of the primary colors red, green, and blue in the image, was long considered the only commercially viable archival printing process. However, the owner of the process, Eastman Kodak, no longer manufactures the materials. Ilfochrome materials, made by Ilford, have been determined not to fade — even in direct light — for more than 100 years. Ilfochrome prints are made only from transparencies and are available in papers (the emulsions are actually coated on acetate) with different degrees of contrast. They print warm colors particularly well.

EverColor is a relatively new archival printing process derived from the graphic arts industry. Digital scans of transparencies produce film separations, which are then used to make prints. It is the only commercial printing process available that solves the problem of excessive contrast in prints made from transparencies. The colors are beautiful and the detail exceptional, and prints are rated to not fade for several hundred years. Not everyone needs an archival print, but if you do, expect to pay more than you would for those that will fade.

SAN LUIS VALLEY, COLORADO—"KODAK EKTACHROME"

SAN LUIS VALLEY, COLORADO—"FUJICHROME VELVIA"

BEING AT THE RIGHT PLACE AT THE RIGHT TIME

THREE

· ·

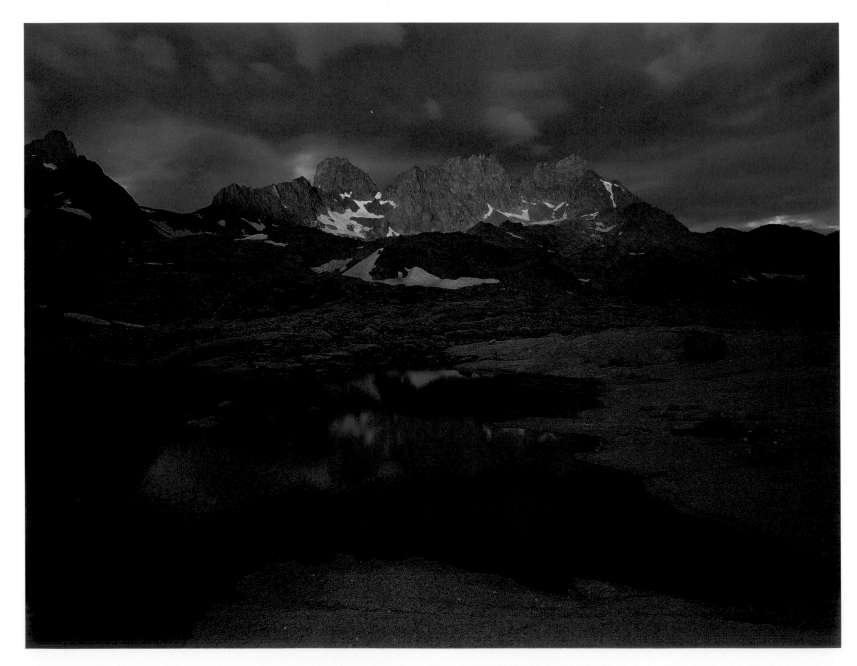

Sunrise, Weminuche Wilderness, Colorado

While Chapter One was written to tune your eye, and Chapter Two to make certain you have the proper tools, this chapter is intended to elevate your photographic skills. The hard-earned, hard-learned secrets in this chapter will increase your chances of ending up in the right place at the right time.

Although most of the information in this book is not new, what I discuss next cannot be learned from any book or workshop. With 23 years experience photographing nature, I have a unique perspective. My photography grew from a love for nature herself — a love for being dirty and cold, for exhaustion following a 20-mile hike, for fatigue from getting up seven mornings in a row at 4:30 a.m., for frozen fingers in February waiting for sunrise.

Excellent photography is a result of roughly equal amounts of two things: having a good eye and being at the right place at the right time. Since we have already discussed ways to improve your eye, now let's discover tricks for being in the right place at the right time.

When it's cold, I enjoy retreating into my "cocoon" with clothing, gear, food, and a proper attitude. Over the years, I've been able to isolate myself from the fiercest of winter snowstorms, even while skiing in the middle of the rage. Years of experience have taught me how to be comfortable on the trail and in camp despite 60-mile-per-hour winds, sub-zero wind-chill temperatures, and five feet of visibility. The key word here is *experience*.

I've learned how to isolate the joy of being in nature from the need to survive her hostility. If the nature photographer does not have the will, the patience, or the skill to endure the worst of nature's wrath, then he or she will never know those ordered moments that lie on the edge of chaos — the once-a-year sunsets that reappear minutes after you thought sunset was over, the sea stacks playing ghost as coastal fog moves out and back again, and the rainbows that follow lightning, thunder, and torrential rain.

Not all nature photography must occur during unfriendly moments, but those that do always seem more special than the rest. Whether you're traveling on foot or by car on extended outings, a variety of factors boost concentration. The quality of the food you eat, the amount of sleep you get, and your overall attitude can have a dramatic effect upon creativity and productivity.

Let's discuss how to maintain enthusiasm through thick and thin.

CLOTHING AND RAINGEAR

The productive, happy nature photographer must remain warm and dry. Cold temperatures and moisture can numb your body and mind and slow you down. It is important to use synthetic base-layer fabrics such as Capilene, Thermax, and polypropylene, which are designed to wick moisture away from your body. More comfortable than wool, and much faster to dry than cotton or silk, these underlayers allow you to stay comfortable and dry while exerting yourself in even the worst weather conditions. Synthetic polyester fleece and pile insulating layers will protect you from the cold without the weight and bulk of wool.

Staying dry in the outdoors is critical to one's physical and mental well-being. For the outdoors person, Gore-Tex and other waterproof and breathable shell fabrics prevent water from coming in while water vapor from perspiration exits. When using the base layer, insulating layer, and waterproof, breathable shell together, it creates an effective system for dealing with the elements.

A waterproof jacket and pair of pants protect you best from rain. Ponchos are adequate, but in windy torrents the only way to stay completely dry is with a rain jacket and a pair of rain pants. Beware of impermeable, rubber-lined rain gear that can't "breathe." In active situations, you will find yourself getting more wet from the inside than you ever would from the outside. And look for jackets that have a zipper under the armpits. This opening allows the number one source of perspiration to air itself out before moisture has a chance to accumulate. And remember: Clothing and equipment labeled *water repellent* are not waterproof in extreme situations.

Be creative with your clothes, and always look for ways to save time when you need to add or remove clothing. For example, I've yet to find a durable, breathable pair of hiking pants I can pull over large boots without first taking the boots off. In variable conditions, I sometimes swap long and short pants several times a day. So I found a seamstress to make a few pairs of tough cotton pants large enough to pull over my boots and wear over my shorts.

On our sixth night of my eight-day, 80-mile ski tour, we ate dinner and slept in snow caves. Digging a snow cave is exhausting. The humidity in the cave and perspiration from the hard work make you very wet by the time you have finished. Fortunately, we had chosen a campsite next to the Conundrum hot springs. Situated at 12,000 feet in the Elk Mountains of Colorado, their 104-degree waters quickly warmed our chilled bodies. Three hours later, we emerged from the ponds into minus 10-degree air, shriveled and relaxed and ready to disappear into warm snow caves (32 degrees) for a good night's sleep. Survival and comfort in such conditions require a variety of clothing, and knowing what to wear at what time is essential. With the right gear and a little practice, you can actually be quite cozy in most environments.

BRIAN LITZ PHOTOGRAPH

FOOTWEAR

One of the greatest distractions to the nature photographer is a pair of wet, cold feet. I have been using Gore-Tex-lined hiking boots for many years, and the ones I still use were the first to employ a waterproof and breathable inner bootie. I can stand in water for an hour without leakage, yet my sweaty feet are allowed to breath on the trail. There are many brands of Gore-Tex-lined boots these days, but my favorite is still Danner.

Boots are made for light- to heavy-duty use, and their weight tends to increase proportionally. Light-duty boots are fine for hikes with a day pack or camera fanny pack, but hiking all day with medium to large backpacks requires heavy-duty boots. I would bet that half of all of my photographs are made either in wet grass, in standing or running water, or on the edge of the surf. Rubber boots would be fine if you didn't have to hike so much. High-top, waterproof, breathable hiking boots are a must.

The best socks are reinforced in all of the right places, and they combine wool with synthetic fibers for more durability and warmth. They wick away moisture, and they come in many different weights tailored to the time of year and type of activity. Good socks require me to replace them once every couple of years instead of every two months.

On overnight backpacking excursions, I often take an extra pair of sandals, sneakers, or lightweight hiking boots to wear around camp. Just in case you can't keep your feet dry during the day, you can look forward to peeling off wet socks and boots and putting on other footwear after returning to camp.

JAROD TROW PHOTOGRAPH

Nature photographers love photographing water, which frequently requires standing in it. In addition, rain, snow, and dew clinging to plants mean boots are wet more often than dry. Warm, dry feet allow the creative mind to concentrate on photography, not on discomfort.

Whether you're on the coast or in the mountains when you photograph before sunrise and after sunset, expect to feel cold. It is not always possible to work with warm hands and fingers, but when you do, photography is much easier. Whether you use 35mm equipment or 4 x 5 format, you have enough buttons to push and dials and knobs to twist that numb fingers will affect your coordination and slow you down.

CLOTHING AND NON-PHOTOGRAPHIC GEAR THAT I TAKE INTO THE BACKCOUNTRY	
THREE-SEASON CLOTHING (non-winter)	Rain Jacket
	Rain Pants
	Fleece Jacket
	Capilene Shirt
	T-Shirts (2)
	Long Pants
	Shorts (2)
	Socks (2)
	Gore-Tex Lined Hiking Boots
	Sandals
	Hat
	Hankies (2)
	Fingertipless Gloves and Glove Liners
	Fleece cap
THREE-SEASON CAMPING GEAR	3-Man Tent
	5-Degree Down Gore-Tex Lined Sleeping Bag
	ThermaRest Inflatable Pad
	Crazy Creek Chair
	Kitchen:
	MSR "International" Stove
	6- and 4-quart pots
	bowls
	spoons
	cups
	Biodegradable soap, scrubber, dish towel
	Pure Water Filter
	5-Gallon Collapsible Water Jug
	Plastic Water Bottle
	First Aid Kit
	Head Lamp
	Compass
	Mirror
	Swiss Army Knife

To work in cold conditions, I have always used "fingerless" wool gloves — gloves without fingertips. Somehow the coverage of the rest of my hand seems to keep my exposed tips warm. In the coldest of weather I wear thin ski glove liners beneath the fingerless gloves. Between exposures, I warm up my hands in my pockets.

On overnight backpacking excursions, the ways in which you haul your equipment and manage your camp can significantly increase your productivity as a photographer. It's important to carefully choose your tent, camp furniture, kitchen supplies, and first aid kit.

Tents

Like camera equipment, tents come in many sizes and shapes, so only concern yourself with the most important features. The ability to quickly set up a tent is important to me. I have always used tents that allow the supporting poles to remain inside their sleeves — even when folded up — because it makes for fast setup. Including the time it takes to attach the rain fly, I can erect my tent in two minutes, which is very useful when a storm is approaching quickly.

I use a three-man, hexagonal-shaped tent that allows me and a companion to occupy the center and put packs in the corners. You can leave camera packs outside if you cover them, but keeping them inside lets you conveniently clean and work with your gear. Make certain to use tents large enough to accommodate all of your domestic gear, as well as your camera equipment. Give yourself enough room to endure those once-a-year, 24-hour storms. You'll want to separate yourself and your camera gear from wet, dirty clothing.

Dry bodies and camera gear are critical to your ability to survive hostile elements, as well as to feel comfortable enough to want to make photographs. Use tents that are large enough to hold you and all your gear — but not too big to carry in a pack.

Sleeping Bags, Pads, and Chairs

Being warm and cozy contributes to a good night's sleep, and sleeping well makes it much easier to get up with enthusiasm at 4:30 a.m. I use a five-degree rated down bag with a Gore-Tex shell all year long — even in summer. When it is hot, I use it as a blanket. When I get cold, I zip it up. Down-filled bags compact to a smaller size than synthetically insulated bags, especially when carried in stuff bags with compression straps. However, when wet, down filling doesn't insulate as well as synthetic filling.

You can't beat an inflatable sleeping pad. They provide better insulation from rocky and irregular surfaces than foam pads, and they roll up into a smaller parcel when not inflated.

They also double as a comfortable place to sit when inserted into a lightweight nylon shell such as the ThermaRest and Crazy Creek camping chairs. For an aging body, there is nothing better than resting the lower back at the end of a long day. I keep my inflatable pad inside the chair permanently, and I only have to undo two buckles to convert it from chair to sleeping pad when I turn in for the night.

Kitchen Supplies

Food and its preparation occupy a large part of any overnight excursion. I only use small gas backpacking stoves, even at developed backcountry campsites. Building fires in the back-country for heat or cooking is a thing of the past. Fires are time-consuming, messy for you and nature, and require fuel that is sometimes difficult to find unless you violate a live tree. Also, they leave a mark on the landscape for future visitors to scowl at. Lightweight stoves can work for a week on a single bottle of fuel, and they create enough heat to cook the best of dinners. Even at higher elevations, boiling water is a snap.

I carry pots, bowls, and cups that nest efficiently inside one another. In one medium-sized stuff sack, I can carry all the kitchen gear I need for up to six people. In that same bag goes a dish towel, scrubber, and biodegradable soap. That's my entire kitchen.

First Aid

The deeper you penetrate the backcountry, the more important it is that you know first aid and have proper supplies. At the very least, load a complete backpacking first aid kit in your car and your pack. Most of these kits include all the basic medical supplies you need for minor injuries and maladies, as well as instruction books to help you with more serious situations.

Good food, good company, and proper equipment and experience make for pleasant journeys over difficult terrain and through challenging weather. Practice makes perfect, and personal comfort is the foundation for creative photography.

Lack of sleep and the wrong food can kill your will to photograph during backcountry excursions. Wind, cold, and heat can sap your strength all by themselves, regardless of the number of miles you might hike in a day.

During long summer days, it's not uncommon for me to be up at 4:00 a.m. preparing to hike to a place to photograph twilight. In the evening, I will often photograph until 9:30. After changing sheet film holders, cleaning gear, and relaxing with a book for a while, I'm lucky to be asleep by 11:00. Stringing together seven of these long days doesn't allow nature photography to be the vacation some people think it is. The amount of sleep I allow myself is the bare minimum I need to perform at my best. Each of us has different needs and levels of tolerance, and only practice will teach you your own sleep requirements.

As important as sleep is diet, and as with sleep, each of our needs is different. In the days when I backpacked by myself, sometimes carrying packs weighing 90 pounds, I could only carry the weight of freeze-dried foods. Though very useful because of their light weight, and reasonably good tasting, they have almost no fat content. After hiking with the big pack for a week, I found myself tired and emaciated by midweek, which substantially affected my desire to make photographs. I have discovered over the years that my body needs fat — enough to counter the body fat lost during long, exhausting weeks.

Over time I began to recruit friends to help pack gear with me into the backcountry, which allowed us to take better food. I stopped using freeze-dried food and began to experiment with fresh and canned meats, sausages, white cheeses (which don't spoil as quickly as yellow cheeses), butter, peanut butter, vegetables, pastas, and ramen noodles. Now I know the quality and quantity of food I need to maintain my strength, which I believe has led to improved photography. Even in August in the Rocky Mountains, cool evening temperatures will re-cool foods that might have warmed up during the day. Insulated soft-sided coolers help keep food cold and can be carried inside a backpack. In hot environments, don't burden yourself with foods that will spoil.

WATER

The higher the altitude and the hotter the temperatures, the more water your body needs. You have to consider the availability of water when you decide where and how far to travel on foot. Potability is also important — gastro-intestinal ailments can quickly end your will to photograph.

Water availability is usually not a problem in the mountains, but it can bze in the desert. It is important to scout the country you plan to visit, which I will talk more about later. I recommend camping near water when you can. In a camp with four people, we typically use five to six gallons in the course of an evening and morning. I take a five-gallon collapsible jug on all of my backcountry excursions, which I fill each evening and morning. It's lightweight and compact for carrying, and it sure beats having to keep pots full of water or constantly having to refill drinking bottles.

I also take along at least one hand-held, pump-style water purifier. You can choose from a half dozen on the market; they all seem to work differently and with varying degrees of success. Experiment with them or ask friends about performance, and you will eventually gravitate to the best one. The decision when and where to purify drinking water is a personal one. I tend not to purify water drawn directly from melting mountain snow, but I usually do everywhere else. The infamous giardia protozoan is rumored to be ubiquitous, and once inside of you, it is difficult to eliminate. Boiling your water or adding iodine tablets 20 minutes before drinking also purifies your water.

HIKING TIPS

Although I primarily photograph in the morning and evening, I also work all day along the trail when the light is good. This means I must react spontaneously to my environment. Because weather can negate your spontaneity, it is important to get into your "cocoon" right there on the trail during rain, wind, or snow so you can comfortably make the image.

No matter what size pack I carry, I always keep quick-need items readily available. These include water, snack food for those distracting pangs, long pants and long-sleeve shirt for cooler weather, and rain jacket and pants. A Swiss Army knife (or Leatherman multi-tool) and compact first aid kit are mandatory.

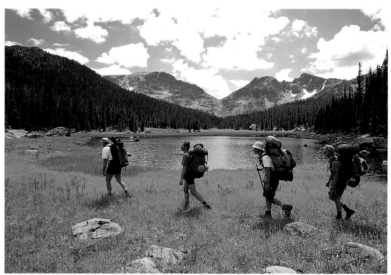

JON OSBORNE PHOTOGRAPH

I try to have quick-need items, such as rain gear, water, and snacks, readily available and not buried in the bottom of my pack. I can hike farther and faster when I eliminate unnecessary and lengthy stops.

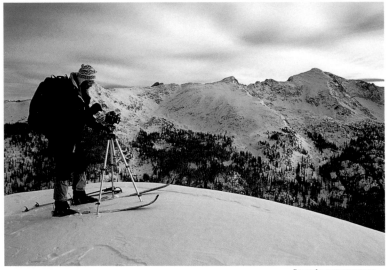

In winter's snow, conditions are generally brighter, allowing more hand-held use of the camera. Taking a hand-held photograph at 1/250 second will be just as sharp as one made on a tripod at 1/8 second. Nevertheless, to achieve maximum depth of focus, and when photographing in low light conditions such as twilight, a tripod is still mandatory equipment for the nature photographer.

WINTER EXCURSIONS

Visiting the mountains in winter is one of the most peaceful experiences on the planet. Most of the animals are hibernating, the birds have left for warmer climates, and the only noise you hear is the wind in the trees. My home state of Colorado has more backcountry ski huts and yurts available for the winter traveler than any other state. With skis and climbing skins, or snowshoes, you can access a challenging environment, have great fun, and even make wonderful photographs.

During winter, basing your photographic enterprise out of a hut is much easier than camping in tents or snow caves. Snow caves become very humid, and the disparity between temperatures inside and out can quickly fog a lens and its internal elements. Camping in tents in sub-zero temperatures is not fun, and the discomforts can distract you from creative photography.

PACK ANIMALS

As I get older, I dread carrying the large loads on my back; my view camera equipment, including tripod, weighs 70 pounds. It just doesn't seem like the best thing to do to my body. When I hike on trails or perform moderate bushwhacking, I use my three llamas, Tommie, Tensing, and Kerwood. Wearing panniers, they can carry up to 100 pounds of gear and supplies. I can even put my large camera pack on top of a llama in such a way that I can release it as quickly as I would off my back. All I have to carry is a small pack with quick-need items.

Llamas happen to be the ultimate pack animal for people who prefer hiking to riding horses. They don't need much water (they are cousins of the camel), and I don't need to take any feed along for them. They browse on just about everything from grass to bark, and they do it in such a way that they hardly make any visual impact on the landscape. Llamas are much lighter than horses, so they do very little damage to trails or fragile environments such as tundra. Best of all, they have the

disposition of a cat: aloof yet cooperative without the obstinacy of equines. Llamas are quite nimble animals with the ability to walk just about everywhere I can. They are most useful in the mountains, but they can also work in desert country during the cooler seasons when temperatures are below 90 degrees.

When I'm not burdened with a large pack, I can hike 80 miles in a week. This means I see a great amount of country, and I am rarely so exhausted my photography suffers. Using pack animals is just one more way to mitigate the challenge of surviving the rigors of backcountry travel so you can concentrate on being creative with the camera.

LIGHTNING

I recently met a doctor who studies lightning strikes on people. He told me he has seen several cases when the metal, cloth-covered button on top of a baseball cap attracted lightning. What a way to go! If a button of metal is enough to get you killed, just think how attractive 10 pounds of tripod and camera might be.

Wherever you see thunderstorms, expect lightning. It strikes almost anywhere, so the best thing you can do is be conservative in your judgement. If you witness lightning nearby, take immediate precautions to prevent being hit. These include leaving your camera and tripod right where they stand, staying away from water, and descending from high places without retreating beneath any solitary, prominent feature like a tree or tall rock. If you can't retreat to the forest, crouch down and balance on the balls of your feet to minimize ground contact. Then pray.

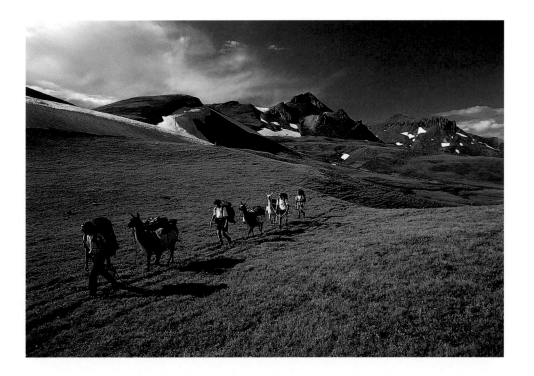

I don't know what I would do without my llamas. They have made me a much more productive photographer by keeping 70 pounds of metal and glass off of my back. I can hike farther, faster, and feel stronger at the end of an 80-mile week. And llamas don't talk back. (Good llamas spit only at each other.)

PREPARING FOR PHOTOGRAPHIC EXCURSIONS

Landscape photography can be more enjoyable and relaxing than any other kind of photography because it allows spontaneity. A commercial photographer must consult with an art director and carefully preplan a shoot. A wildlife photographer must respond to the habits of animals, possibly waiting for days in order to photograph them. But the landscape photographer can just wander around, aimlessly if he or she wants, responding to nature's all-inclusive and ever-changing conditions — to a degree.

Good landscape photographers never lose their appreciation for spontaneity. Some of my own best work has been done off-the-cuff while reacting to conditions I could have never predicted. Nevertheless, planning can increase the nature photographer's productivity by boosting the chances for spontaneity. Let's discuss a number of ways you can prepare.

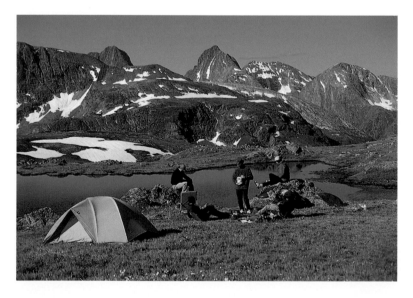

CAMPING IN THE WEMINUCHE WILDERNESS, COLORADO

PREPARING YOUR PHOTOGRAPHY EQUIPMENT

Though I've said before that dust and scratches on a lens won't affect the photograph, this doesn't mean clean equipment isn't beneficial. I only shoot with a dirty lens when I don't have time for cleaning. Before every photography excursion, I clean each piece of gear inside and out, using soft tissue or cloth and lens cleaning fluid. Compressed air from a can — or better yet from a high-pressure compressor — is necessary to get dust and dirt out of all the cracks. But beware: compressed air can damage delicate parts inside your camera.

For my view camera, I remove each dark slide from every film holder, and I use compressed air to blow away particles of dirt lodged in tight places. Scratches on the film caused by dirt can be the scourge of sheet film photography. In the field, it is extremely difficult to eliminate all dirt from your environment, so always have your gear clean and ready for the first shoot.

Don't forget to check the charge in batteries in cameras and hand-held meters before you leave, and make certain you have replacement batteries. Carry lens tissues and small bottles of cleaning fluid on the trail, as well as a soft cloth for wiping wet gear dry. At the very least, have a clean shirt tail available. And take along whatever tools you know you might need to repair camera equipment. Electronic 35mm cameras are much too sophisticated to attempt to repair by yourself, but you can usually self-service other cameras. I bring along jeweler's screw drivers, a spanner wrench, a Leatherman multi-tool, and various replacement parts that have given me trouble over the years, such as tripod leg joints and latches and extra pieces of ground glass for the view camera. Duct tape removed from its roll and folded into compact wads is, of course, a must in the field. Whatever can go wrong will go wrong at one time or another. Make certain your investment in time, money, and energy to travel and photograph 50 miles into the middle of nowhere isn't wasted.

Serious 35mm photographers with a fully electronic camera should take a non-electronic camera body along as a backup. Programmable cameras are only as good as the reliability of their electronics. A fizzled chip or dead battery renders them *completely* useless.

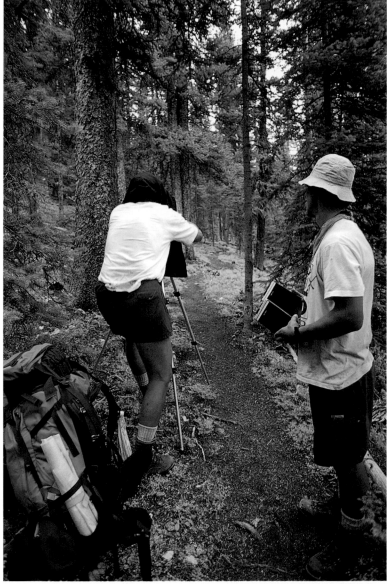

Though my best images are planned and previsualized, I enjoy testing my ability to be spontaneous along the trail. I constantly scan the landscape while hiking, looking for those gems that are hidden along the way.

HOW MUCH FILM TO TAKE

Just like shooting style, everyone's film and processing budget is different. This book is intended to allow you to see more than you have before, so you will probably begin shooting more film than less. When you bracket more exposures, you naturally use more film.

To serve as a barometer, here's how much film I use. When using the 4 x 5 view camera, I expose an average of 500 sheets per full week of photography. During the week, I will average 35 exposures per session during each of 14 morning and evening sessions, with some daytime photography in between. Because it doesn't cost as much, I will make more exposures if I am using either medium-format or 35mm cameras. For purposes of my stock photography business, the more copies I have of any given image, the better. However, using more film than less doesn't make me any less diligent about calculating the correct exposure the first time.

Also, consider weight and bulk when deciding how much film to carry. Per exposure, roll films consume much less space than sheet films. If you can carry the load, always take more film than you think you will need; it is a sad day when the most spectacular moment of the week occurs after you have run out of film.

GETTING TO KNOW KINDS OF PLACES

In science we call certain kinds of landscapes *ecosystems*. Usually created by a particular geology or elevation, they feature a unique climate, as well as distinct animal and plant life. As I noted earlier in this book, the nature photographer cannot successfully photograph a place without first knowing it. Knowing it can only come from touching it, hearing it, and seeing it. When setting out to photograph an ecosystem you've never visited — regardless of your expertise — put the camera away for a few days and just hike and observe. If you do this, you will ultimately make much better photographs.

Once you decide where you would like to photograph, whether you'll be doing it out of your car or hiking the backcountry for a week, try to imagine what your destinations will look like. You can do this by just dreaming, or you can approach it more scientifically.

Take a look at a road map. Better yet, find one of the *Delorme Atlas & Gazetteers* that are published about most U.S. states. These map books break each state into small geographic sections, and they contain both improved and unimproved roads, as well as major trails and topographic information. By understanding the general location of your destination in relation to the geography of the region, you can create the foundation for planning a trip. For example, you may realize that being on the top of one mountain range might open up views of another.

Acquire topographic maps of your destination. Once you learn to read contour lines, you'll begin to see the map in three dimensions. Topographic maps include elevations, names of geophysical features, and rivers, creeks, and lakes. They usually indicate forests with green shading. Once you've been to a certain kind of landscape (mountains, desert, or coast), you can *previsualize* what to expect to see at similar locations. Thank goodness you can't imagine everything a new place reveals. Otherwise, you wouldn't have any surprises to discover.

I use topographic maps to decide both where I want to go and what I will do when I get there. Knowing that morning and evening photography is best, I always study geophysical features in relation to east and west. Will that cliff, peak, or outcrop catch the direct sun in the morning, or will it be a side-lighted scene? Will it reflect into the lake nearby? Which part of the mountain will be in shadow at sunset? How long might the meadow or lake in the foreground be illuminated? Where

will I camp so I can be close to the best photography locations, and is there water nearby? Is that ridge on the mountain or cliff along the coast passable, and what is an alternative route if it isn't? What is the chance that a drop-off, over which the creek seems to pass, will create a waterfall? If I decide to go off-trail and bushwhack through the timber, how far will I go before exiting into the open? Where are all trails and where do they lead in case there is an emergency? Where will I camp each day in the week, and does the associated route allow me to return to my vehicle on the appointed day? Does that route have a long day that might sap my strength?

With so many creative and mechanical things to think about in photography — and with weather sometimes creating a distraction — the last thing you need is too much camera gear. How much you carry should be directly related to your skill level and ability to haul it. If you cannot manage the gear you have, and if this prevents you from putting the moment on film because you can't decide which lens to use, then why have it in the first place? In Chapter Two I discussed what I believe are the most important features to have on a camera, as well as what accessory gear is important in nature photography. Let's discuss two more considerations.

Do not take more lenses than you are comfortable using and carrying. Only bring lenses that offer the angles of view with which you feel comfortable working. From time to time, recall how much you've been using each lens, and leave any at home that you don't really need. In 35mm photography, zoom lenses alleviate the need for multiple lenses, and in most cases three lenses serve the landscape photographer well: a wide-angle zoom, standard fixed focal length lens, and a telephoto zoom. The absence of zooms in medium- and large-format systems requires carrying more lenses in order to have the same flexibility 35mm systems offer. Nevertheless, I have always been productive with just three fixed focal length lenses in my medium-format system. The system I use most frequently, the 4 x 5, contains

ROUTT NATIONAL FOREST, COLORADO

My friend, George, and I were driving through the Routt National Forest one day when we spotted an open gate to what must have been private property. We didn't see any dwellings, so we decided to proceed ahead in search of someone who would grant us permission to explore further. After a five-mile circuitous drive through the aspen forest, we arrived back at the gate. Here we spotted a man who was just about to lock the gate. He was the property's manager, and after hearing our explanation,

he said he didn't mind that we had toured it. Thank goodness he was friendly.

White cloudy light allows the natural colors of nature to shine. Throughout our drive, this quality of light persisted, and I made image after image of soft autumn colors within this private reserve of aspen groves. This one is my favorites, and it contains some of each photographic element.

seven lenses, all of which I carry all the time. I know I will use each lens often enough to justify taking them, and their weight doesn't seem to slow me down.

I only recommend taking more than one format when you have a clear need for more. For example, there's rarely a good reason to take both medium- and large-format on an excursion. For most publication purposes, larger medium formats (6cm x 6cm and up) make almost as good a reproduction from film as 4 x 5 format. A better combination is 35mm and 4 x 5. When I have enough strong backs or llamas, I use the 4 x 5 for all serious landscape work, and I take along the 35mm for photojournalism along the trail. Many of my books display exhibit-format 4 x 5s along with journal entries and 35mm images evocative of life on the trail. "People in nature" pictures sell well as stock photography, too.

SONOMA COUNTY COAST, CALIFORNIA

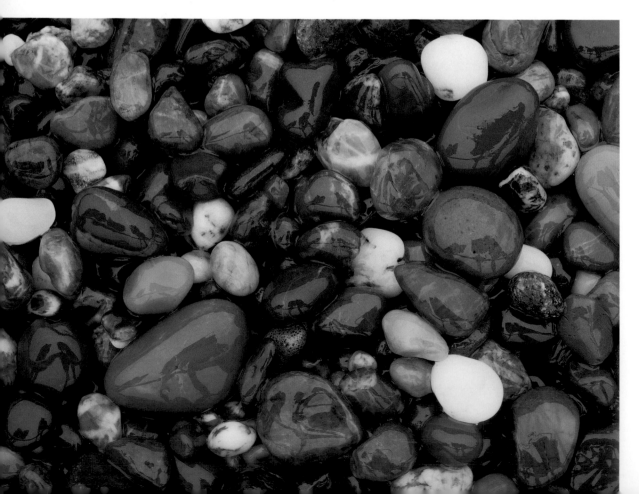

This photograph is a one-to-one (1X) macro image of stones freshly washed by seawater. It exemplifies the power of the microcosmic world, and it confirms the need for the nature photographer to constantly look beneath his or her feet. Nevertheless, I was not as vigilant as I should have been. It wasn't until I was viewing transparencies on the light table that I noticed this one was a self-portrait. Almost every stone contains a reflection of the camera, the tripod, my wife standing nearby, and me holding the cable release.

SEIZING THE MOMENT

The very best nature photographers react quickly to changing conditions, which are often when the most unique images are made. Working quickly is a function of many things. The photographer who can keep a clear head when the moment is brief will make more excellent photographs than the one who panics. Despite all there is to think about when making a photograph, it can eventually become pure instinct. An action or reasoning that might now take you a minute to perform will only require a few seconds once you've had enough practice. Let's discuss some of the ways a photographer can seize the moment.

VERSATILITY IN THE FIELD

Versatility is all about knowing what to photograph when. Long shadows and warm light of sunrise and sunset on clear days cultivate grand scenics, as well as any other composition. When the light is flat, and white or gray clouds cover the sky, move inward to make intimate landscapes and microcosms of nature. Use this same afternoon light when you want the colors of the landscape to appear pure and saturated on film.

On clear days, make silhouettes when the sun is behind the horizon, before the day begins and after it ends. Test the limits of color saturation of film at these times, too. Reflections in water scenes only work in clear weather when the sun has not reached the reflecting surface. When direct light hits the lake, reflections can be destroyed. Only photograph blurred water in cloudy light, or at the ends of the day when the light is saturated with color. White water is highly reflective, and it can't be photographed at longer exposures in direct light. Besides, longer exposures require apertures smaller than what your lens can achieve.

And don't be afraid to admit that sometimes — though not often — it's not worth making a photograph. Why waste the film? When that sun is directly overhead on a clear day, you can't expect to capture a scenic or microcosm. When the afternoon clouds are simply too gray and dark to allow any color to manifest itself on film, pull out a good book or keep hiking.

Do not assume that a given place, perhaps not attractive and photographable when you were there, cannot some day become the next Sierra Club calendar cover. From one moment to the next, one day to the next, one season or year to the next, every *place* has an infinite number of personalities. Even the flattest and dullest of places can be interesting in the right condition of light. Return to places that have a special lay of the land; eventually they will show their best face.

SEIZING THE MOMENT

*The entire day had been cloudy and rainy.
Our hike to the head of Cataract Creek was
uneventful, and we ended up in a funk next to
several tundra pools of water high on a ridge.
Just as we began to set up our tents, the rains
started again. We retired inside for dinner and
what we assumed would be an evening devoid
of photography. Still, I always check outside
conditions through the tent door — which we
usually position to allow us to see the sun as
it sets or rises.*

*Just as we had finished a dinner of fettuccini,
the telltale glow through the translucent tent
caught my attention. We bounded out of the
tent, grabbed the camera gear, and hurried
over to the closest pool. With fettuccini in my
throat, I managed to expose three sheets of
film as the sun disappeared behind the horizon.
This photograph was my first view. Somehow
the sun had broken through the clouds
and penetrated still falling rain. For only
two minutes it cast its copper light on
Eagles Nest Peak.*

EAGLES NEST WILDERNESS, COLORADO

170

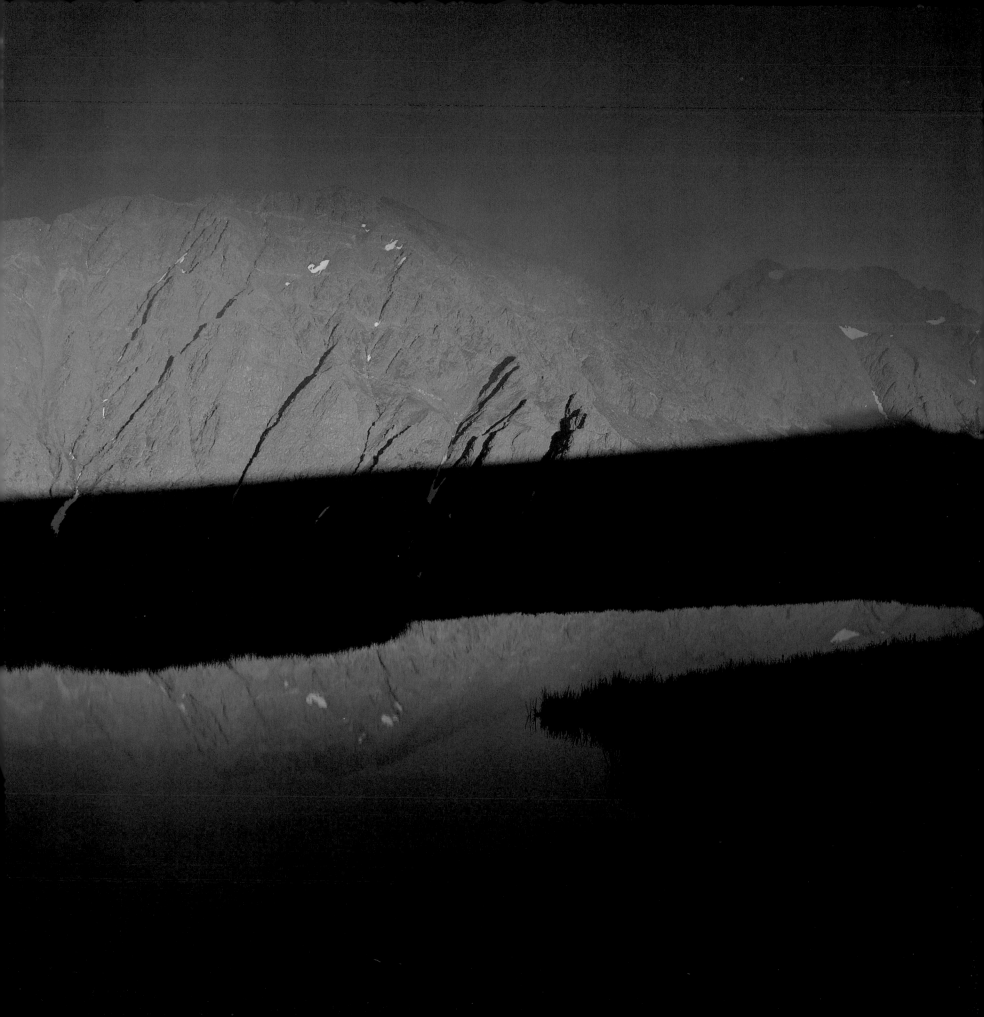

SCOUTING AND PREVISUALIZATION

Once you finally arrive at your destination, take pleasure in comparing your previsualizations with reality. You will find that the mountain indeed faces east, and that the lake is exactly where you thought it would be. Topographic maps are incredibly accurate. What will surprise you is the field of flowers you could never have known would be there, and you'll find nature's colors and shapes that no map can predict.

Now continue the process you started at home. If you were smart, you planned your days so you could arrive at camp well before dinner. Spend an hour or two without the camera so you can get to know the place. This is when I begin to look for all of the elements we discussed in Chapter One. What will I use for my foreground in a grand scenic? Which features will make a good intimate landscape when the sky is not as interesting? Where are nature's microcosmic repetitive patterns that I can photograph close up? Based upon the lightness in color of that rock ridge, how much contrast will there be when it is in direct light and the foreground is in shadow? When during the morning will the sun finally rise over the peak and illuminate the place where I stand with my camera?

While scouting, you are a painter collecting ideas to eventually combine on canvas. Nature photographers often call the hour after sunrise and the hour before sunset the *magic hour,* for that is when light is warm and thick and shadows long and broad. I spend all the time I can before the magic hours composing photographs in my mind and storing them for later recollection. I often previsualize a dozen different scenes, and I sequence them in the order I think they should be photographed based on my predictions about the progression of light.

But the light does not always do what you think. Perhaps the pink clouds never materialize because the sun has disappeared behind clouds at the horizon that you cannot see from your vantage. Or maybe there is not enough dust in the atmosphere to create strong bands of color in the sky after sunset. Sometimes I am lucky and my predictions prove correct, but when they do not I consult the list in my mind and move on to the next preconception. When nothing goes right, I merely thank Mother Nature for the opportunity to be present and hope the future brings better luck.

Don't forget you will have a hard time scouting in the dark for your morning shoot. Do all of your previsualization for the morning shoot the evening before. It's not awfully difficult — just remember that the sun will be coming up approximately opposite to where it set. Remember that the arc of the sun changes during the course of the year, and knowing *exactly* where the sun will rise or set may significantly affect what you plan to photograph during the magic hour.

More often than not, weather and atmospheric conditions change all your plans without notice. You shouldn't be surprised when things happen more or less dramatically than you expected, so react quickly and spontaneously to unpredicted moments before they are lost. Spontaneity and the ability to change plans are what make the best of nature photographers.

PATIENCE

People often tell me they think nature photographers must be very patient. I usually deny this. The classic image of the landscape photographer is of a person who will wait until the light is perfect before making the image, even if it means waiting for days. Of course, this is not practical.

In the context of planning and previsualization, a nature photographer is patient, though an even better description would be "deliberate." I tend not to be patient when the light is not cooperating, but I will be deliberate in finding something else to photograph in the condition of light I am given. If the light remains limited, I usually hike toward the next camp or destination with the goal of finding subject matter to photograph — even in marginal light. If that means picking up camp one day early, I'll make this change to my itinerary in hopes of finding the unexpected sooner.

Only when the lay of land is so potentially perfect will I sacrifice the chance to see something new by remaining at a place burdened with marginal light. The combination of colors and form and the subject matter itself may be so unique I conclude it worthwhile to wait one more day for the weather to clear. In reality, I find such places only once a year. If I ultimately leave without the image, I tell myself I'll return another day. And more often than not, what I photograph in new places more than makes up for that one big loss.

Though the best of planned situations require some degree of spontaneity, it is while hiking and driving that you have to think on your feet the most. I have a difficult time getting people to ride in the car with me. Imagine being a passenger in a vehicle in which the driver usually looks out the window, not the windshield. And because I am always looking for photographs around me while hiking, I also trip on rocks and roots in the trail. My companions have learned to keep their distance.

In every facet of photography, practice makes perfect. Twenty years ago I always had to study a place first before I could find a composition. Now I see potential images almost instantly when they present themselves. I'm not always sure I want to make a photograph, but setting up the camera and composing in the viewfinder provides the basis for a final decision. Sometimes when I see a feature briefly — perhaps a solitary shape or blob of color — I discard it from my mind as not useful. I continue driving or walking, and 10 seconds later stop dead in my tracks as an internal alarm goes off. In these situations, I *always* go back to study the scene more closely because more often than not it turns out to be a good photograph. No matter the size of the hook for my imagination, fully half of the photographs I make are made spontaneously with no meaningful planning.

I can make exposures with my view camera as quickly as most people might with their 35mm systems — despite having to calculate exposure with a hand-held meter and having to swing and tilt the front and rear standards to regulate depth of focus. Years of practice have made that camera an extension of my mind and body, allowing me to make a photograph in less than a minute if necessary. And such moments are not uncommon.

Although the following tips cannot replace practice with your own camera, they may help you develop spontaneity. Let's discuss them one at a time.

Quickly Maximizing Depth of Focus

If you work on a tripod, you need not worry about shutter speed — even when it's as much as 40 seconds. Most landscape photographers prefer everything to be in focus, just like the eye sees things. Given those two facts, for what reasons would you photograph at anything other than your smallest aperture? Other than freezing subject matter in motion with a faster shutter speed, there are none. With the 35mm camera, always work with either aperture-priority mode or manual-metering mode with the aperture set to its smallest opening. Take whatever shutter speed the meter gives you; then bracket your exposures with the exposure compensation dial or with the programmable camera equivalent.

Either memorize your hyperfocal chart for given distances at your smallest aperture for each lens or merely remember that if you focus on an object twice as far away as the closest object in view, everything from foreground to infinity will be in focus. But don't forget that every lens and f-stop has a limit to just how close your foreground can be without pushing the background out of focus, even when you are focused at the hyperfocal distance. To give yourself room for error, don't compose important features too close to the foreground limit.

Finally, double-check your work with a preview button or the depth of focus scale on a fixed focal length lens barrel. With practice, you should be able to do all of this in less than 10 seconds.

Quickly Calculating Exposure

If your built-in meter or spot meter fails in the field, here are a few rules to remember. Using 100 ISO film on a clear day in the summer at noon, all exposures can be based upon the combination of 1/125 second and f/22. Most conditions of light have a standard intensity that will not vary over time. For example, during the magic hour around sunrise and sunset in direct light, EV on the spot meter scale is always 13-2/3. White, cloudy afternoon light is usually around 12. With examples like these in mind, you can use the scales on your broken spot meter to figure exposures.

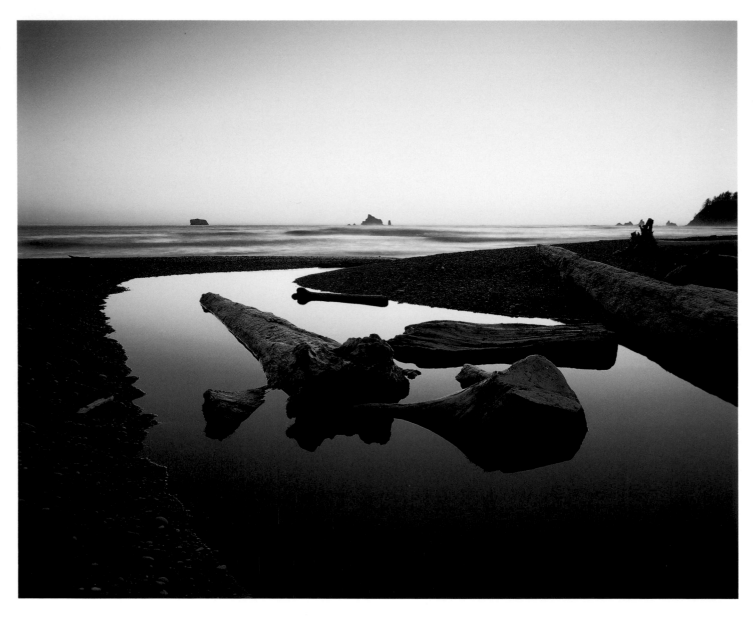

OLYMPIC NATIONAL PARK, WASHINGTON

The log entering this scene from the right actually extended for another 10 feet behind me. While I was composing this photograph, I noticed movement out of the corner of my right eye. However, when I looked to my right, I saw nothing but the log. I made a couple of exposures before I finally caught sight of my company: a family of six otters lined up next to each other behind the log. They must have been standing on their haunches, for all I could see were heads and necks. Every time I would disappear under the dark cloth they would reappear, one next to the other,

and when I would emerge, they would duck behind the log. We played our game with each other until I used up the last sheet of film for the evening.

To quickly calculate the exposure, I pointed my spot meter at the rock in the middle of the pool, which I felt was equivalent to the reflectivity of 18 percent gray. With this reading I began to make bracketed exposures, though this photograph was the image I made first.

STANDARD EV VALUES IN VARIOUS CONDITIONS AT DIFFERENT TIMES OF THE DAY

These readings would be produced by an incident light meter or a spot meter with a gray card, and they are only approximate. Atmospheric conditions will cause readings to vary from one day to the next. These readings will render detail in the landscape, not the sky, on film as it might appear as if photographed at noon. Remember that skies alone can be many stops brighter than the landscape.

CONDITIONS	EV READING	SETTING: ISO 100 FILM
Noon in lightly colored landscape such as snow or sand. Clear sky.	16	f/22, 1/125 second
Noon. Clear sky.	15	f/22, 1/60 second
Noon. Hazy sky.	14	f/22, 1/30 second
1 hour after sunrise or before sunset.	13 $^2/_3$	f/16 $^2/_3$, 1/30 second
1/2 hour after sunrise or before sunset.	12 $^2/_3$	f/16 $^2/_3$, 1/15 second
Noon. Cloudy sky or open shade.	12	f/22, 1/8 second
At sunup or sundown.	8 $^2/_3$	f/16 $^2/_3$, 1 second
1/4 hour before sunrise or after sunset.	6	f/22, 8 seconds
1/2 hour before sunrise or after sunset.	2	f/22, 2 minutes
1 hour before sunrise or after sunset.	0	Insufficient light to expose film.

Checking the Edges of Your Viewfinder

One of the most common mistakes I see novice photographers make is to compose UFOs in their images. That's right: unidentified flying objects. By not scanning the very edges of your viewfinder for parts of objects that don't belong in the composition, you miss the odd shapes that happen to sneak into the scene. It might be a stray tree branch, lonely cloud in an otherwise clear blue sky, or even an entirely out-of-focus stalk of grass that you never saw within the boundaries of your viewfinder. When you get your slides back from the lab, it's always a big disappointment to realize that the image would have been an award-winner if it were not for the UFO. Get into the habit of scanning your viewfinder's edges after you compose and just before you press the shutter button.

Sometimes viewfinders are to blame because not all of them show the portion of the scene that ends up on the film. Many cameras give you 10 percent more view on the film than you actually see in order to decrease the chance that you might crop off someone's head. Always check your camera's manual for the coverage of your viewfinder, usually expressed as a percentage of the area exposed on the film.

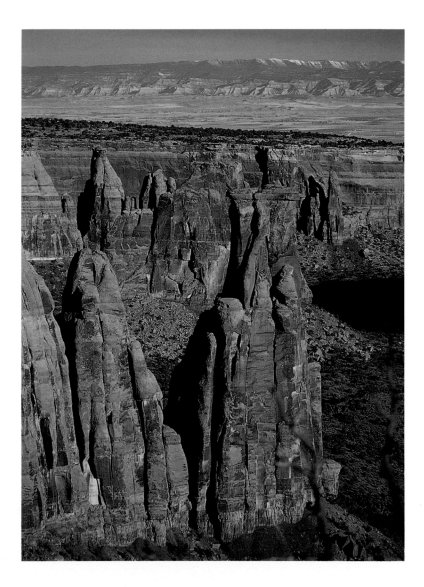

UFOS IN YOUR PHOTOGRAPHS

Here's a common example of a UFO in a photograph. Note the out-of-focus dead tree in the bottom right corner of the image.

Leaving Cameras on the Tripod

Since screwing a camera onto a tripod requires valuable time, I find ways to leave the camera on the tripod while traveling on foot — without sacrificing the safety of the camera, of course. My 4 x 5 field-style view camera folds up neatly and looks like an extension of the tripod head. With the dark cloth tied around camera and tripod head for extra protection and speed of use, I can carry it easily on my shoulder or secure it to a pack. Lenses stay in the pack until it's time to photograph.

Carrying camera and tripod together is more difficult with fragile 35mm and medium-format SLR cameras. When photographing planned sessions in concise areas, it's easy to simply carry the camera and tripod over your shoulder. Extended hikes along the trail require more thought.

PACK WITH VIEW CAMERA
AND TRIPOD READY TO GO

Shutter Speeds Necessary to Stop Motion

Sometimes depth of focus isn't your only consideration when wind blows plants in the foreground. Unless you intentionally want blurry subjects, you will have to compromise depth. The farther into the scene the moving subject is placed, the less distracting it will be, and the less important it is to freeze it.

Grass and flowers in the lightest of breezes can be stopped with 1/4-second or faster shutter speeds. Plants moving in the roiliest of winds must be stopped with a 1/125-second shutter speed. Flowers blowing in moderate winds need 1/15 to 1/30 second to prevent blurring. Obviously these are very subjective evaluations, so become familiar with the shutter speeds you use so you can stop motion on your own without sacrificing too much depth of focus. These rules also apply to cameras and tripods shaking in fierce winds.

The only other way to maintain depth of focus in windy conditions is to employ patience. Though I claim to have little patience, I have been known to have my arm and hand cocked holding the cable release for up to 45 minutes waiting for the only 1/2-second, motionless interval of the day.

Pushing and Pulling Film

Pushing film means simply exposing it with less light than it would normally require to make a correct exposure, which you employ when you need to use faster shutter speeds. To make the images appear as they might during normal exposure, whoever processes the film at the lab can compensate for underexposure by adjusting how long the film sits in the developer. An entire roll of film must be pushed to the same degree. Pushing is usually affected by changing the ISO rating on the camera to a higher ISO. Usually calculated in one-stop increments, the light meter will think that less light is necessary than you know is really required.

For example, I sometimes push a slow film like ISO 50 to ISO 100 so I can use a one-stop faster shutter speed to freeze motion in my scenes. However, whenever you push a film, the resulting image will have slightly more contrast and apparent grain structure than if you did not push it. *Pulling* film is the

opposite of pushing film, and you use it when you want the film to receive more light than it normally would. I rarely pull films in nature photography.

Reciprocity Failure of Film

Some films do not perform well during exposures longer than a few seconds. Two things can occur: The film may need more exposure time than the light meter indicates, and the color of the processed film can shift away from normal. Kodak Ektachrome films require extra light for exposures longer than a few seconds. After a few seconds, these films will also exhibit a green cast, which gets worse as the exposure lengthens. Always check the information sheet about reciprocity failure provided with Kodak film, and use the longer exposures and magenta filters as recommended.

Fujichrome films do not tend to shift as much in color or exposure value. For exposures up to 10 seconds, I expose the way the meter tells me to. After that, I add one-half to one full stop.

Working Without Tripod and Cable Release

Hand-holding exposures longer than 1/60 second without a tripod and cable release is risky. Nevertheless, you can make exposures as long as 1/2 second or more if you brace the camera against an immovable object, such as a wall. Find a niche that prevents the camera from rocking in any direction, and firmly press it against that niche. This will effectively simulate a tripod and make a sharp image even while you push the shutter button with your finger.

A timed delay automatic release of the shutter creates no more vibration than one activated by a cable release. Most cameras have a 10-second delay; others have additional choices as short as two seconds.

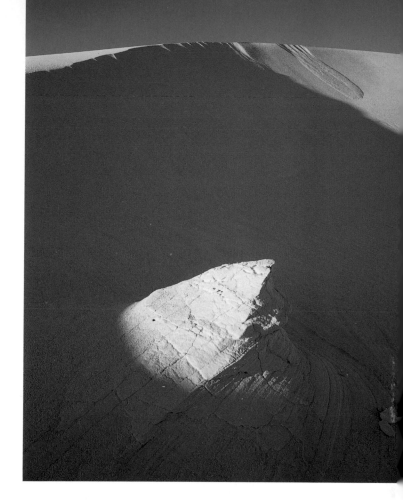

WHITE SANDS NATIONAL MONUMENT, NEW MEXICO

Though not a function of weather, I still call this instance a moment. The sun is just at the right angle to light a spur of congealed sand but not its background (the leeward side of the dune). This moment only lasted for minutes, and I never could have predicted it. My perception of the moment was spontaneous, and my ability to focus, maximize depth of focus on the fly, and meter for the exposure allowed me to put the image on film.

I estimated the promontory to be three feet from my lens; therefore, I focused six feet away, knowing that at f/22 my entire scene would be sharp.

Protecting Film

Contrary to popular opinion, professional films do not require refrigeration. Even if left out at room temperature for months, they will make the same quality image as if refrigerated during that time. In terms of years, film merely lasts longer if kept refrigerated. Almost all photographic materials are less susceptible to fading if kept cool and dry.

Film must not be overheated, scratched, or touched by moisture. Desert heat can damage film, but only if baked in a closed, sunlighted container. Water on unprocessed film can leave marks once the film is processed. And it only requires one small grain of dirt — either between the film and camera back or between the sheet and film holder — to scratch a negative or transparency.

Always carry roll film in its plastic canister or in zip-lock bags. Keep opened boxes of sheet film and sheet film holders in zip-lock bags, too. Try to keep film — and the packs in which you carry it — out of direct sunlight, and use light-colored packs that reflect heat, not absorb it. This is easier said than done because most packs seem to be made with dark fabrics.

Photographing in Rain, Snow, and Cold Weather

Electronic cameras need only a drop of rain in the wrong place to shut them down. On the other hand, my view camera is not electrical, and I can use it in a downpour. I know of no easy way to protect cameras in rain, except to jury-rig plastic bags

SIERRA NEVADA RANGE, CALIFORNIA

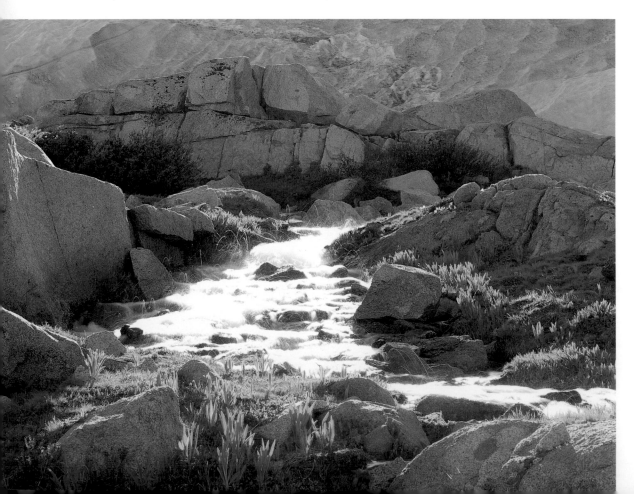

Notice the flying drops of water in the creek that, over the course of my one-quarter second exposure, have turned into wet fireworks. This is one of the unusual things camera and film can do with motion that the eye cannot. Back-lighting makes the arcs of water more conspicuous, and the pastel greens in the grasses and blues in the rocks and snow manifest one of nature's more delicate moments.

around them or have someone hold an umbrella over them. Neither method appeals to me, and I prefer to put electronic cameras away until the rain stops. For that matter, the end of rain showers tend to make better light than the storms themselves do.

Lens glass tends to accumulate raindrops. A few drops on the surface of the lens here and there will not affect the image, but many large ones can cause distortion. Always have a clean, absorbent cotton cloth in your pocket for wiping lenses dry. I always carry a cotton hanky in my pocket, and I use cotton dark cloths to cover my view camera. If you can keep up with the rain, you might be able to make a unique image.

Snow is not usually a problem when the camera is cold and doesn't melt snowflakes that settle on it and the lens. The biggest problem with snow is the cold associated with it. In fact, cold temperatures are a greater problem for the fingers than for most cameras. I have used all formats in temperatures as low as 25 degrees below zero, and except for dials and knobs not turning as quickly as they do normally, the cold hasn't stopped me from making photographs.

Batteries are an entirely different matter because they don't keep their charge well in cold temperatures. Nevertheless, when you return them to warmth, in time they regain their charge. Between exposures, try keeping cameras, flash attachments, and hand-held meters that contain batteries warm inside your coat.

When making exposures of snowy landscapes, remember that white is the most reflective color; in fact, white is about two stops more reflective than 18 percent gray colors. I usually set my exposure compensation dial or program to automatically overexpose by one or one and one-third stops until I leave that white place.

Additional View Camera Techniques

Though I've already talked about using view cameras in relation to depth of focus control, perspective control, spot meters, film, and hauling them around, here are a few more tips for maximizing their productivity.

I permanently keep a cable release attached to each lens I carry. This saves a minute transferring a cable from one lens to another. Cable releases shorter than 14 inches don't get in the way of one another in the pack.

Connect your focusing loupe to your spot meter neck strap with a nylon cord. Since you usually carry your spot meter around your neck, the loupe is then forever available to fine tune focusing in the corners of your viewfinder. This way, you only have to remember one tool in order to bring two.

Don't hesitate to use apertures all the way up to f/90 available on many slower telephoto lenses. Even though extremely small apertures can ultimately compromise resolution, f/64 and f/90 won't. Remember that Ansel Adams created a group called the F/64 Club made up of members who believed that every feature in a photograph should be in focus.

JAROD TROW PHOTOGRAPH

Here I am making an exposure with the Linhof Technika 4 x 5 field view camera mounted on a Bogen 3020 series tripod. Note the dark cloth over the shoulders and the spot meter and loupe around the neck.

TWILIGHT

My first of three mornings at this remote beach on the northwestern tip of Washington was the most dramatic. Rising with the first light usually pays off, and it certainly did this morning. However, you never know how long such light will last. It can disappear instantly if an unseen cloud below the horizon gets in the way of the sun. Therefore, I play it safe by setting up the camera and focusing well before I think such moments might occur. I will even begin to calculate preliminary exposures, adjusting them slightly as light intensity increases. By doing this, I assure myself that if excellent images are ever available, I'm ready to make the exposure.

SHI-SHI BEACH, WASHINGTON

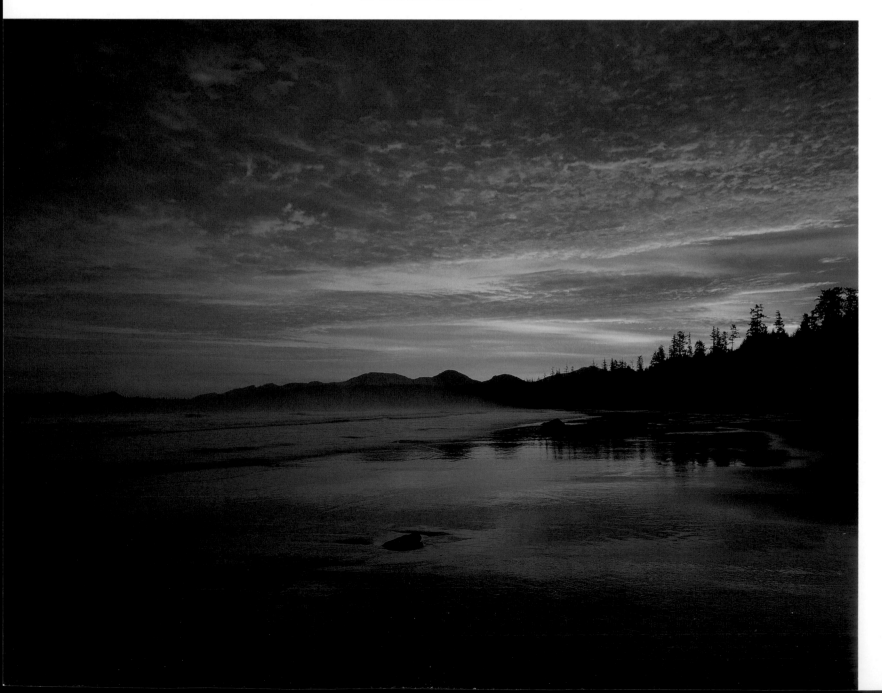

In order to seize the moment, you must understand the progression of light during the cycle of a day. In Chapter One we discussed the kinds and colors of light from one end of the day to the other. How does the excellent nature photographer react to these kinds of light in order to maximize productivity with the camera? Come with me now as my son, J.T., and I guide you on a photography excursion through Colorado's great Sangre de Cristo mountain range.

It's the end of July, the midpoint of my most productive season of the year. We are in my beloved Sangre de Cristo Wilderness in the heart of the southern Rocky Mountains near the 100-year-old town of Westcliffe, Colorado. These mountains compose the longest linear, block-faulted range in the world, extending over 200 miles from Salida, Colorado, to Santa Fe, New Mexico. We are in the middle of a week-long backpacking trip.

Today we wake up next to three beautiful tarns named Lakes of the Clouds on the east side of this north-south-oriented range. All around us peaks loom 13,000 feet high, and not far to the south are some of Colorado's tallest "fourteeners," including Crestone, Kit Carson, and Blanca peaks. It is a gorgeous clear summer day, and we can see down drainage across the Wet Mountain Valley over to the Wet Mountains and as far as the plains of eastern Colorado.

The frost on my sleeping bag indicates the temperature must be about freezing. My wrist-watch alarm repeats its cacophony of signals a second time, reminding me that if I don't react now, the next time I wake up the magic hour will be over. The watch says 4:23. At 12,000 feet, the cool and refreshing air provides a better jolt than any cup of coffee. There is not a sound in the air, save the occasional predawn warning call of nearby ptarmigan birds.

I holler to J.T. to get up quickly. I can see a warm orange band of color and light hugging the eastern horizon, and I know we must quickly get to that place I scouted last night. The rest of the sky is blue-black, but it won't be long before more colors of the spectrum will tempt me to begin making exposures.

Twilight

J.T. grabs the pack with lenses, sheet film holders, and accessories, and I grab the big view camera, always attached to the tripod and wrapped in my black cotton dark cloth. We don't forget the granola bars for that mid-morning pang. A last swig of night-cooled snow-melted water and we are off. Thank goodness for cozy fleece jackets.

Last evening I tried to envision what I might photograph between nascent morning light and the time when the sun would begin to create too much contrast for the film to understand. I planned a circuitous itinerary within this alpine valley that, if all went as planned, would yield about a dozen images — not including verticals of horizontals, or exposure brackets. It's still quite dark in our valley, but we only need to find that perfect spacing of spruce trees I had seen yesterday farther down the hill. We are on the very edge of treeline, so the trees are only silhouettes against the slowly brightening sky. Stumbling over logs and clumps of tundra grass, we soon spy that symmetrical combination of six or seven spruce still fresh in my memory.

I remove the camera from my shoulder and spread the tripod legs, searching for a solid, level base upon which to begin recording time on film. J.T. drops the pack, unzips its top, and we are ready to rumble. With dark cloth over my shoulders, light meter and loupe around my neck, gray card in my left pocket, hankie in my right, and fingerless gloves pulled tight, it's time to go to work. Out comes the 150mm standard view camera lens, the one I guessed right away would provide the angle of view I would need to compose what I saw yesterday and am beginning to see again.

Under the dark cloth I go, and there it is (upside down, of course): the black silhouettes of shapely spruce trees married against a background of shades of blue on top of magenta, on top of orange, on top of yellow. These are the colors of a clear, Colorado twilight sky. I focus on this two-dimensional composition — no tilting needed this time — with the loupe guaranteeing every bit of my ISO 50 film's incredible resolution. I lock the focusing knob, withdraw from under the cloth, grab the meter and gray card, and begin exposure calculations. First I spot meter on the sky at about 45 degrees on a mid-blue color that looks to me like an 18 percent gray color. My gray card reading

of ambient light is four stops darker than this one, which makes sense considering the sky is bright and the earth is still dark. The gray card goes back in the pocket until sunrise.

F/22 and four seconds, EV 8 — hopefully the right exposure to not make the sky too dark or too light, for I don't want to lose any of the sky's subtle "in-between" colors. My gray card reading of ambient light, EV 4, and the four-stop difference between sky and earth confirm there's no way those spruce trees will be anything but black against the brightening sky. It's time to begin making images on film. "Film holder, please, J.T." Into the back of the camera it goes, out comes the first dark slide — oops, forgot to cock the shutter. I press the shutter cable with thumb and forefinger, hold very still for four seconds, and we've got it. Back in goes the dark slide, the film holder is reversed, I stop down one-half stop to f/22-1/2, cock the shutter — here we go again. "Film holder, please, J.T."

Sunrise

Ten minutes later the sky is noticeably lighter. Sunrise is approaching. After swallowing granola bars, we dash back up the hill to set up on the eastern edge of the middle lake. The evening before, I had noticed that Mount Marcy reflected in this lake. I know that the mountain faces dead east, and I know that while catching the first light of sunrise, it will reflect in the tarn with great intensity. Fortunately, there is no wind; the lake is calm, and the reflection should be perfect.

Alpenglow! The tip of our gray granite Mount Marcy is now orangy-pink, and the line of sunrise is moving ever so slowly down the ridge. "75!" J.T. hands me the wide-angle 75mm lens, equal to about 22mm on a 35mm system. On it goes and under the cloth I go. A little bit of front tilt brings the rocks in the foreground of the lake into focus along with the top of the mountain. I stop down to f/45 just to make certain that all is in sharp focus. I pull out the gray card and meter: EV 10. I meter the peak: EV 12. I meter its reflection: EV 10-1/2. I meter the grass around the lake — it's 18 percent gray: EV 10. We start shooting at EV 10-1/2. What's my exposure time? I don't really care that it's three seconds — we're on a tripod and nothing's moving.

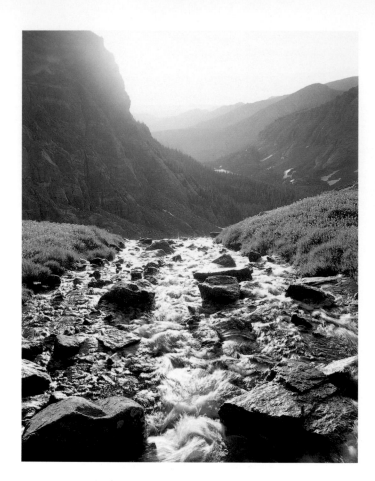

ROCKY MOUNTAIN NATIONAL PARK, COLORADO

SUNRISE

Just as at Shi-shi Beach, my speed and readiness helped me make this image. Any other position of the camera would have changed my composition of Andrews Creek and the particular rocks in it, as well the way in which it pointed to the emerging sun. If the sun had already made its entrance into the scene, lens flares would have ruined the photograph. Therefore, I had to have previsualized this moment and been focused and metered well before the sun appeared. I only had a one-minute interval between the time the sun back-lighted the tundra grass and creek and the time it struck the glass of the lens.

At EV 10-1/2 I know from experience that my shadowed location, still devoid of direct light, will look on film half a stop darker than it might at noon because that's what meters are programmed to do. But I want to see the detail of the grasses and the sprinkling of flowers, as well as the color of it all set below this gorgeous mountain range. I also know that one and a half stops is not enough to excessively overexpose my alpenglow-highlighted Mount Marcy, especially with such rich orange light. Marcy will appear lighter on film than it appears to my eye, but that's OK, for I like the ethereal feel of slight overexposure on peak tops.

I shoot this scene a half stop lighter and a half stop darker. With three different exposures I am sure to have a winner. Let's shoot the other side of the last holder back at EV 10-1/2, for I'd like two of these in case one happens to have a scratch from the film change the night before.

The sun begins to illuminate trees, and off we go from one preconceived location to another. By 9:00 we are finished, having made images of most of my preconceptions and of a few unpredictable compositions, too. It's warming up and the sun is rising high in the sky, so we return to camp to heat up water for hot chocolate and oatmeal. Sitting back, we look at each other, then down valley and up to Mount Marcy, finally at Colorado cutthroat trout beginning to rise in Lakes of the Clouds. How could life get any better than this?

Midday

After breakfast, J.T. takes down the tent, which we had only set up as a place to retreat in case showers arrived in the middle of the night. We both prefer sleeping under the stars. While he is packing up, I change film holders in the warm sun. At night when I am tired, this job is the worst of the profession, but now it's not so bad. With arms inserted into the black bag, and with no way to extract them until the job is done, I hope no mosquitoes find my head.

By 10:30 my big camera pack contains freshly loaded film holders, enough — I hope — to last the rest of the day. J.T. attaches the deflated pad and chair, tripod, and camera to the outside of the pack for quick removal. The camping gear

and provisions are secured inside his pack. Now we begin the trek to Cotton Lake on the western side of the range.

Today we will hike six miles, and our route will take us from 11,500 feet up to 13,400 feet and back down to 11,700 feet for tonight's camp at Cotton Lake. We have decided to climb Mount Marcy with full packs, cross the crest of the Sangre de Cristo range, and descend into a west-facing cirque. I hope that afternoon showers will erupt, not to test the reliability of my Gore-Tex raingear once again, but so we can photograph these mountains in cloudy light.

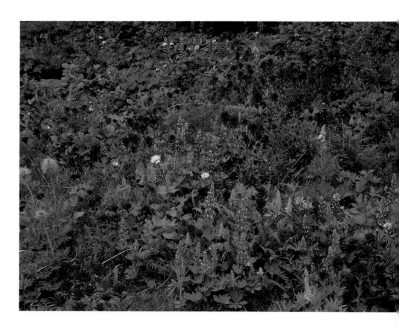

MOUNT RAINIER NATIONAL PARK, WASHINGTON

MIDDAY FLOWERS

Clouds covering the sky are the only salvation to summer days between 9 a.m. and 6 p.m. White or gray, both allow the nature photographer to be productive all day long. The rich color of lupine and paintbrush and their green foliage is best portrayed on film in the afternoon when the sun is hidden.

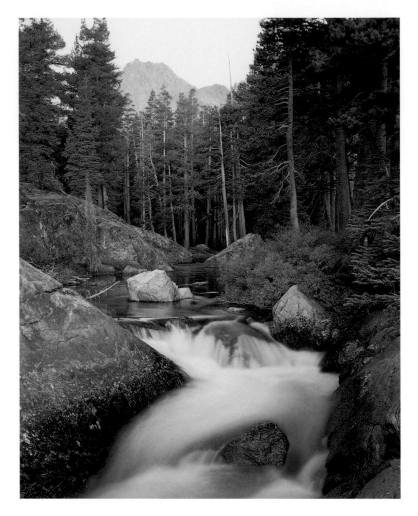

MIDDAY WATER

All things white and light need cloudy light, too, in the middle of the day. Cascades and waterfalls — such as these along Shadow Creek — demand a reprieve from direct sunlight. Notice the soft tones of greens and reds in the forest, as well as the detail in rocks and water. This photograph is overexposed by one-third of a stop to create a soft, unsaturated appearance, and it proves you don't need nature's more flamboyant colors to make an excellent photograph.

This morning I spied a patch of red about two miles away at the head of the cirque. Guessing it might be Indian paintbrush wildflowers, and since we will be off-trail anyway, J.T. and I make a beeline for the color. By noon we arrive at what may be the thickest field of paintbrush I've ever seen. Nestled below the main ridge of the range, I visualize a composition that might include the field and Spread Eagle Peak to the southeast. We walk around the flowers, careful not to leave tracks that will show up in the shot. The scene is perfect, but the light is not. With sun directly overhead and not a cloud in sight, the colors of the landscape are completely washed out. Reds and greens are a poor and pale version of what they might be with clouds overhead. Vowing to come back here another day, we decide to record the memory in our minds and set a goal of having lunch atop Mount Marcy.

The next 1,000 feet of ascent has us puffing and sweating by the time we reach the talused-top of Marcy. Long pants and polypropylene shirts prevent the inevitable peak-top chill as we extract "jack" cheese and salami for lunch. Exercise dulls our appetites, so except for extended swigs of the cold, snow-melted water with which we filled our bottles below, lunch only lasts long enough to enjoy the 360-degree view. And what a view. More Sangres to the north and south, the San Luis Valley and the San Juan Mountains to the west, and Pikes Peak in the distance to the northeast. However, I do not immediately see the clouds approaching from the southwest. When I finally do, I wonder if this could be the beginning of monsoon season. If it is, the rest of the summer will provide daily thundershowers and much of that white, soft afternoon light so complementary to mountain colors.

Before we leave Mount Marcy, J.T. plans our route down to Cotton Lake. He spies waterfalls at the head of Spring Creek, and I see patches of yellow and purple sprinkled throughout the cirque. Wildflower season is approaching its peak. By the time we reach the falls, blue sky is only visible as a thin wedge along the western horizon, and the colors of the alpine landscape are thick and rich without the handicap of direct sunlight. The light is perfect for photographing 30 feet of cascades in Spring Creek. The water that melted in the past few hours dances from one clump of creek rocks to another. "Let's do it, J.T." Off come packs, and I grab the tripod with camera already attached as J.T. unzips the Super Trekker pack. Within a minute I have my 115mm view lens attached, and I'm already metering the

exposure. I know that at 2:00 in the afternoon with white clouds above, light intensity in Colorado *always* equals EV 12. I use the spot meter to give me the f-stop and shutter speed options. Tilting the lens takes care of most of the depth of focus I need, and I'm not worried about aperture, so I concern myself with managing a two-second shutter speed that will turn the water into cotton.

Though I usually try to make nature look the way it does to the eye, I have a hard time resisting the ethereal appearance of blurred water. To enhance the contrast between wet rocks and water, I put the 82mm polarizing filter on the lens and watch through the ground glass as the wet reddish rocks darken when I twist the filter. It's the perfect cascade, so I don't bother including mountains behind, preferring to let the integrity of the creek stand alone. Nevertheless, I know I have a family to feed, so I step back a ways, put on the wider angle 75mm lens, and compose a classic scenic with cascades in the foreground and mountains behind. I know this will be more attractive to the stock photography market than the image I like best.

Never presuming that good light will last, J.T. zips up the pack, and I throw tripod, camera, and lens over my shoulder. With the big pack hanging precariously over one of my shoulders, we hurry across the basin to scout the yellows and purples seen from above. Spring Creek has slowed to spread its nourishment in a meadow, and the fecundity of growth is amazing. Yellow arnica, purple larkspur, and Colorado columbines just out of their buds decorate the landscape. I spy a particularly ordered clump of all three and recognize the opportunity for an "in your face" extreme depth of focus image of flowers in the foreground and mountains behind. Now sitting in the dirt, I detach the center post of the tripod in order to get the camera down to the level of the flowers. With my legs now tangled with tripod legs, I realize that I am here to stay until the image is made. With the 75mm already on the camera, I sneak it within seven inches of the flowers, knowing full well that I can bring those mountains into focus with enough tilting and swinging of the camera's front and rear standards. When it's all over, the bellows looks like a twisted slinky. I know that even though all is not yet in focus, it soon will be when I force the aperture down to f/45. Unfortunately, I know that the one-second exposure this aperture requires will be violated by flowers blowing in the breeze.

If there's one thing I've learned about nature photography, it's that nothing comes easily. Holding my cable release frighteningly still and not allowing my eye to leave the flowers for a blink's worth of time, I make the one-second exposure just as the flowers stop moving for the first time in 15 minutes. As always in capricious winds, one second seems like 10. Though I believe I have successfully made the image, I have learned only to draw conclusions when viewing processed film on the light table. I end this shoot with a few more exposures, slightly darker and lighter, confident that I have calculated a good exposure — so easy to do in such evenly lighted conditions.

Sunset and Beyond

Looking back on this particular day of our week together in the Sangre de Cristos, J.T. and I will never forget the sunset the evening of the Mount Marcy climb. Thank goodness I was faithful to my habit of scouting locations for photographs, for we were blessed by the powers that protect and guide us with one of those once-in-a-year photographs.

Cotton Lake turned out to be the kind of tarn that contains large, smooth rocks whose tops decorate the surface of the lake. Every four feet, in an asymmetrically balanced pattern too attractive to believe, lay rocks along Cotton's eastern shore. What I would have guessed would have been an uneventful evening with clouds blocking the setting sun turned out to be anything but. Just as I thought a sunset was no longer possible, the sun squeezed between the cloud bank and the horizon, projecting crimson-colored light along the bottom of the clouds from one end of the Sangres to the other. All of this reflected in the tarn as textured lake rocks became black goblins silhouetted against water on fire. Before I got into position, I knew where to put each tripod leg in order to make the photograph. I already knew the lens, the focal point, and the amount of tilt I needed to make the perfect image. This Colorado drama lasted for 10 minutes, during which time I made enough exposures to satisfy every magazine on the continent. Though I do this for a living and see many remarkable moments, in this case we marveled at it all once again and were humbled enough to suppress our egos for a while.

PEAKS OF THE NEEDLE MOUNTAINS, COLORADO

SUNSET

Note the color of the peaks and ridges; purple mountain
majesty. The color of the sky always affects the color
of the landscape. Learning its effect is no different than
a painter learning how to combine the colors of paint
on the palette.

I like to say to workshop students, "If skiers don't fall down every once in a while, they're probably not skiing fast enough. If you don't make a bad photograph sometimes, you probably aren't experimenting often enough by photographing new types of composition and new kinds of light." I don't like to admit it, but I throw away photographs. These are not images that are marginally acceptable, but images that would not be tolerated under any value system or theory of impressionism — just plain awful.

Nevertheless, these misfits bring me pride because I know they allowed me to find the boundaries of creativity. As I attempted to reconcile, or stretch, the gap between how the eye sees nature and the film records it, I crossed the fringes of acceptability. If you do not experiment with new ways of seeing, you will never know the full capabilities of film. And you won't reach your potential as a creative photographer.

The ways in which you evaluate your photography need not be any different from what I do when I critique the photography of workshop students. And it happens to be the same way I elevated myself from one skill level to the next. You must simply be prepared to admit your mistakes, and you must be willing to make the effort to learn from them. Unfortunately, some people are very insecure and cannot push themselves to examine the shortcomings of their photography. Others believe that photography as an art form is entirely subjective and cannot be analyzed objectively.

If you have learned anything from this book, I hope you realize that every aspect of nature landscape photography can be isolated and discussed cogently. From elements of composition to colors of light and the mechanics of cameras, you'll apply these lessons when you critique your work. Why does this photograph not attract me? What is the type of composition? Is it scenic or microcosmic? Is my eye directed immediately to one place in the scene? If not, why not? Is this good or bad? What other elements, our "toppings" on the pizza, does it contain? Is it missing any elements? Is there a sense of moment?

Make the effort to take hand-written notes in the field. Record f-stop, shutter speed, depth of focus, and the general conditions of light for each frame or sheet you expose. Consult this information when viewing prints or slides on the light table. Ask yourself if these images represent what you intended to portray in relation to the data you logged.

Remember, too, how I started in photography — by viewing and evaluating the photography of those people I aspired to emulate. By comparing my work side-by-side with the work of Eliot Porter and Ansel Adams, I could see explicit differences. But to do this you must be motivated by a love for nature, and you must be psychologically prepared for the letdowns.

If it weren't for a few good "how to" books and the exhibit format books of Porter and Adams, my photography avocation — much less my career — might never have left the ground. I hope this book is similarly useful to other photographers. Browse through the photography section of your favorite book retailer and look for other books that might complement this one. Having been involved in another career, and having been much too poor, I was never able to attend photography workshops. If I had to do it over again, I would attend as many credible workshops as possible, which would have accelerated my learning by a few years.

If a workshop instructor can fill you with useful facts and take you into the field to apply what you've learned (followed by a constructive critique of your work), you can rise to the next level of photography in no more than a weekend. Though no preparatory schools exist purely to teach nature photography, many two- and four-year accredited colleges teach general photography. If you aspire to make your living from nature photography, I encourage you to do so. If you love nature, it is the most rewarding of careers.

Here I'm reviewing transparencies on a color-corrected light table. Note the loupe used to check focus in all corners of the photograph.

POVY KENDAL ATCHISON PHOTOGRAPH

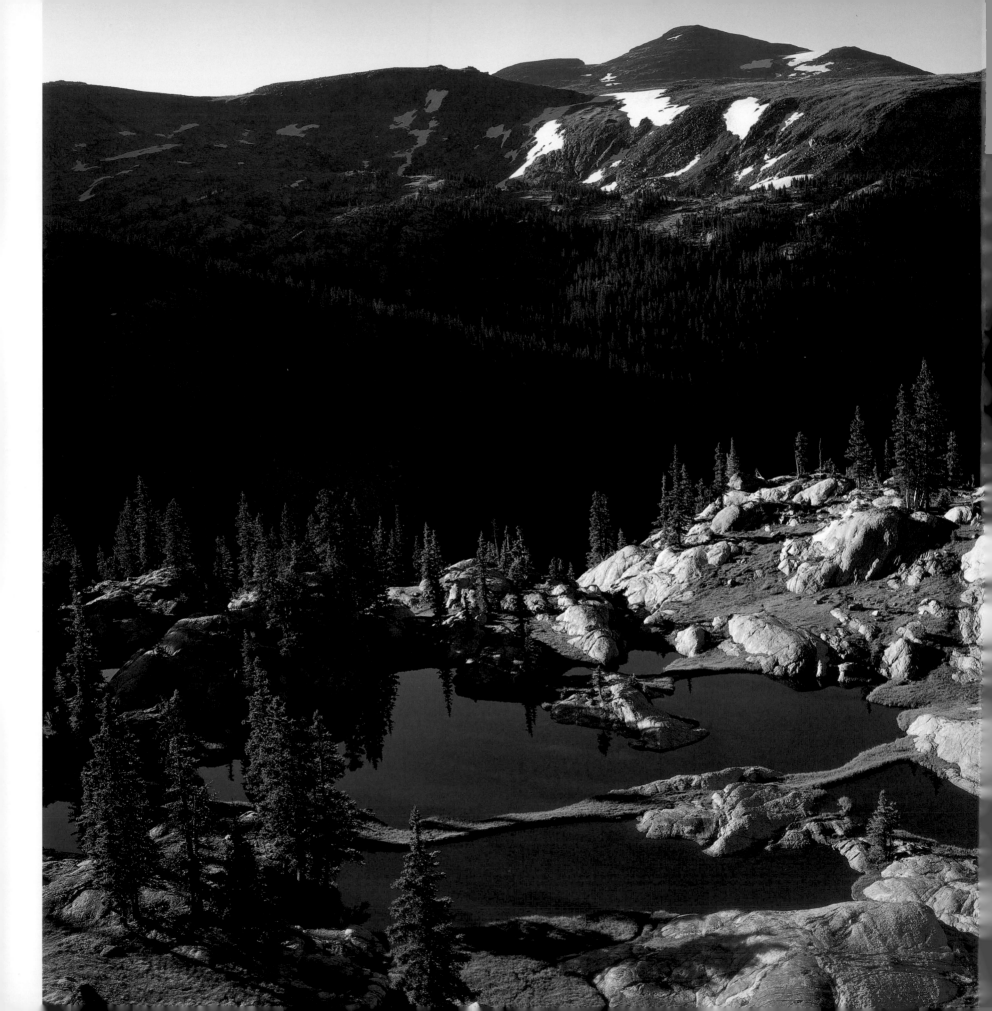

THE WILDERNESS GARDENER

I've always felt that the powers that be grant me the opportunity to make a finite number of excellent photographs each year. If I've had an especially good year making images of nature, I worry that the law of averages will make it difficult to get any more. Just when I thought I had spent all of my "chits" during a successful two-year project in Rocky Mountain National Park, I came upon a scene that made all others seem trite.

The discovery of the visual order of these ponds, the complete lack of chaos in the scene, was the highlight of my eight weeks in this wilderness. My first thought was that this remote place had been tended by a wilderness gardener for thousands of years, like a Japanese man caring for his bonsai tree over a lifetime. Some day I will go back to this place to find that person.

ALPINE PONDS, ROCKY MOUNTAIN NATIONAL PARK, COLORADO

DENNIS JOHNS PHOTOGRAPH

This book is dedicated to everyone who cares about the natural world — including my family. — J.F.

I have hiked many miles and explored some of the most remote wilderness in search of nature's sublime and sensuous offerings. I've witnessed sights, sounds, and moments unique to any I could have imagined prior to my avocation and career as a nature photographer. From mountains to deserts to oceans, I have discovered places that are bastions of ecological health and diversity, as unique and valuable as any on our planet.

For me, our wildest places are our best places. Wilderness is an unequalled stabilizing force that never changes, that is always there, that connects us with our beginnings. The personal sense of security derived from things permanent, like wilderness and God, is more important now than ever as the world becomes more crowded and chaotic. And yet, wilderness is not a static landscape frozen in time. It's a living, dynamic environment full of the fury and calm of nature. To explore the vast wilderness, we must abandon worldly schedules and immerse ourselves in the flows and patterns of nature — rise with the sun, sleep with the darkness, huddle from the storm.

In today's age of nuclear catastrophes, oil spills, and rapidly depleting ozone layer, perhaps we should ask ourselves some serious questions about the degree to which we live in harmony with the natural world. Toward what end are we taking our civilization if we do not arrest our disrespect for our environment? And what could be more important for us to pass along to future generations than the promise of pristine wilderness?

I learned a valuable lesson about nature when my son, J.T., accidentally put an ice pick through his finger. It was a Saturday morning, just as I was about to leave on a photography excursion. As always, I was excited to be heading into the wilds for a week of creativity and therapy with nature. A lengthy stay in the emergency room unfortunately postponed my trip. Sitting in the waiting room, feeling a bit sorry for myself and for my son, I reflected on the value of wild places.

I couldn't help thinking that the physical act of being in wilderness might not be as important as the mere knowledge that it exists. Yes, we humans enjoy our backcountry escapes. We certainly need the solitude of wild places and open spaces to soothe our minds following a week of city noises. And where else can one better learn about natural forces and the web of life that sustains us all? Yet, the act of going there may be insignificant in comparison to the simple knowledge that we have a refuge from the pressures of human society. When we're sitting in front of a computer terminal in a high-rise office or slumped over a factory line on Wednesday while looking forward to that weekend hike along a tranquil stream or mountain trail, isn't the realization that we have the ability to "get away from it all" at least as valuable as doing it? The psychological boost we gain from knowing wild places exist comforts the soul and lends us a sense of security not available from any other worldly source.

I hope all of us will work together to protect what remains of wild places on Earth, and I hope your own photography of Nature will influence others to regard her with reverence.

— J.F.

OTHER JOHN FIELDER BOOKS IN PRINT:

Rocky Mountain National Park: A 100 Year Perspective (with T.A. Barron)
Explore Colorado, A Naturalist's Notebook (with the Denver Museum of Natural History)
Cooking with Colorado's Greatest Chefs (with Lynn Booth)
A Colorado Autumn
A Colorado Kind of Christmas (with Laura Dirks and Sally Daniel)
To Walk in Wilderness (with T. A. Barron)
Colorado, Rivers of the Rockies
Along the Colorado Trail
Colorado, Lost Places and Forgotten Words

COLORADO LITTLEBOOKS:
Wildflowers of Colorado
Colorado Waterfalls
Colorado Reflections

COLORADO GUIDEBOOKS:
The Colorado Trail Official Guide (with Randy Jacobs)
The Complete Guide to Colorado Wilderness Areas (with Mark Pearson)
BLM Wildlands: A Guide to Hiking & Floating Colorado's Canyon Country (with Mark Pearson)

ANNUAL COLORADO CALENDARS:
Colorado Scenic Wall Calendar
Colorado Scenic Engagement Calendar
Colorado Wildflowers Wall Calendar
Colorado Reflections Wall Calendar
Colorado Waterfalls Wall Calendar
Colorado Parks & Monuments Wall Calendar

OTHER:
Colorado Writing Journal
Colorado Scenic Address Book
Colorado Note, Christmas, and Postcards

To order titles or to receive a free color catalog, call
Westcliffe Publishers at 303-935-0900 or fax 303-935-0903.

John Fielder photography is available for stock and advertising use and is also reproduced
in limited gallery edition prints. For information, contact Westcliffe Publishers.